"*Youth, Arts, and Education* is a smart book working at the intersections of education and the popular (wonderfully present here as street dancing). Hickey-Moody generously engages the most important writers and concepts, including publics, governmentality, resistance, hybridity, subjectivity, difference, and affect. Always connecting her theoretical steps to the rhythms of youth's lives and performances, she makes a compelling case for both the pedagogical power of the popular arts, and the popular power of an affective pedagogy. In the contemporary world, where both education and youth are under attack, Hickey-Moody has written a book that challenges us on many planes, that questions the short cuts that have become too common when we deal with education and youth, while offering us another way forward."

Lawrence Grossberg, Morris Davis Distinguished Professor, Editor, Cultural Studies

Youth, Arts, and Education

How are the arts important in young people's lives? *Youth, Arts, and Education* offers a groundbreaking theory of arts education. Anna Hickey-Moody explores how the arts are ways of belonging, resisting, being governed, and being heard.

Through examples from the United Kingdom and Australia, this book shows the cultural significance of the kinds of learning that occur in and through arts. Drawing on the thought of Gilles Deleuze, Anna Hickey-Moody develops the theory of affective pedagogy, which explains the process of learning that happens through aesthetics.

Bridging divides between critical pedagogical theory, youth studies, and arts education scholarship, this book:

- Explains the cultural significance of the kinds of learning that occur in and through arts.
- Advances a theory of aesthetic citizenship created by youth arts.
- Demonstrates ways that arts practices are forms of popular and public pedagogy.
- Critiques popular ideas that art can be used to fix problems in the lives of youth at risk.

Youth, Arts, and Education is the first post-critical theory of arts education. It will be of interest to students and scholars across the social sciences and humanities, in particular in the sociology of education, arts education, youth studies, sociology of the arts, and cultural studies.

Anna Hickey-Moody is a Lecturer in the Department of Gender and Cultural Studies at the University of Sydney. She is the author of *Unimaginable Bodies: intellectual disability, performance and becomings* (Sense 2009), co-author of *Masculinity Beyond the Metropolis* (Palgrave 2006), co-editor of *Disability Matters: pedagogy, media and affect* (Routledge 2011), and *Deleuzian Encounters: studies in contemporary social issues* (Palgrave 2007).

Routledge Advances in Sociology

1. **Virtual Globalization**
 Virtual spaces/Tourist spaces
 Edited by David Holmes

2. **The Criminal Spectre in Law, Literature and Aesthetics**
 Peter Hutchings

3. **Immigrants and National Identity in Europe**
 Anna Triandafyllidou

4. **Constructing Risk and Safety in Technological Practice**
 Edited by Jane Summerton and Boel Berner

5. **Europeanisation, National Identities and Migration**
 Changes in boundary constructions between Western and Eastern Europe
 Willfried Spohn and Anna Triandafyllidou

6. **Language, Identity and Conflict**
 A comparative study of language in ethnic conflict in Europe and Eurasia
 Diarmait Mac Giolla Chríost

7. **Immigrant Life in the U.S.**
 Multi-disciplinary perspectives
 Edited by Donna R. Gabaccia and Colin Wayne Leach

8. **Rave Culture and Religion**
 Edited by Graham St. John

9. **Creation and Returns of Social Capital**
 A new research program
 Edited by Henk Flap and Beate Völker

10. **Self-Care**
 Embodiment, personal autonomy and the shaping of health consciousness
 Christopher Ziguras

11. **Mechanisms of Cooperation**
 Werner Raub and Jeroen Weesie

12. **After the Bell**
 Educational success, public policy and family background
 Edited by Dalton Conley and Karen Albright

13. **Youth Crime and Youth Culture in the Inner City**
 Bill Sanders

14. **Emotions and Social Movements**
 Edited by Helena Flam and Debra King

15. Globalization, Uncertainty and Youth in Society
 Edited by Hans-Peter Blossfeld, Erik Klijzing, Melinda Mills and Karin Kurz

16. Love, Heterosexuality and Society
 Paul Johnson

17. Agricultural Governance
 Globalization and the new politics of regulation
 Edited by Vaughan Higgins and Geoffrey Lawrence

18. Challenging Hegemonic Masculinity
 Richard Howson

19. Social Isolation in Modern Society
 Roelof Hortulanus, Anja Machielse and Ludwien Meeuwesen

20. Weber and the Persistence of Religion
 Social theory, capitalism and the sublime
 Joseph W. H. Lough

21. Globalization, Uncertainty and Late Careers in Society
 Edited by Hans-Peter Blossfeld, Sandra Buchholz and Dirk Hofäcker

22. Bourdieu's Politics
 Problems and possibilities
 Jeremy F. Lane

23. Media Bias in Reporting Social Research?
 The case of reviewing ethnic inequalities in education
 Martyn Hammersley

24. A General Theory of Emotions and Social Life
 Warren D. TenHouten

25. Sociology, Religion and Grace
 Arpad Szakolczai

26. Youth Cultures
 Scenes, subcultures and tribes
 Edited by Paul Hodkinson and Wolfgang Deicke

27. The Obituary as Collective Memory
 Bridget Fowler

28. Tocqueville's Virus
 Utopia and Dystopia in western social and political thought
 Mark Featherstone

29. Jewish Eating and Identity Through the Ages
 David Kraemer

30. The Institutionalization of Social Welfare
 A study of medicalizing management
 Mikael Holmqvist

31. The Role of Religion in Modern Societies
 Edited by Detlef Pollack and Daniel V. A. Olson

32. Sex Research and Sex Therapy
 A sociological analysis of masters and Johnson
 Ross Morrow

33. A Crisis of Waste?
 Understanding the rubbish society
 Martin O'Brien

34. Globalization and Transformations of Local Socioeconomic Practices
 Edited by Ulrike Schuerkens

35. The Culture of Welfare Markets
 The international recasting of pension and care systems
 Ingo Bode

36. Cohabitation, Family and Society
 Tiziana Nazio

37. Latin America and Contemporary Modernity
 A sociological interpretation
 José Maurízio Domingues

38. Exploring the Networked Worlds of Popular Music
 Milieu cultures
 Peter Webb

39. The Cultural Significance of the Child Star
 Jane O'Connor

40. European Integration as an Elite Process
 The failure of a dream?
 Max Haller

41. Queer Political Performance and Protest
 Benjamin Shepard

42. Cosmopolitan Spaces
 Europe, globalization, theory
 Chris Rumford

43. Contexts of Social Capital
 Social networks in communities, markets and organizations
 Edited by Ray-May Hsung, Nan Lin and Ronald Breiger

44. Feminism, Domesticity and Popular Culture
 Edited by Stacy Gillis and Joanne Hollows

45. Changing Relationships
 Edited by Malcolm Brynin and John Ermisch

46. Formal and Informal Work
 The hidden work regime in Europe
 Edited by Birgit Pfau-Effinger, Lluis Flaquer and Per H. Jensen

47. Interpreting Human Rights
 Social science perspectives
 Edited by Rhiannon Morgan and Bryan S. Turner

48. Club Cultures
 Boundaries, identities and otherness
 Silvia Rief

49. Eastern European Immigrant Families
 Mihaela Robila

50. People and Societies
 Rom Harré and designing the social sciences
 Luk van Langenhove

51. Legislating Creativity
 The intersections of art and politics
 Dustin Kidd

52. Youth in Contemporary Europe
 Edited by Jeremy Leaman and Martha Wörsching

53. Globalization and Transformations of Social Inequality
 Edited by Ulrike Schuerkens

54. **Twentieth Century Music and the Question of Modernity**
Eduardo De La Fuente

55. **The American Surfer**
Radical culture and capitalism
Kristin Lawler

56. **Religion and Social Problems**
Edited by Titus Hjelm

57. **Play, Creativity, and Social Movements**
If I can't dance, it's not my revolution
Benjamin Shepard

58. **Undocumented Workers' Transitions**
Legal status, migration, and work in Europe
Sonia McKay, Eugenia Markova and Anna Paraskevopoulou

59. **The Marketing of War in the Age of Neo-Militarism**
Edited by Kostas Gouliamos and Christos Kassimeris

60. **Neoliberalism and the Global Restructuring of Knowledge and Education**
Steven C. Ward

61. **Social Theory in Contemporary Asia**
Ann Brooks

62. **Foundations of Critical Media and Information Studies**
Christian Fuchs

63. **A Companion to Life Course Studies**
The social and historical context of the British birth cohort studies
Michael Wadsworth and John Bynner

64. **Understanding Russianness**
Risto Alapuro, Arto Mustajoki and Pekka Pesonen

65. **Understanding Religious Ritual**
Theoretical approaches and innovations
John Hoffmann

66. **Online Gaming in Context**
The social and cultural significance of online games
Garry Crawford, Victoria K. Gosling and Ben Light

67. **Contested Citizenship in East Asia**
Developmental politics, national unity, and globalization
Kyung-Sup Chang and Bryan S. Turner

68. **Agency without Actors?**
New approaches to collective action
Edited by Jan-Hendrik Passoth, Birgit Peuker and Michael Schillmeier

69. **The Neighborhood in the Internet**
Design research projects in community informatics
John M. Carroll

70. **Managing Overflow in Affluent Societies**
Edited by Barbara Czarniawska and Orvar Löfgren

71. **Refugee Women**
Beyond gender versus culture
Leah Bassel

72. **Socioeconomic Outcomes of the Global Financial Crisis**
Theoretical discussion and empirical case studies
Edited by Ulrike Schuerkens

73. **Migration in the 21st Century**
 Political economy and ethnography
 Edited by Pauline Gardiner Barber and Winnie Lem

74. **Ulrich Beck**
 An introduction to the theory of second modernity and the risk society
 Mads P. Sørensen and Allan Christiansen

75. **The International Recording Industries**
 Edited by Lee Marshall

76. **Ethnographic Research in the Construction Industry**
 Edited by Sarah Pink, Dylan Tutt and Andrew Dainty

77. **Routledge Companion to Contemporary Japanese Social Theory**
 From individualization to globalization in Japan today
 Edited by Anthony Elliott, Masataka Katagiri and Atsushi Sawai

78. **Immigrant Adaptation in Multi-Ethnic Societies**
 Canada, Taiwan, and the United States
 Edited by Eric Fong, Lan-Hung Nora Chiang and Nancy Denton

79. **Cultural Capital, Identity, and Social Mobility**
 The life course of working-class university graduates
 Mick Matthys

80. **Speaking for Animals**
 Animal autobiographical writing
 Edited by Margo DeMello

81. **Healthy Aging in Sociocultural Context**
 Edited by Andrew E. Scharlach and Kazumi Hoshino

82. **Touring Poverty**
 Bianca Freire-Medeiros

83. **Life Course Perspectives on Military Service**
 Edited by Janet M. Wilmoth and Andrew S. London

84. **Innovation in Socio-Cultural Context**
 Edited by Frane Adam and Hans Westlund

85. **Youth, Arts, and Education**
 Reassembling subjectivity through affect
 Anna Hickey-Moody

Youth, Arts, and Education

Reassembling subjectivity through affect

Anna Hickey-Moody

Routledge
Taylor & Francis Group

LONDON AND NEW YORK

First published 2013
by Routledge
2 Park Square, Milton Park, Abingdon, Oxfordshire OX14 4RN

Simultaneously published in the USA and Canada
by Routledge
711 Third Avenue, New York, NY 10017

First issued in paperback 2014

Routledge is an imprint of the Taylor & Francis Group, an informa business

© 2013 Anna Hickey-Moody

The right of Anna Hickey-Moody to be identified as author of this work has been asserted by her in accordance with sections 77 and 78 of the Copyright, Designs and Patents Act 1988.

All rights reserved. No part of this book may be reprinted or reproduced or utilised in any form or by any electronic, mechanical, or other means, now known or hereafter invented, including photocopying and recording, or in any information storage or retrieval system, without permission in writing from the publishers.

Trademark notice: Product or corporate names may be trademarks or registered trademarks, and are used only for identification and explanation without intent to infringe.

British Library Cataloguing in Publication Data
A catalogue record for this book is available from the British Library

Library of Congress Cataloging in Publication Data
Hickey-Moody, Anna, 1977
 Youth, arts and education: reassembling subjectivity through affect/Anna Hickey-Moody. – First [edition].
 pages cm – (Routledge advances in sociology; 85)
 Includes bibliographical references and index.
 1. Arts and youth. 2. Arts–Study and teaching.
 3. Youth with social disabilities–Education. 4. Problem youth–Education.
 I. Title.
NX180.Y68H53 2013
700.71–dc23 2012027476

ISBN: 978-0-415-57264-4 (hbk)
ISBN: 978-1-138-82053-1 (pbk)

Typeset in Sabon
by Sunrise Setting Ltd.

Contents

List of figures xii
Acknowledgments xiii

Introduction: youth, arts, and education 1

1 Little publics: performance as the articulation of youth voice 17

2 Assemblages of governance: moral panics, risk, and self-salvation 41

3 Tradition, innovation, fusion: local articulations of global scapes of girl dance 67

4 Do you want to battle with me?: schooling masculinity 93

5 Affective pedagogy: reassembling subjectivity through art 119

Notes 149
Bibliography 159
Index 173

Figures

5.1 *Towards a Promised Land*, Wendy Ewald, 2006.
 Commissioned and produced by Artangel 131
5.2 *The Margate Exodus*, Penny Woolcock, 2006.
 Commissioned and produced by Artangel 133

Acknowledgments

I am fortunate in having many people to thank for their assistance with the completion of this book. I'd like to warmly thank the following scholars and significant others. This would be a far lesser book without the feedback and contributions of Catherine Driscoll, Glen Fuller, Daniel Marshall, and Melissa Gregg. Catherine especially responded to text that constituted the early stages of chapter one and was part of the formation of the idea of little publics. Thanks Catherine, Glen, Daniel, and Melissa. My previous research with Jane Kenway, as well as Jane's astute and caring career mentorship, has significantly shaped the scholar I am today. Gerard Goggin encouraged and mentored me when I was in need. Jane Park sat in cafes with me while I wrote. Patricia Thompson supported my application to the Australian Academy for the Humanities, and Deborah Youdell, Jessica Ringrose, Sarah Ahmed, and Mary Louise Rasmussen also offered critical engagement.

Johannah Wyn from the Youth Research Centre at Melbourne, Greg Noble and Megan Watkins from the Centre for Cultural Research at UWS, and Ian Maxwell, Amanda Card, and Justine Shi-Pearson from the Department of Performance Studies at Sydney either facilitated or responded to the presentation of the ideas presented within in public contexts. Thanks to each. Raewyn Connell, Jean Burgess, Tanja Dreher, Fiona Probyn-Rapsey, Natalya Lusty, Graeme Turner, and Gilbert Rodman also offered support. Elspeth Probyn reminded me to keep writing.

My dearly loved friends and mother nurtured me through the writing process. Thanks to Deana Leahy, Valerie Harwood, Brigitte Hadley, and Penny Moody. Mary Finegan lived with the start of the book in Sydney and Mary Calderwood, Frankie Hemming, and Lord Bonceroy at the Shoreditch House saw the true birth of the book. The manuscript was completed on study leave at The Institute of Education, the University of London.

xiv *Acknowledgments*

I want to offer big thanks to Kyra Clarke for her careful and caring research assistance. I'm not sure the book would have reached completion without an other with whom to work, especially one as diligent as Kyra. Tony Mack from ASSITEJ taught me a great amount about youth performance and, many years ago, set me along the scholarly path that led to this book. Jessica Cadwallader and Liam Grealy taught the framework for the book as GCST2612 Youth Cultures in the Department of Gender and Cultural Studies. Thanks also to colleagues who appreciated my work at conferences, online, and over coffee, especially Robyn Ewing, Joel Windle, Christine Sinclair, Timothy Laurie, Shirley Brice Heath, Elizabeth Ellsworth, Julie Allan, John O'Toole, Lauren Berlant, Kerry Robinson, Glenn Savage, Felicity Colman, Julie Matthews, Peta Malins, Geraldine Bloustien, Greg Hainge, Aislinn O'Donnell, Margaret Somerville, Bronwyn Davies, Trevor Gale, Charlie Blake, Emily Potter, Greg Siegworth, Cristyn Davies, Diana Masny, Erin Manning, Kristina Gottschall, Eva Bendix-Petersen, Emily Gray, Lucian Chaffey, Gerard W. Johnson, Dorothy Bottrell, Anna Powell, Michael Anderson, Anna Munster, Simon O'Sullivan, Charles Stivale, Andrew Murphie, Dan Goodley, Claire Charles, and Beckie Colman.

The ethnographic research and international case studies that form the empirical content of the book were funded by the Faculty of Education at Monash University, who, under Sue Willis' guidance, awarded me a postdoctoral research grant to study creative arts engaging youth at risk of leaving school early. School Focused Youth Services and the Darebin City Council funded the materials needed for arts-based research methods, including visual diaries, disposable cameras, and photo development costs. The Department of Criminology at Melbourne University provided office space and collegial support while I was conducting parts of the fieldwork. The community education organization and the secondary school involved in the research were incredibly welcoming and supportive.

While I abstract critical ethnographic moments from my work in the school[1] in order to make broader points about the politics of schooling, for two years the performing arts department of the high school welcomed me into their staffroom, chatted to me at lunchtime, introduced me to significant members of the school and local Koori community, and involved me in performing arts productions. I warmly express my very genuine gratitude to the staff, students, and parents of the school community, especially the dance teacher and the performing arts department. Thanks to the very

talented and generous Wendy Ewald for allowing me reproduction rights for her divine photographs, and to Creative Partnerships.

Some small sections of the subject matter of this book have been published in different forms. As such I'd like to acknowledge Taylor and Francis for permission to reprint sections of "Youth arts and the differential becoming of the world" from *Continuum: journal of media and cultural studies*, 24/1: 203–14 and *UNESCO Observatory*, Faculty of Architecture, Building and Planning, The University of Melbourne refereed e-journal for allowing the republication of parts of (2011) "Tradition, Innovation and Fusion: Local articulations of global scapes of girl dance" 2/2. The reproduction costs associated with the inclusion of images have been subsidized by a publications bursary from the Australian Academy of the Humanities. Finally, very warm thanks to my commissioning editor in the Routledge Advances in Sociology Series, Gerhard Boomgaarden. Thanks also to Jennifer Dodd and the lovely, untiring Emily Briggs at Routledge for their editorial assistance. Thanks also to you, reader. I hope that you find some use in the ideas and stories contained within. I hope that you teach them, write with them, think through them.

Introduction
Youth, arts, and education

Young people live through art. Music, film, YouTube, dance, magazines: popular and high forms of art are the languages young people speak. The ways young people consume and make art articulate their voice. School systems and popular culture encourage young people to be particular kinds of subjects in the way art is taught. Often, young people desire these forms of subjection. But making art can also be a resistance, a subcultural response to a perceived norm. It can be a way of acquiescing; regardless, when a young person makes a work of art they effect a political statement, call the public to attention and invest in particular ideas about identity, community, and belonging. More than this, tastes in consuming popular art, practices of participating in youth arts, and representations of such communities are means and media that imagine different figures of youth. They teach diverse audiences unique ideas about young people.

Exploring these propositions, *Youth, Arts, and Education* employs a liberal definition of "art" that brings images and texts from popular culture into stories from the field. The rationale behind this is my belief that we must develop critical awareness of the ways arts are used by youth, and by adults, to make "youth" in everyday life. This can, too often, include being a tool for governing, or "helping," young people who are in need of social resources. The arts are not technologies for social control; they are methods through which young people become themselves and can express opinion and critique through style. They create new scapes and senses: new ways of knowing and being. Both in and out of school, arts can be used as everyday ways of belonging to a community. Public art projects can confront and change community sentiment about particular demographics of young people.

2 *Introduction*

In order to provide some context for the ways I advance these lines of argument, the ensuing sections of this introduction situate the theoretical work undertaken in the book in scholarly and practical terms. I map some of the intellectual debates to which the book contributes and introduce the ethnographic project and case studies on which the book draws and the young people whose arts practices inform my writing.

Interdisciplinary conversations

This book responds to an interdisciplinary scholarly landscape. In the 1990s, the sociology of education saw the continuation of conversations started by the intersection of critical theory and pedagogy studies. This revitalized interest in the possibilities for education as a form of social activism, which came to light in the 1970s through the uptake of continental philosophers such as Foucault, Deleuze, and Guattari (amongst others, including Bourdieu, deCerteau, and Althusser). With the development of increasingly nuanced theoretical resources, this decade of research in the sociology of education saw the refinement of questions about the ways agency, class, race, and gender are lived.

The terms on which young people, institutional settings, and bureaucratic power structures converge were thus analyzed within the sociology of education in much greater detail, across increasingly personalized contexts. This burgeoning of inquiry at micropolitical levels, and enrichment of theoretical resources, facilitated nuanced considerations about how young people make themselves through processes of learning. Advancing this line of inquiry into the relationships between learning and becoming a subject, I write in response to a need for new theoretical assemblages that facilitate interdisciplinary forms of inquiry into the politics of young people's experiences of art. More than this, I examine the vernacular kinds of education and learning that are part of youth art, but which might not be generally discussed in educational literature. My focus on the politics of aesthetics as they articulate through the production and consumption of youth arts broadly, and the school dance curriculum more specifically, is an expression of the continuing politicization and theoretical enrichment of the sociology of education. I want to offer new intellectual resources with which to further politicize arts education scholarship.

More specifically, this book extends, and in some instances critiques, the work of theorists such as Giroux (2001a, b, 2004b, 2005),

Kelly (2001), Kenway and Bullen (2001), and Tait (1995, 2004), each of whom have developed unique approaches to making visible the ways in which young people's lives are shaped by forces of governance and pleasure. These theorists, along with others working in the sociology of education (Youdell 2006, 2010) and cultural studies of education (Rasmussen and Harwood 2004), have maintained a focus on how it is that young people contribute to conversations about their governance in ways that are material as much as they are verbal or obviously intellectual. These debates are politically important to the fields of education and youth studies and to the lives of young people. The contributions of writers such as Williams (1966), Hoggart (1958), Wright (1998), and in the Australian context, Turner (2008), Hartley (2009), and Noble and Watkins (2009, 2011) also bring the critical perspectives of cultural studies to bear on processes of learning and young subject formation in important ways. This book is not able to do justice to the importance of their contributions.

I employ the work of some American cultural studies scholars to help better understand how youth taste and youth choice are contextually determined. I inquire into the nature of youth agency in contexts that are to some extent socially compulsory, such as schools, or significantly determined by adults, such as out-of-school arts programs. I bring stories from the field that illustrate how the arts work as a form of youth governance and a performance of taste, together with the scholarly resources introduced above, with the intention of understanding the politics of processes of arts education.

Youth, Arts, and Education, then, illustrates young people's arts practices as gendered and racialized modes of production and consumption. It explores the everyday kinds of learning that are important parts of making and consuming arts and the vernacular meanings youth arts can have – meanings that are not about "art" per se, but might be comments on everyday life or social context. The book critiques the popular use of youth arts as forms of social governance that tend to be connected to particular media practices of representing and characterizing young people and the knowledge systems through which these young people are encouraged to understand themselves as being at risk. The notion of education as a form of consciousness-raising is embodied in this critique. It is also advanced through the concept of affective pedagogy – the idea that aesthetics are modes of learning and can be means of building alternative forms of community. The case studies in chapter five illustrate some activist possibilities which art can possess. They do this through showing the ways in which public art can prompt marginalized young people to

be imagined differently, how learning communities can be configured in ways that engage marginalized learners through the arts, and how youth arts institutions can operate as institutional forms of cultural pedagogy: they can facilitate configurations of young community that would not otherwise exist.

While my research fieldwork was largely dance-based, I utilized other arts methodologies, such as photography, video making, music, and drawing, as research tools that generated ethnographic data (Thomson 2008; O'Toole, Sinclair and Jeannret 2008). As the book was written, material generated from these methods did not form a focus of my inquiry, as this material did not express young people's perspectives in as clear a way as the ethnographic tales from the field (Skeggs 2001; Bloustien 2003). These stories allowed for a context-specific, comprehensive reading of young people's engagement with art, which their photos and visual diaries exploring dance, art, music, and futurity did not; nor did the creative texts they made to comment on these themes. The task of having to perform critique or comment produced artifice, whereas the dance practices spoke of context. The locations in which the ethnography was undertaken speak to the politics of education as a form of activism, and it is to a discussion of these contexts that I now turn.

Research contexts

The practical research for this book comprised two ethnographic sites and three case-study sites. I have anonymized all research sites except for two arts organizations, who wanted to be named as acknowledgment of their work in the field. I was based at Monash University for the duration of my fieldwork and this partially determined the educational institutions chosen for in-depth ethnographic study, as for two years I spent a number of days each week (usually three) in the school and one day each week in the community education context. The ethnographic sites were a school and a community education organization. These sites are both in metropolitan (suburban) Melbourne in Victoria, Australia. The school was the site in which I spent the most amount of time, and as such I discuss it in more detail than the community education site.

The school is a government-funded secondary college with a reputation for excellence in Aboriginal Australian education. It is an inner north-eastern suburban educational institution and has the largest population of Koori students in Melbourne (Galati-Brown 2006). Koori is the preferred proper noun used by the Aboriginal

people of Victoria, some parts of New South Wales, and Tasmania; twenty-five percent of students enrolled at the school identify as Koori (Galati-Brown 2006). The school principal actively engages with, and advances the school profile within, the Koori community. The school campus is on a large main road next to a shopping center, which is a major public transport hub for the northern suburbs of Melbourne. Young people loiter in the center's train and bus stations, smoking, talking, and checking each other out. The students wear a very informal uniform that consists of a navy-blue polo neck t-shirt featuring the school emblem and jeans of the students' own choosing. Most girls wear skirts with hemlines above the knee. The school's pedagogical practices are based around moderately informal student–teacher relations.

The school features incredibly well equipped performing arts studios and music recording studios, which were furbished by a generous donation from a benefactor who wanted to support the school's commitment to performing arts education and Koori culture. The school has an excellent dance rehearsal room and a good-sized performance area. These facilities are put to good use by the school's specialist programs, as the school runs vocationally based programs in a range of fields.

The school is one of a very select number of institutions that offer the subject of dance as part of the Victorian Certificate of Education (years eleven and twelve). Some of the other secondary education institutions in Victoria that offer dance as part of the VCE are private dance schools, whose fees and culture mean they are not accessible to the demographic of students enrolled at the school site. The school's focus on Aboriginal engagement and its performing arts facilities meant that it was an ideal location in which to conduct my research. Through the dance program, I worked intensively with two groups of young people, although I was involved in the dance program in different ways. The nature of my work was slightly different with each of the two groups with which I was intensively involved, and I discuss this in detail in the section on research design below.

The community learning organization that formed the second ethnographic research site was located in a western metropolitan suburb of Melbourne, Australia. It was established to support newly arrived Sudanese refugees and migrants. The organization runs learning programs out of a local church and the suburban location was chosen for convenience – it is where a large percentage of Sudanese refugees have been housed. The organization is a volunteer, non-profit, secular organization that provides English literacy support,

numeracy education in English, and other community services, such as food and clothing provision, to the Sudanese refugee and migrant community in Melbourne, Sydney, and Perth, Australia. The organization has multiple campuses in each of the states in which it is based. The community services provided by the organization include recreational activities run on Sundays after English literacy and numeracy classes. The dance programs I designed and ran were offered as an option in the Sunday recreational activity program.

The dance practices undertaken by the young people in both the school and the recreational contexts were of their own choosing and, to this extent, need to be read as a performance of agency. In school, dance was an elective subject, so while the curriculum was not the student's choice, their place in the subject was. Participation in my research was a choice. All but one young person took up the invitation, and my sense was that the participants were curious to see what we might make and do together in exploring ideas about arts.

In order to open the practical inquiry beyond the in-depth ethnographies of the Melbourne sites, the case studies discussed in chapter five explore the meanings of, and cultural currencies attributed to, youth arts in regional Victoria, in London, and in Margate in Kent, UK. These sites offer useful economic and cultural comparisons and there are strong parallels between the student demographics in the research sites featured in the case studies and the ethnography. While I discuss the organizations featured in the case studies in greater detail in chapter five, here I introduce and comment on the parallels between contexts in the case-study sites (the three arts organizations) and the ethnographic sites (the school and community education institution).

The first case study was a community arts project run in the UK by the arts education group Creative Partnerships. The project was located in Margate, a coastal town in the district of East Kent. The Margate community has experienced race-related conflicts surrounding the arrival of new immigrants. As a response to these conflicts, the project explored themes of finding a home and belonging. It was called *The Margate Exodus* and had three components: a large art installation and film that involved the community, a public photography exhibition called *Towards a Promised Land* that featured images of migrant and refugee youth, and a series of workshop programs run in schools exploring the plagues featured in the biblical story of the Exodus. As my description suggests, the story of the Exodus formed the focus of the three aspects of the project. The story was chosen because it is an exploration of journeys to find "home." The

case study in chapter five explores the *Exodus* project as a means of community building.

The second case-study site is the performing arts program of a London sixth-form college, which is an educational institution for students over the age of sixteen. The majority of students enrolled at the college have progressed from year eleven at school. The college is located in a disadvantaged borough that is statistically considered the sixth most deprived local authority in England and is the most ethnically diverse area in the country. The majority of students at the college are from minority ethnic groups, most come from statistically disadvantaged areas, and many receive financial support from the government, known as an Educational Maintenance Award. The college runs a performing arts program with an industry focus. This practical focus of the arts program is emphasized by its location in an industry performance space and commercial hub. The case study in chapter five explores the geographic and architectural features of the industry location of the performing arts programs as pedagogical features of the college arts education program.

The third case-study site is a youth arts center in Geelong, which is the largest city in regional Victoria. The center provides professional development for young artists in the Geelong region through offering skills-building workshops and providing resources for the production and display of different artforms. The young people who attend the center are from a range of socio-economic and ethnic backgrounds. Most are still attending secondary school or have recently left school. The programs offered through the center are varied and it operates in a similar manner to the sixth-form college performing arts program, in the respect that it provides industry connections and professional development for students who are approaching school leaving age and would like a career in the arts. The case study in chapter five explores the architecture of the building in which the center is located and the design of the programs the center runs.

There are interesting parallels between the research sites. The socio-economic and cultural environment of the sixth-form arts college in London has similarities with the Victorian school ethnographic site. Both educational institutions offer vocationally focused arts education to an ethnically diverse population. They are both located in areas that have traditionally been occupied by a low socio-economic demographic. The student body of both institutions is thus ethnically diverse and socially and economically disadvantaged. Although the Australian secondary school site featured an emphasis on Aboriginal Australian student education, the student cohort was diverse and was

composed of students from Middle Eastern, Maori, Greek/European, Asian, and Anglo Australian as well as Aboriginal Australian heritages. The student demographic at the London sixth-form college was equally mixed, and was composed of a majority of students from first-generation Asian backgrounds, Indian, and African American students, with a relatively small percentage of students from an Anglo background. As such, both secondary institutions taught arts with a vocational focus to a culturally and ethnically diverse student body using relatively limited economic resources.

The locations for two of the arts organizations featured in the case studies – Margate in Kent, in the United Kingdom, and Geelong in Victoria, Australia – are, respectively, a coastal colonial town and a small city (Geelong), both of which have been pressed to engage with the relatively new arrival of refugee and migrant families. The community in Kent is composed of a significant number of refugee, migrant Muslim youth who arrived in Dover, a coastal town that serves as a gateway to a large number of migrants and refugees (Office for National Statistics 2012). Similarly, 20 percent of the people in Geelong are from culturally and linguistically diverse (CALD) backgrounds (Geelong City Council 2012). Over the past four years both communities have experienced humanitarian arrivals. Thus, the case studies of youth arts projects in both sites are explorations of the arts as a media for negotiating cultural diversity and cultural change. The projects examined are different in the respect that the project based in Kent, *The Margate Exodus*, was discrete, while the case-study site in Geelong, the Courthouse Youth Arts Centre, is an educational institution. However, both sites were being called to respond to, and have meaning within, multicultural, changing communities.

The community refugee education site in Victoria was established in response to new arrivals and was intended to counter negative community responses to illegal migration in Australia. Exactly such negative dynamics surrounded the arrival of asylum seekers in Margate (see for example Collins 2010). As such, the ethnographic community education context and the UK Creative Partnerships case study are examples of how the arts can offer means of building community relationships and negotiating racism.

Each of the research contexts, then, engaged young people from a range of different backgrounds in forms of arts practice. Often the sites had been established to negotiate transition into new communities; in the case of the formal educational institutions, the culture of the organization had been developed to facilitate the most effective engagement possible with a socially marginalized community of

youth. All the research sites are characterized by an imperative to engage young people from multicultural backgrounds. These young people are often living in economically disadvantaged conditions.

Research design

My research design brought ethnographic research methods – namely, in-depth participant observation recorded in extensive fieldnotes – together with arts-based research and case studies. The ethnographic research consisted of participant observation across a two-year period, during which I became part of the culture of the educational institutions. In the school I was a rehearsal director, choreographer, and sound technician for the major school dance production of the year; I ran warm-ups in dance classes and did other useful jobs in the dance classroom. In the community education context, I was involved in a range of the community educational programs before facilitating two dance programs for refugee youth. The ways I utilized arts-based methods were determined in consultation with the needs of the teacher who ran the specialist dance program at the secondary school and with the young people attending the community education program.

The school ethnography comprised in-depth observation, interviews, photo diaries, video diaries, and focus group discussions (Alasuutari 1995; Bloustien 2003; Skeggs 2001; Thomson 2008). The design of my ethnography at the secondary school was shaped in relation to the school curriculum. I supported a group of year nine boys in making a hip hop dance piece that was performed at a couple of community events and I choreographed a dance work for a group of very socially marginalized year ten boys. Both of these formed the boys' major assessment pieces for the semester and were publicly performed. In addition to this, I ran focus groups with all year ten dance students in which we discussed their dance practices; under my guidance, they kept visual diaries and some made short films about their dance practice. The visual diaries were illustrated in part with photographs from disposable cameras. I gave the students cameras and asked them to take photographs representing what dance means to them, what it feels like to dance, and things that make them think of dance. The students also collected images of bodies and objects that they felt offered expressions of their experiences of dance. These resources filled the pages of their visual diaries. Their short films included statements about how and why they dance and footage of each other dancing. I assisted the students in layering music tracks over the films. As I stated earlier, when grappling

with the task of considering the kinds of learning that occurs in and through arts practices, the resources that made this most plain were my ethnographic journals of dance rehearsals and performances. These illustrated the ways young people engaged with arts in context. As such, my tales from the field are spoken from a place of feeling the culture of the school and the dance classroom. I speak with appreciation of, and great respect for, the work of the teachers in the school.

In the community education setting I extended my ethnographic observation by designing and running two dance workshop series. The process of designing the dance programs happened in dialogue with the young people involved and, as such, took a considerable amount of time in the field. In developing connections with the refugee youth in the community learning site, I joined in an established soccer group which ran on Sunday mornings. Playing soccer was a way of participating in the existing culture of the program and developing some visibility in the community. After participating in social soccer for a season, I ran gender-based focus groups with potentially interested young people. The choice to work in gender groups was a response to community dynamics – typically, the Sudanese young men and women did not mix when undertaking recreational activities and, as such, preferred to maintain single-sex groups for their recreational dance programs.

Initially, the Sudanese boys were unsure about working with a white woman. In spite of the fact that I had been playing soccer with them for a considerable period of time, I was a body with little authority in their eyes. My abysmal soccer skills would have done little to contribute to any possibility that my body might be read as possessing agency. The boys were keen to dance hip hop and were particularly excited by the prospect of videotaping their dancing. The technology of the video camera was not something to which the boys had previously had access and the fact that we could play with technology was of particular appeal to them. After an extended planning session one morning post-soccer, the boys' dance program, a series of hip hop workshops which were to be recorded and reviewed on video, was born. The boys really wanted to dance – they just were not sure a white woman could teach them anything. I kept extensive ethnographic notes and these provided a means of reflecting on, and better understanding, the ways the boys chose to dance and the meanings dance had for them.

In comparison with the boys, the Sudanese girls were much more enthusiastic about the prospect of my involvement in dance classes. Rather than reading my body as that of a white woman who lacked

authority and presented a different version of femininity to the boys' mothers, the girls thought I was exciting. My whiteness was read as a signifier of desirability rather than as a marker of a body without authority. The girls did not have words to express their aspiration to dance in certain ways – they just said they wanted to dance. I assumed that, in running the dance workshops, questions around genre and the structure of the workshops would be resolved. Communication was affected by age differences, the girls' shyness, and language difficulties: the girls' English was broken and I have no Dinka. I was thrilled that the girls were so keen to dance, and without a shared language through which we might negotiate exactly what this would look like, I undertook to run a series of dance workshops with the girls and trusted that I would develop the workshops in a manner that satisfied their desire to dance in specific ways. The girls' dance workshop group led to a community performance and the boys' workshop group generated vernacular video texts that mapped their dance practices.

The case-study sites were researched through observation and practitioner interview. In the instance of the Australian youth arts center, I participated in some of the programs run through the center as a way of developing a better understanding of the organization. I undertook research interviews with key practitioners at each of the sites, some of which inform my analysis in chapter five.

Ethics and institutions

Running this ethnographic project taught me a great deal about institutionalized racism across a range of contexts and at different levels of institutional, educational, and interpersonal relations. My first encounter with institutional racism came in the form of the university research ethics committee. The committee retains systems that have been established in relation to experiments conducted in the "hard" sciences and, as such, does not possess specific protocols for engaging with communities who are illiterate and/or who do not speak English. The research ethics committee required consent from parents for the involvement of their children in the study – a seemingly justified and important request. However, the nature of this consent needed to be written in English and the university ethics information, to which parents needed to agree, assumed an understanding of university systems and particular technologies which the Sudanese parents of the young people involved in the study did not have; neither did most Koori parents. I did my best to explain these processes, such as describing

how I would retain images and documents relating to the study in my office and how I would not use real names. The verbal communication was far more effective than the preformatted statements that the university required to be signed, which were written in ways that were not accessible to those involved in my research.

Sudanese parents mainly spoke Dinka, and as such, I had the ethics forms translated into Dinka. Koori parents spoke English but many could not read or write English. A number of parents signed their consent forms with an "X" after having the nature of the project explained verbally. My point in conveying this information is simply that this institutionalized process of obtaining ethics clearance values written literacy above verbal and oral literacies and, to my mind, assumes a colonial knowledge system. I rang and, in some instances, visited parents in order to obtain signed consent forms, but felt distinctly as if I was hassling them in relation to an issue which, in their eyes, did not concern them. It seemed that as far as most of the parents were concerned, the forms were my forms about my things that I was doing with their children. The Sudanese mothers proved an exception to this: as discussed in chapter three, they became excited and decided they wanted to join the dance classes.

Ethics clearance took over a year to complete. The positive aspect of the process was that it engendered meetings with parents. In ways I had not expected, it connected me with the families and daily contexts of young people attending the community education program and the year nine and ten school students. A process that was, on one level, about answering an institutional need in ways the parents could not understand also became about getting to know parents and talking about research. While the words remained white man's words, the relationships they engendered became useful.

Core arguments

In different ways across the chapters, the book advances the following lines of argument: youth arts practices are popular and public pedagogies. That is, they are popular pedagogies, ways young people enjoy learning and through which they produce their identity. Youth arts are also public pedagogies: they make citizen states that I call "little publics," and teach specific ideas about young people to these audiences. Little publics facilitate the articulation of youth voice and are constituted through aesthetic citizenship. They are a means of giving social visibility to the tastes and perspectives of young people.

However, the ways youth arts work as popular and public pedagogies can be problematic. For example, specific figures of marginalized youth are often created and popularized by arts practices. Drawing on the philosophy of Deleuze (1968a, b, 1970, 1981), I show that clichéd representations of youth need to observed and avoided. "Art" is indeed only "art" when it makes a new image of youth or attaches a new sense to young communities. Representing cliché through dance, rap, or visual image cannot be considered "art" per se, although it might be seen as a valuable expression of youth voice.

As a popular and public pedagogy that operates through style, genre teaches gender and race in ways that can hold great power. This is why production and consumption of art and music through popular culture are practices of belonging to community for many young people. It is also a reason why new communities can be formed, and original voices articulated, through atypical arts practices. While youth arts practices and popular cultural representations of these practices generally reproduce stereotypical ideas about socially marginalized youth (Te Riele 2006), they also have the capacity to create new figures of young people and to rework community sentiments surrounding youth.

After Habermas (1962), Fraser (1990), Warner (2002), and Berlant (1997), chapter one advances the concept of little publics. As they are produced and consumed in popular and high forms, youth arts are kinds of aesthetic citizenship. Constituted through practices of production, such forms of citizenship are often localized but have global dimensions that are activated through youth participation in publics of media consumption. Publics, then, are always/already multiple. A theory of little publics captures the political agency of minority that is inherent in this multiplicity. It also speaks to the materiality of youth. Through asking "what makes such a public 'counter' or 'oppositional'?" (2002: 85), Warner shows us that the nature of political "opposition" is difficult to define. Both in and out of school, arts often try to create dominant cultural positions on and of youth, and I consider these as popular young publics. Often arts programs can attempt to do this by involving marginalized young people and utilizing arts practices that are of interest to such youth, or exploring themes that are topical in the lives of marginalized youth. However, youth arts practices are also often politically conservative. There are major distinctions between the natures of the publics formed and addressed through different kinds of youth arts. The contribution to the public sphere that they advance is often small in scale, and thus the public they address is selective. Little publics, then, are the

myriad ways young people reconfigure the public sphere through involvement in the arts. They are built on different forms of aesthetic practice and consumption that "commence with the moment of attention" (Warner 2002: 88), attention that is invoked as soon as a young person calls a public, or chooses to be part of a consuming public.

Chapter two characterizes assemblages of governance in relation to which youth arts become cast as a mode of redemption, or a practice through which youth "at risk" might come to save themselves from the perils associated with risk trajectories (O'Brien and Donelan 2008a, b; Dwyer and Wyn 2001; Leahy and Harrison 2004; Tait 1995, 2004). This popular positioning of youth arts as practie is only possible because of the location of arts within a specific assemblage of governance. This assemblage is composed of media moral panic discourses that characterize particular youth subjectivities as "deviant," educational and psychological notions of "risk" and individual biographies based on these ideas, and "the arts" as a means through which potentially "deviant," "at-risk" subjects might be skilled or kept out of harm's way. Accordingly, the publics that are constituted by these arts practices, and to which they speak, are configured around specific taste and value systems that are too often governed by adult choice. The inclusion of arts in assemblages of governance not only produces impoverished arts practices; it can also (but does not always) take away young people's voices through imposing adult tastes on the lives of youth. The Foucaultian (1975, 1991, 2003, 2005, 2010) idea of governance provides a conceptual framework for developing awareness of the ways the arts are used to shape certain young people and young people use the arts as ways of governing themselves. One example of such governance is how youth agency and desire can be closely aligned with the performance of conventional ideas of genre. Fitting in with popular ideas of genre offered a sense of pleasure and achievement for many of the young people involved in the study. It was a form of self-governance that is evident in the girls' and boys' dance practices discussed in chapters three and four.

Theorizing the ethnographic material from the school, the community education project and the three case-study sites, chapters three, four, and five suggest new ways of thinking about the kinds of learning that happen in youth arts and consider the cultural values that inform young people's choices and tastes in participating in and consuming the arts. In order to do this, chapter three takes up Appadurai's (1996, 2000) concepts of mediascapes and ethnoscapes

to understand how Sudanese refugee girls living in Australia become part of a global community of non-white dancing femininities. It examines some of the pedagogical processes through which the girls came to belong to this global scape and explores the negotiations of traditional and contemporary knowledges that were important parts of this process. My use of the concepts of mediascapes and ethnoscapes acknowledges and responds to the globalizing contexts in which young people live and the changing cultural environments that lead the girls to belong to communities in Sudan, Australia, and North America.

Chapter four turns to look at dance as a means through which masculinity is constructed and publicly negotiated. Through the stories of four groups of boys, I consider how genre works as a pedagogy of gender and race. Via the work of Louis Gates Jnr (1988), I illustrate the different kinds of critical purchase young men had on the dance practices they were required to learn within schools. Through a case study of Sudanese refugee boys dancing in the community education context, I argue that genre does not always have to work as a way of teaching particular kinds of gender identifications. These boys danced free-form to the same songs that the schoolboys chose as ways of constructing and displaying their "strong" black masculinity; however, unlike the schoolboys, the Sudanese boys danced to experiment with producing their subjectivity in new ways, not to prove they were men.

Chapter five considers the case studies of the large British public art project, the innovative arts education program in the United Kingdom, and the regional Australian community arts center. Each constitutes a different kind of community that can be made through arts. Part of this examination includes a consideration of how, more than engaging with popular cultural forms or making public statements about identity, arts practices involve learning through affect: through making feelings connected to senses, scapes, and images that are created through youth arts. Ideas and ideologies are then built on these feelings. Drawing on Deleuze (1968a) and Grossberg (1997), I argue that this process of community change happens through affective pedagogy, which involves practices that in other academic discourses might be considered "popular" and "public" pedagogy. However, the frameworks of popular and public pedagogy impose particular models of subjectivity on the young subjects that form the object of their analysis. These analytic frames also fail to acknowledge the models of adolescence and youth on which they depend, and rely on adult readings of popular culture rather than youth-driven

practices of art and music production and consumption. As an alternative for thinking about the kinds of learning that happen in art, affect expresses the preconscious affiliations, alliances, and kinds of subjective change that articulate in a young person's feeling or experience of belonging or isolation generated through a work of art. Affective pedagogy also examines how youth arts can create new community sentiments towards young people.

Across its five chapters, *Youth, Arts, and Education* tells some new stories about young subjects who are often written about as being socially disadvantaged, marginalized, or "at risk." As a way of understanding the production and consumption of youth arts as a form of aesthetic citizenship, the concept of little publics shows the value of the varied choices young people make in relation to popular and high art forms. The critique of the assemblages of governance through which particular young people are encouraged to make art advanced in the book demonstrates the often inherently problematic processes of becoming a subject that are encouraged through the view of youth arts as a neo-liberal technology of governance. As such, the book is critical of some ways young people are encouraged to engage with the arts, such as the delivery of curriculum in select schooling and community education contexts. I also acknowledge young people's investments in governing themselves through making and consuming art. This critique is advanced as a means of furthering the way arts education can be seen as contributing to the lives of young people and communities. I advocate for the work of the educational institutions in which the ethnographies were undertaken and the case-study sites. My appreciation for them is the reason why they form the focus of my analysis. I would like to extend my thanks to the institutions, the people, and the traditions of thought on which this study depends. I can only hope to offer a contribution that seems worthy. I began this contribution with the concept of little publics, and it is to this theorization of aesthetic citizenship that I now turn.

1 Little publics
Performance as the articulation of youth voice

"I had sex with your mother. No, no, I'm serious. I cleaned your pool and then I had sex with her in your bed. Nice *Star Wars* sheets."

This attempt to distract the opposition falls flat and the home team are still losing. Red and white jerseys face off: it's time out on the American football field. The team captain calls "hit it!" Hand claps and synthesizers fill the air as Beyoncé Knowles' popular song *Single Ladies* blasts from the stadium speakers. Muscled young men spring into action, performing a tightly choreographed routine with impeccable timing. It looks like it has been honed through hours of rehearsal (perhaps in the bedroom?). As these gridiron bodies work their quads and roll like pole dancers, the opposition don't know where to look. They are intrigued, but also shocked and embarrassed. Their faces ask questions like: is this really happening? Is this disgusting, funny, or interesting? When the sequence ends, a burly red-and-white-garbed body darts across the field. His run is unopposed by the challenging team, who remain in shock. Touchdown. A slight young man enters the pitch. Kurt is the team's goal kicker. At his call, *Single Ladies* fills the airwaves again. His body dwarfed by the other players, Kurt's nymph-like form dances "like a girl" in the middle of the oval and he shakes his booty like a professional. He stops, aims, and kicks a field goal. The home crowd roars. Dance moves saved the game.

This vignette is a sequence from the popular American television comedy *Glee*. Prior to kicking this field goal, the young gay character Kurt teaches his school football team how to perform the routine Beyoncé made famous, as the dance is featured in the film clip to her song. The act of learning this dance had been intended to "loosen up" the team who, paralyzed by their anxiety about winning, had been

consistently losing. Kurt realized he always kicked goals effectively after dancing the sequence and the men's ambition to win evolved into bravery as they decided to try Kurt's formula for success. The scene introduces some core themes of this chapter. Arts practices, and in this instance dance, articulate youth voices. Through drawing an audience together, however small and contingent it might be, the act of staging performances creates little publics in which youth voices are heard.

In the example from *Glee* above, the men's performance of "women's dancing" draws attention to the fact that dance styles are often pedagogies of gender, as the ways bodies move in dance are read as gendered in cultural contexts. In addition, through the example of television as a form of a public pedagogy, the sequence shows us one way textual forms contribute to the processes of making the publics they address. The joke inherent in the camp dance routine may be intended to speak to communities of Gay, Lesbian, Bisexual, Transgender, and Intersex (GLBTI) viewers or GLBTI publics, as well as American football players and other members of the international viewing public. In drawing together such publics, the joke extends existing GLBTI communities. A YouTube search for "football teams dancing 'Single Ladies'" now brings up a number of clips of "real life" North American teams who have made their own version of the *Glee* sequence. The dance created in the show has fans who not only constitute the public to whom the show speaks, but who also make their own pedagogies of dance and gender through YouTube and video technologies. As such, the sequence shows a number of ways culture is pedagogical, in the respect that American football, popular music, and dance are all examples of learning how to "do" certain kinds of gender. More than this, *Glee* is a critical public pedagogy of dominant models of arts programs as they run in schools. The program is "critical" to the extent that it satirizes youth arts as a mode of salvation[1] for marginalized young people. At the same time, *Glee* offers viewers a humorous and sympathetic depiction of why this model of youth arts has become so popular.

The pleasure derived by viewers is a core aspect of *Glee*'s pedagogy. This pleasure is complex and is configured around generational ambiguity, which is constituted partly through the blurring between ideas of youth and adulthood which the program effects. *Glee* shows us that there are many pleasures which "adults" can derive from watching "youth" programming. To some extent, adults take pleasure in witnessing the "becoming-adult" of the young characters. More than this, though, *Glee* reminds viewers that demarcations between

"youth" and "adult" are as much a question of identity, taste, and style as a matter of biological age.[2] If *Glee* weren't enjoyable to watch, it wouldn't have a market, or a viewing public.

In arguing that youth voice is articulated through performance and heard by little publics, I construct a strategic, interdisciplinary history for the terms "public" and "popular" pedagogy. This history is a selection of texts drawn from cultural studies and critical education. The account of these terms which I give is characterized by my desire to acknowledge the political work undertaken through youth arts practices and school arts curricula. For example, in the following chapters, I explore moments audiences are called to attention to watch Sudanese girls' performances of femininity crafted through dance; low-SES[3] white Australian, Koori, and multicultural boys producing, satirizing, and commenting on their masculinity through dance; and a global listening and viewing public drawn to witness a community art project in Margate, in the UK, which rearticulated the face of refugee youth in the local community. While each of these examples arises from and speaks to very different communities, in each instance the little publics created are audiences drawn together to view texts that young people create. They are little publics because they are spaces in which youth voices are heard.

The idea of little publics is my development of contemporary theories of counterpublics. In order to understand the ways cultural processes of learning are a part of youth arts practices and are also affected by youth arts performances, I suggest that the term "public pedagogy" can be thought of as offering an education-specific version of Habermas (1962), Fraser (1990), and Berlant's (1997) discussions of publics and counterpublics. John Dewey's (1927) concept of the public sphere as a space in which citizens assemble to respond to negative effects of market or governmental activities forms a prehistory to this minor genealogy of discourses on the public sphere. As a negatively defined notion of a group of citizens drawn together as a means of protest, Dewey's public sphere is not generative in the same sense as that in which I imagine multiple little publics as productive fora. Dewey does briefly characterize what he calls "little publics" as associations based on culture – religion, race, hobbies (arts and sport), labor, interest. This can be held as a starting point for the idea I trace with my notion of little publics,[4] although, unlike Dewey, I want to suggest that we take young people's actions in making little publics seriously; that the materiality of their arts practices constitutes a form of citizenship. What begins as affect, style, art practice, effects modes

of community attachment that can influence community sentiment and can provide frameworks for policy and legislation.

In developing an alternative history of public pedagogy I also suggest that the concept can be read as a continuation of the call made by Raymond Williams (1966) to establish a role for education in contributing to debates about public good. Sandlin, Schultz, and Burdick (2010) argue that public pedagogy has had three main meanings: it has been used to refer to projects concerned with social democracy, which are invested in an idea of advancing a "public good"; to refer to the pedagogical capacity of mainstream, publicly accessible, popular cultural texts; and to discuss the pedagogical nature of public spaces and events. All of these meanings can be taken up to consider youth arts in and out of schools as forms of public pedagogy. I utilize each of these in this book.

In developing the notion of little publics, in this chapter I examine ideas of public good that are embedded in a youth performing arts event called the Rock Eisteddfod Challenge (REC). The works shown in this event are crafted in schools and, as such, the nature of the youth voices created in REC performance pieces can be read as performances of adult ideas about youth. Embedded in my perspective is the idea that popular pedagogy is a classroom-specific version of the strain of public pedagogy that is concerned with what pop culture teaches. Popular pedagogy is a term that refers to the classroom-based analysis and use of popular cultural texts. Kenway and Bullen (2001) use the term to describe practices that involve the use of popular culture and ordinary knowledges in the classroom. To the extent that they are educational practices that involve the valuation of common forms of knowledge, popular pedagogies can be read as a classroom-based version of early British cultural studies theorists' arguments that we need to value "everyday" literacies and knowledges (Hoggart 1958; Williams 1958; Willis 1977) as a way of engaging students who are on the edge of schooling systems (Giroux and Freire 1989: xi). As such, there is a relationship between the idea of popular pedagogy and the strand of public pedagogy concerned with the messages in pop culture. Both lines of inquiry are centered on mobilizing the roles that non-canonical knowledges and students' tastes and pleasures play in the formation of subjectivity and the production of belief systems. Both concepts read pedagogy in a liberal[5] sense, as a culturally specific process of teaching and learning. In the different forms these ideas take, public and popular pedagogy draw on a history of critical education (e.g. the work of scholars such as Apple 1979; DuBois 1973; Freire and Macedo 1987;

McLaren 1989; Shor 1980; Vygotsky 1978). They are strategies for utilizing education as a form of social inclusion. Broadly speaking, I agree with the politics of these ideas. However, by mobilizing this history of critical education, I want to make a point that critiques the idea of social inclusion to the extent that it recreates a concept of a privileged group. Working with little publics as a concept opens out and activates the politics that the term "social inclusion" signifies.

The term "inclusion," then, privileges an existing social structure from which some youth are excluded. Although strategic engagement with discourses of dominant cultural forms is required in order to have a position of use in educational theory, the assumption of the hierarchy embedded in the idea of social inclusion brings with it models for thinking about young subjectivity to which I am opposed. This becomes clear in the analysis I advance in chapter two of the "at-risk" youth discourse, which constructs specific young subjects as deviant. Drawing on the work of sociologists and educational theorists (Cuban 1989; Dryfoos 1995; Kelly 2001, 2007; Ralph 1989; Tait 1995; Te Riele 2006; Swadener and Lubeck 1995), I argue the "at-risk" youth discourse needs to be understood as a governmental strategy that reproduces selected young people as deviant and thus in need of control. Here, art is a means of governance. I introduce this argument as the chapter progresses through suggesting that in the REC, performance becomes a vehicle through which adult ideas of youth voice are shaped. Both discourses of youth at risk and the REC are largely ways adults control young people.[6]

For now, I want to introduce my argument that the projects of contributing to the "public" as a sphere and valuing everyday literacies as a way of engaging the socially marginalized in processes of schooling are taken up in educational theory through the ideas of public and popular pedagogy. Youth arts projects and curriculum units, especially those focused on popular dance, are forms of public and popular pedagogy. Dance texts are usually publicly shown, and this constitutes youth voice in a little public sphere. The process of creating these texts utilizes young people's knowledges of popular culture and style as forms of critical engagement.

Making little publics

Schools and community arts organizations craft different kinds of audiences: in so doing, they shape the little publics to whom youth arts speak. The role of youth voice in drawing together what I call a little public is crucial, as little publics are, by constitution, spaces

in which young people are heard. Recent research focusing on youth civic engagement has explored some ways youth voices contribute to public debate. For example, with reference to the context of young people's use of digital technologies (writing wikis, blogging, podcasting), Rheingold (2008) argues that community-based processes of creating texts give young people a voice. The pillars of his argument can be related to youth arts practices. Rheingold argues that involving young people in the collaborative creation of texts that are displayed for public consumption not only shapes youth voice but also cultivates a sense of engaging with the public sphere.[7] He contends that the act of preparing a text for public consumption and engaging with issues of civic concern crafts youth voices in modes of public address. It is with Rheingold (2008), then, as well as Habermas (1962), Fraser (1990), Warner (2002), and Berlant (1997), that I argue little publics require that youth voice is heard. Rheingold explains:

> Young people protest that "having your say" does not seem to mean "being listened to," and so they feel justified in recognising little responsibility to participate. ... These trends suggest the importance of social scaffolding for any interventions involving self-expression – other peers in the class and the teacher must act as the first "public" that reads/views/listens and responds. ... It isn't "voice" if nobody seems to be listening.
>
> (2008: 98–9)

A parallel argument can be advanced in relation to youth performances, which, I argue, constitute youth voice to the extent that they are witnessed, or that youth voices are heard. Rheingold goes on to explain:

> If literacy is an ability to encode as well as decode, with contextual knowledge of how communication can attain desired ends—then "voice," the part of the process where a young person's individuality comes into play, might help link self-expression with civic participation.
>
> (2008: 101)

Here, youth voice is classified as "the unique style of personal expression that distinguishes one's communications from those of others" (Rheingold 2008: 101). The materiality of a young performer on stage or of the artwork or music they create constitutes exactly such a unique style.

The processes of using digital technologies to craft youth voice to which Rheingold refers involve negotiations between young people

and adults, which can often be characterized by adults encouraging or instructing young people how to engage with issues of social concern. Youth arts processes, especially those employed in the REC and arts intervention programs for youth at risk, almost always feature adult instruction of youth and, as such, adults play a significant role in shaping what it is that "youth voices" say and the subjects on which they speak. However, there are exceptions to this rule – both in youth arts and in the practices of digital literacy to which Rheingold refers. Youth voice as articulated by youth arts is not always shaped by adults, but instances in which it is witnessed do always make little publics.

The connection I make with the public sphere here is not typical to scholarly readings of youth arts practices. However, an enduring investment in notions of public good links scholarship on public and popular pedagogy to Habermasian notions of the public sphere and post-Habermasian theories of how publics are formed (Bruns *et al.* 2010). As I've intimated, there are major distinctions between the natures of the publics formed and/or addressed through various youth arts projects, both in and out of school. Thinking about youth arts as making little publics allows us to see that the contribution to the public sphere being advanced is small in scale, and the public addressed is also very selective.

Habermas' (1962) *The Structural Transformation of the Public Sphere: an inquiry into a category of bourgeois society* brought a particular iteration of the idea of the public as a social sphere composed of a critical audience into scholarly debate. For Habermas, "the public sphere" is a democratic space that fosters debate amongst its members on topics concerned with the advancement of public "good" (1962: 99). Drawing on Greek configurations of public and private spaces and modes of social operation, Habermas characterizes the public sphere as a space in which "citizens ... interacted as equals with equals" (1962: 4). While this space of citizenship is clearly signposted as a bourgeois arena, Habermas characterizes debate within the public sphere as socially inclusive, "as a realm of freedom and permanence" (1962: 4). It is a space that, due to its access to economic and social resources, is separated from the power of the church and the government, as it is composed of capitalists:

> [M]erchants, bankers, entrepreneurs, and manufacturers [who] ... belonged to that group of the "bourgeois" who, like the new category of scholars, were not really "burghers" [comfortable

members of the middle class] in the traditional sense. This stratum of "bourgeois" was the real carrier of the public.
(Parentheses added, 1962: 23)

Habermas goes on to qualify the fact that the texts the public read are not *necessarily* "scholarly": indeed, he introduces the concept of the public sphere through discussion of an actor performing for his audience (1962: 14). Habermas draws on German linguist Johann Adelung, who also considers the ways different texts gather divergent publics by drawing "a distinction between the public that gathered as a crowd around a speaker or an actor in a public place, and the *Lesewelt* (world of readers). Both were instances of a 'critical (*richtend*) public'" (1962: 26). The attention of audience is crucial here, then. Sites of performance or display – be they distributed or localized – constitute little publics as long as they draw audiences to attention.

The Structural Transformation of the Public Sphere maintains an ongoing discussion of the relationship between different viewing publics and textual forms. This line of inquiry later inspired a scholarly field on media and their publics.[8] As a "public" assembled to watch a performance of Hamlet, or any audience brought together to view a performance text, a localized given public might be quite small. Different textual forms (newspapers, journals, plays, and so on) thus operate as "public organs" (Habermas 1962: 2) that configure distinct critical publics. A constitutive feature of any given public is a concern with advancing a common good, a concern,

> transcending the confines of private domestic authority and becoming a subject of public interest, that zone of continuous administrative contact became "critical" also in the sense that it provoked the critical judgment of a public making use of its reason.
> (Habermas 1962: 24)

An investment in some iteration of democratic ideals and thinking about society is thus a constitutive feature of a "public." Such investments have been problematized, but they remain implicit in the different ways young people express opinion through art or adults encourage youth to be a certain kind of person in art.

This problematization of the possibility of public good was largely engineered by Nancy Fraser, who, in her now famous response to Habermas (1990), argues that marginalized social groups are

excluded from any possibility of a "universal" public sphere. She contests the suggestion that such a space, as it currently exists, is actually inclusive. For Fraser, marginalized groups form their own publics: "subaltern counterpublics," or just "counterpublics." These groups speak back to, or critique, social investments which further the interests of the bourgeois, whom Fraser characterizes as "masculinist,"[9] stating: "[w]e can no longer assume that the bourgeois conception of the public sphere was simply an unrealized utopian ideal: it was also a masculinist ideological notion that functioned to legitimate an emergent form of class rule" (1990: 62). For Fraser, the notion of independent "citizens" is masculinist because in order to function in the public sphere, one must rely on a certain level of domestic (private, usually female) labor. Warner (1992) also critiques Habermas' notion of "the public" for excluding marginalized bodies in ways that require a disavowal of the embodied nature of social difference.

Youth arts in and outside schools often include and speak to marginalized bodies (O'Brien and Donelan 2008b). In so doing, they assemble publics which extend beyond the social category of the bourgeois. Through creating performances that articulate young people's voices in social contexts, youth arts make some counterpublics – but many are just little publics; moderately mainstream conversations. Performances articulate youth voice through embodied style as performances of taste, which are a form of social commentary and critique. Through calling an audience to attention, youth performances create "affective and emergent *publics*" (Bruns *et al.* 2010: 9) which are "structured by affect as much as by rational-critical debate. Such engagement can occur in and through popular culture ... and everyday communication ... [b]y decentering more formalized spaces of rational debate" (Bruns *et al.* 2010: 9).

An example of an affective and emergent public can be found in the work of Savage (2010). Drawing from his research with young people in Melbourne in which he examines how "various educative dimensions operate in young people's lives to enable the conditions for certain imaginations and subjectivities" (2010: 103), Savage considers the significance of informal pedagogies – their interactions with globalization and corporatization as a core means through which young people connect to, and participate in, social imaginations. These social imaginations are part of "multiple and disparate publics, rubbing against each other" (2010: 104).

In order to understand such relationships, Savage argues we need to be open to theorizing "the emergence of a plurality of new counterpublics" (2010: 104) as they form. I agree that we need to

develop more nuanced theoretical sensibilities through which the politics of youth communities and the textual forms they produce, and with which they engage, might be understood. Yet, along with a clear conception of a dominant cultural position, the idea of *counter* publics requires an investment in some kind of political or cultural opposition, an investment that is not necessarily aligned with the nature of youth arts activities in and out of schools. It seems to me that in order to understand the values espoused and the nature and extent of democratic work undertaken in youth arts projects in and out of schools, we are better off thinking about multiple little publics. As Berlant shows in *The Queen of America Goes to Washington City* (1997), and indeed as John Dewey foreshadowed in *The Public and its Problems* (1927), citizenship is a creative process that requires subcultures. Thinking through little publics allows for the articulation of discrete forms of citizenship that are primarily articulated through feelings of belonging to, and participating in, certain youth arts subcultures. These subcultures have divergent relationships with the broader legal public sphere and articulate through style – those performing musical theater in concert halls do so in order to occupy a very different place in public life than those listening to rap music in their bedrooms, or dancing at a rave. The differences between such communities are flagged by the multiplicity in and of little publics.

Considering the little publics that youth art/s create, and to which they speak, is a line of inquiry that allows the discursive positions that young people assemble through art to be read in relation to broader narratives of youth produced by popular media. There is a strain of work on arts practices as public pedagogies that can be mobilized as a history to such a line of inquiry. Existing work on a/r/tography[10] – specifically, the collection edited by Lacy (1995), *Mapping the Terrain: new genre public art* – discusses the politics of how some artworks speak to and assemble publics. Sandlin, Schultz, and Burdick note the significance of this collection to considerations of public art and art curriculum as pedagogy, applauding the ways the collection advances "the activist possibilities of artistic engagement to shift the idea of innocuous artworks *in the public* to the conscious production of transgressive artworks *for the public*" (2010: 27).

While the contributions in *Mapping the Terrain* read various forms of (and discourses on) art as explicitly political public pedagogies, youth arts performances in and out of schools are not discussed as vehicles through which young people assemble specific versions of the public as a sphere. Explicit considerations of the process of public making – and associated experiences of citizenship – that are affected

through youth arts practices need to occur. The communities that young people create (and to which they belong) through practicing in and out of school youth art/s are potentially more significant in the lives of the youth involved than are the pedagogical effects of popular media texts such as those discussed by Williams (1958, 1966) and Giroux (2005, 2004a, b). As such, I respond to Savage's call to look at "multiple and disparate publics, rubbing against each other" (2010: 104) in considering the little publics created by youth arts texts and practices.

The little publics made through youth arts operate on a much smaller scale than Habermas' universal domain of "common concern." They are also much more localized than Williams' discussions of television as an educational force, which is a primary argument advanced in Giroux's analysis of popular cultural forms as public pedagogies, or Lacy's more high-profile public art works and curriculum analysis. But to read the little publics to which the "youth voices" displayed in performance texts contribute without acknowledging the adult intent of mobilizing young people to have a public face is to neglect a key feature of the way these texts work.

Youth voices as heard in little publics demonstrate an investment in an idea of public good. This idea has a long interdisciplinary history. Prior to the development of counterpublics as a concept, Raymond Williams (1958, 1966) also championed an interest in discussing the ways different media and institutions[11] serve, or do not serve, public "good" and contribute to public life. His interest in media also relates to "everyday" literacies as a means of engaging marginalized young people, a focus I return to later in this chapter, but Williams explicates how different media create and speak to publics (or, after Fraser (1990) and Warner (2002), counterpublics). Giroux then extends this interest in the ways that forms of media contribute to public life through his theory of public pedagogy. He defines public pedagogy differently in different contexts. Sandlin, Schultz, and Burdick characterize the trajectory of Giroux's work on public pedagogy as shifting

> from an emphasis on popular culture to an examination of neoliberalism as the primary educative force in culture. Public intellectuals remain the prime mechanism of resistance to hegemonic culture throughout all of this work, and remain closely aligned with the institution of school.
>
> (2010: 52)

The strain of Giroux's work in which he advances the idea of creating publics through textual forms is his examination of the role of popular media "as a powerful form of public pedagogy" which "has assumed a major role in providing the conditions necessary for creating knowledgeable citizens" (2005: 45). He explains:

> [T]he media, as well as the culture they produce, distribute, sanction, have become the most important educational force in creating citizens and social agents capable of putting existing institutions into question and making democracy work—or doing just the opposite.
>
> (Giroux 2005: 45)

Giroux (2004b) calls the pedagogical and ideological forces of neoliberalism and corporatization "corporate public pedagogy," in which popular media become a way of teaching neoliberalism – a process which Sandlin, Schultz, and Burdick characterize as seeking "nothing short of the reaping of the public for decidedly private interests" and which, they argue, needs to be advanced through finding "the spaces in which counterpublics might be theorized, cultivated, and mobilized in defense of democratic ideals" (2010: 47). Here, public pedagogy is not used to create a public "good" as much as to harness the resources of "the public" for corporate gain. Popular media make viewing publics and do so, Giroux contends, with particular intent. An investment in advancing an idea of "public good" through critiquing corporate influences on public spaces is the core of Giroux's analysis here. To this end, the maintenance and cultivation of "democratic ideals" remains the reason why Giroux questions corporate investments in shaping the public sector. The political imperative to think about the intent (implicit or explicit) with which different texts speak to their viewing publics offers a means through which we might better come to understand the cultural logics that give in and out of school youth arts performances their meanings. More than this, corporate-produced popular cultural texts form resources which youth arts texts often use in making art. As such, youth arts both utilize and make their own public pedagogies.

Public pedagogy

Diverse scholarly histories and lines of inquiry have been developed through the three main meanings which public pedagogy has been given in scholarship. While advancing an agenda for how they would

like the term "public pedagogy" to be employed, Sandlin, Schultz, and Burdick (2010) map its core meanings. They suggest that "public pedagogy":

1 is a noun used to describe the contributions made by scholars, artists, politicians, and other public figures to public life (2010: 8–12);
2 can be employed to examine the pedagogical capacities of art, architecture, and public space (2010: 24–6); and
3 is mobilized to read popular culture as pedagogical (2010: 12–26).

They explain:

> Public pedagogy theorizing and research has been largely informed by the contributions of cultural studies as well as various arts-based approaches to examining learning in the public sphere, and is concerned with both the socially reproductive [e.g. politically conservative] and counter-hegemonic dimensions of these various pedagogical sites. The term itself is given a variety of definitions and meanings by those who employ it, with educational scholars emphasizing its feminist, critical, cultural, performative, and/or activist dimensions. Additionally, some strands of public pedagogy inquiry seek to broaden and de-institutionalize conceptualizations of teaching, learning, and curriculum across the discipline of education.
> (Parentheses added, Sandlin, Schultz, and Burdick 2010: 2)

An investment in creating democracy as an expression of "public good," usually achieved through activism or critique, underlies each of these lines of inquiry. My use of the term "public pedagogy" thus gestures towards the history of scholarship on art as pedagogy, outlined above, as a way of advancing the intersections between cultural studies, performing arts, and education on which the term builds. More than this, though, I want to draw attention to the fact that all scholarship on public pedagogy is grounded in an investment in what the public sphere "should" look like, or would look like, if the world was a better place. Scholarship on public pedagogy either criticizes, or responds to, the ways cultural forms shape the public sphere. A commitment to informing processes through which the public sphere is figured must be acknowledged as a driving force in scholarly projects that explore public pedagogy, in spite of the fact that this investment is not always explicitly stated.

30 *Little publics*

Savage (2010: 104) similarly contends that scholarship on public pedagogy does not adequately account for issues surrounding both the definition of the "public" or the disparate levels of access that young people have to various resources that might be considered "publicly" available. For Savage, this raises specific difficulties for thinking about "informal pedagogies," because the ways informal pedagogies work are often more regulatory than has been acknowledged in existing theorizations of public pedagogy. Informal pedagogies contribute to the public sphere through regulation as much as critique, and these relationships need to be read as legitimate and further investigated.

Importantly, in examining the paradoxes and limitations he has found in working with public pedagogy, Savage notes that "publics" are constituted differently across spaces of socio-economic advantage and disadvantage, as capitalism's influence changes their constitution. This results in divergent processes of "public formation." One of these divergent processes of formation can be found in the little publics made through youth arts, which clearly demonstrate a range of diverse socio-political and aesthetic investments. Savage illustrates divergent processes of public formation by explaining there is a great difference between the two areas in which he conducts research, despite their closeness and the differences in visibility of youth. He notes the visibility of the young Sudanese refugee population, the ways in which the media focuses upon it, and the abuse and issues they face. He emphasizes how different this is to the nearby affluent spaces, with "public" differences even within a small area of Melbourne. He argues:

> [S]urely the ways young people learn cannot be adequately understood without recognizing the power of local spaces to mediate the ways forms of knowledge are received and experienced. Familial histories, local schools, distinct "communities of sentiment" (Appadurai 1996: 8), the complex meshing of cultures and religions, economic advantage or disadvantage, distinct place-based imaginaries, and so on, arguably converge to govern the conditions of possibility for young people's pedagogic engagements.
>
> (2010: 105)

Savage particularly problematizes the idea of the "public" in relation to what Giroux calls corporate culture (2010: 105), noting:

> Central to Giroux's argument, therefore, is a belief that due to advancing neoliberalism and the expanding power of

corporations throughout the world, "non-commodified public spheres are replaced by commercial spheres as the substance of critical democracy is emptied out and replaced by a democracy of goods available to those with purchasing power" (Giroux 2004b: 74).

(Savage 2010: 106)

While Giroux contends that a new type of public sphere is formed through the expanding power of corporations, Savage questions the possibility that a corporate, non-democratic sphere can actually replace a democratic sphere. Agreeing on the importance of considering "corporatizing discourses" critically, he questions the applicability of the term "public," as we are always already "implicated in the consumption of *private* and *corporate* forms of knowledge," a process which facilitates a "blurring of the classic public/private distinction" (2010: 106). National contexts clearly need to be considered in relation to these debates. It is problematic that such specificities currently constitute an "outside" to this scholarship.

As such, Savage suggests using an alternative term to consider how corporations influence and shape young people's everyday lives. While he notes that "public" can refer "to what is available to the general population" (2010: 106), exactly what is available to everyone, or what access young people have to media texts, is uneven and mediated by institutionalized and socialized power structures. This call for definition clearly has utility. I agree with Savage's suggestion that research which employs the term "public pedagogy" does not always allow for effective engagement with nuances in young people's learning experiences. In a move to develop more nuanced understandings of young people's experiences of learning across informal and formal educational spaces and in and outside engagement with popular culture, Savage does away with the term "public pedagogy." I am sympathetic to the line of inquiry which leads to this point, but also think there is a shared interest in "what matters" to society – part of which are ideas about what is "good" for young people and what a democratic society would look like – that is core to the work of scholars who write about public pedagogy.

These investments in the public good, and in shaping young people so they can contribute to the public good, are important parts of youth arts projects in and out of schools. It is this acquiescence to an idea of a better community, healthy citizens, and an enriched culture that lends practices of youth arts to being considered as speaking to an interest in a "public" or common good. Youth arts can, then, be

seen as a kind of public pedagogy. The production of texts available for public consumption, texts that can be read as articulating a position on youth, or alternatively as constituting "youth voice," means that youth arts in and out of schools contribute in a small way to any given public sphere and constitute one of their own. Through performance and display youth arts texts create statements on public good for their viewing public. They are a public pedagogy and they make little publics, as opposed to speaking to "The Public" as a possibly open-ended realm.

The little publics created through youth arts performance and secondary arts curricula are local, but they also connect to and articulate through global scapes of "youth art/s." The presumption that the arts are good for young people, that they mobilize youth at risk for their own betterment and the good of society as whole, echoes in many youth arts practices, especially those that adhere to, rather than mix, particular genres.[12] For example, the REC is based on the premise that involvement in the performing arts makes young people better citizens. By improving young people through involving them in art, the REC partly advances what it sees as a public good: it makes young people fitter and less likely to strain healthcare systems. It contributes to the democratic functioning of society through giving young people a public stage for a voice that is shaped and articulated through performance.

The Rock Eisteddfod Challenge

The REC is a large, competitive public performing arts event that has been corporatized and franchised.[13] It started in Australia and is now global, having expanded to include Japan, New Zealand, the United Arab Emirates, and Britain. REC is a registered brand name and the event has become corporatized to the extent that it even has its own merchandise. The Challenge is thus "global" in the sense that it is a registered trademark event held in countries around the world and respective REC National champion teams go on to compete against each other in the "Global Rock Challenge." More importantly, however, the REC speaks to local–global imaginations to the extent that it cites the genre of the high school musical[14] (McWilliam 1996), which articulates across the history of colonial schooling and is given life in numerous media texts.[15] Kenway and Bullen (2001: 116–68) also argue that the REC is a form of popular pedagogy.

The REC thus constitutes a local–global public produced and articulated through a popular secondary arts event, an event typically also

used to meet secondary curriculum assessment criteria. To the extent that those who participate in the REC do so by choice, and that this choice is a performance of investment in the idea that art contributes to public good through enriching community life, the REC can be thought of as making a little public.

The REC website describes the event by stating:

> Rock Eisteddfod Challenge® events are produced by the Rock Eisteddfod Challenge® Foundation, a not for profit organisation. The event is a unique and exciting opportunity for schools to take part in a dance, drama and design spectacular where *the students are the stars*. Each year, the events are professionally staged in some of Australia's top entertainment venues.
> (Emphasis added, Rock Eisteddfod Challenge 2011: online)

There is a discipline-specific model of arts practice underlying this event, which consistently produces performances that adhere to the genre of the high school musical/dancicle. More than this, in the REC, the idea that young people can "be a star" is explicitly concerned with teaching ways to be "healthy" and "active" citizens, a project which is core to the organization of the competition. This idea also resounds with Habermas' early characterization of the public sphere as a place that features "competition among equals [in which] the best excelled and gained their essence – the immortality of fame" (1962: 4).

The website cited above constitutes an example of the way that stardom is a mode through which the REC teaches healthy living. The site has sections for students and teachers (as well as sponsors, ticket info, and an "about REC" section). The student section features "get involved" and "healthy lifestyle" hyperlinks, which detail lifestyle strategies that help in becoming a "star." The teachers' section features "production tips" which link to genre-specific resources in costume design, set design, and lighting and seek to furnish teachers with the know-how to reproduce the look of the high school musical.

The teachers' section also features links to the online teaching resource website "Teacher's TV," in which classes are presented in video format. The videos are organized firstly through levels of schooling (early childhood, primary, secondary) and secondarily through subject areas (Arts, English, Health and PE, Languages, Maths, etc.). Dance classes are displayed in Health and PE but not Arts, which largely features lessons on digital technology and music. These design features demonstrate the fact that, for the REC, dance,

and musical theater are seen as ways of improving what is considered to be the health and wellbeing of the young people involved, rather than as arts practices that extend young people's aesthetic vocabularies. As such, to some extent, the REC clearly sees itself as improving the social value of young people through enhancing their health and wellbeing.

The site explains that:

> As part of the Global Rock Challenge™, nearly 300 Australian schools and 25,000 students compete in Rock Eisteddfod Challenge® and J Rock™ shows across Australia. Teams as small as 20 or as large as 142 students plan an eight-minute performance based on a theme of their choice and set it to contemporary commercially available music. *Students, teachers and entire communities work together* over a period of months planning and rehearsing, before competing against other schools at events in a 100% drug and alcohol free environment.
> (Emphasis added, Rock Eisteddfod Challenge 2011: online)

In facilitating pseudo-democratic conversations between adults and young people, the REC shapes young people's voices through conventions of genre as much as it facilitates young people's expression. The REC can also be seen as enabling a form of democratic conversation to the extent that it creates a framework for connecting communities that are otherwise geographically and institutionally separated. Schools from low socio-economic and well-off suburbs come together to compete in the event. Both these outcomes – giving young people a voice, albeit a carefully crafted one, and fostering dialogue between socio-economically diverse communities – align with Habermas' notion that conversations about public good are separated from the power of the church and the government. These outcomes somewhat "bracket" social status through the inclusion of socially and economically diverse communities. Young people on stage at the REC are not necessarily equal to their teachers or their audience members, but performing, rather than speaking or writing, offers a social voice and a scale of dialogue not otherwise afforded to secondary students as a community. This said, and as I have intimated, the narratives which young people are able to articulate through the REC are firmly shaped, if not policed, by the nature of the event and the genre it mobilizes.

The experiences of citizenship that accompany the formation of little publics of youth arts such as the REC are constituted

through pleasure, disciplinarity, and affective responses to broad social imperatives for young people to have socially readable identities. Berlant (1997), Warner (1992), and Riley, More, and Griffin (2010) argue that experiences of pleasure need to be considered as forms of citizenship which can be more powerful than official or "legal" citizen status. Youth arts and school art projects are, in part, exactly such a pleasure-based citizenship. There is often great satisfaction in being disciplined enough to rehearse and perform, or make and show, a work.

To the extent that in and out of school arts practices are part of what both Williams and Willis refer to as "common culture"[16] and are presented in formats that are publicly accessible, they can be considered a form of public pedagogy. In making and speaking to very particular local–global communities, they constitute little publics. In the case of arts practices for youth run by adults, these little publics are often groups invested in "the power of the arts" to better society through the inclusion of marginalized young people in "mainstream" culture and "adding value" to young people as social commodities.

In order to better understand the cultural logics at play in the little publics made by youth arts, it is useful to think through the processes via which youth arts performances are made. Part of the way youth arts in schools operate is by mobilizing young people's knowledges of popular culture and their everyday literacies. This is a method of valuing knowledge that aligns with the politics of early British cultural studies theorists' call to value non-canonical forms of knowledge, which in part acknowledges the classed, raced, and gendered natures of student taste. The utilization of popular literacies is one way youth arts practices are democratic activities: to the extent that all young people possess popular literacies, all young people's knowledges can be mobilized through in and out of school youth arts.

Popular literacies

Williams' (1958, 1963, 1965, 1966) work on culture, cultural forms, and processes as pedagogical, Hoggart's (1958) call to value everyday literacies, and Paul Willis' (1977) discussion of how class is learnt through culture and labor each value everyday or popular knowledges (knowledges outside "the canon") as a way of democratizing education and involving those who might be considered to be on the "margins." Such means of employing popular literacies and cultural forms as a political strategy for engaging marginalized bodies, advancing calls for education as a democratic project and a means

of advancing "public good," later became core to the ideas of public and popular pedagogy.

A framework for valuing everyday and popular knowledge forms can thus be drawn from a conversation that began in part with Richard Hoggart's 1957 *The Uses of Literacy*, a text that John Hartley describes as having "set the agenda for a generation's educational and disciplinary reform" (2007: 1).[17] *The Uses of Literacy* offers an account of Northern working-class life in Britain, in which Hoggart reads "culture" as the experiences and habits of being part of "everyday" community life, as opposed to "popular culture" and popular (mass produced and widely distributed) publications. As the fields of audience studies and new media studies demonstrate, with the rise of new computer technologies and producer–user (Bruns 2006) media forms, the distinction between mass-produced and electronically distributed cultural forms and "ordinary" community life is no longer necessarily as useful as it may have been in 1957. The grounds on which such a distinction might be drawn have shifted. However, the need for educators to think through the importance of considering the classed nature of practices of literacy, and to value "everyday" literacies, endures. At the time, Hoggart claimed his focus on "ordinary" literacy was anti-Marxist, but to my mind it has clear parallels with critical literacy theorists' (Giroux and Freire 1989: xi) call to engage students with the language(s) of their community, state, and world.[18] While Hoggart and Williams' contributions to conversations about cultural studies and education are worthy of more extensive treatment than I am able to offer here, I want mainly to note, as Giroux (1994a: 283–4) has done in slightly different terms, that these thinkers mark one kind of origin for the consideration of popular literacies as a way of engaging marginalized learners. Youth arts projects constitute an ideal vehicle for such a project as they work with young people's popular or everyday tastes.

Youth arts practices and school arts curriculum are generally optional extra-curriculum activities for young people, which are not likely to succeed without young people's concerted involvement. Such an investment is clearly an expression of taste. At more senior levels, school arts curriculum subjects are selective areas of study, the pursuit of which similarly reflects youth taste and agency. Thus youth arts practices and curriculum utilize popular culture, but must also be considered *popular* to the extent that they are chosen. The articulation of youth arts practices and curricula as forms of disciplinarity and modes of activism ("education" versus "schooling") is site specific. These processes occur simultaneously – both political slants on

these forms must be recognized, as both youth arts practices and curricula create and promote particular forms of subjectivities and social relations.

Valuing popular literacies is an important part of the social work undertaken by arts practices, especially those involving marginalized young people. This validation of the tastes, actions, and embodied voices of marginalized youth can be read as an extension of Williams' (1958) argument in "Culture is ordinary," where he furthers Hoggart's valuation of everyday knowledge through suggesting that cultural processes and educational institutions need to be opened up to accommodate the involvement of all classes.[19] Williams developed this educational project in *Communications* (1966), where he argues for the importance of cultivating an awareness of the politics of popular culture as a source of democratic education. Part of this process of cultivating public awareness of the politics of processes of cultural communication[20] requires us to read cultural forms as pedagogical, as all drive for communication happens through what Williams (1966: 19) calls a "struggle to learn." Young people's popular cultural knowledges are part of this struggle to learn.

Popular literacies – knowledges about dance moves, different bands, musical styles, and their meanings – are core to the ways young people communicate about arts. They are knowledges that are central to how youth arts texts are composed. These knowledges are relied on and mobilized by youth arts in ways we might look at society and see "some of our characteristic relationships – in new ways" (Williams 1966: 20).

Young people's pleasure is the means through which all learning via popular literacies happens. As a practice, popular literacy mobilizes people's pleasure in reading and producing different cultural forms. Williams demonstrates the ways this mobilization of pleasure is pedagogical: "who can doubt, looking at television or newspapers, or reading the women's magazines, that here, centrally, is *teaching*, and teaching financed and distributed in a much larger way than is formal education?" (Williams 1966: 14). This identification of popular cultural forms and media as sites in which educational processes occur is one possible beginning of discussions of popular and public pedagogy that suture the validation of pop culture to social action. Calling "for a permanent education of a democratic and popular kind," Williams argues it "is in the spirit of this kind of programme that I discuss communications, the field in which one or other version of a permanent education will be decisive" (1966: 15). The arena of popular culture, which is grounded in pleasure and taste, and in which processes of

cultural communication occur, is "the field in which our ideas of the world, of ourselves and of our possibilities, are most widely and often most powerfully formed and disseminated. To work for the recovery of control in this field is ... a priority" (Williams 1966: 16).

The REC is an example of a process of schooling that mobilizes texts from popular culture, which to different extents may (or may not) be grounded in young people's pleasures and tastes. Performances are set to popular music and, as I have noted, the event itself is modeled on the trope of the high school musical popularized within mainstream film. It offers one instance of learning via popular literacies and makes little publics that are called to hear and respond to the adult and youth voices expressing genre-specific images of healthy young citizens.

Building on Hoggart and Williams' awareness of the educative dimensions of popular cultural forms and the politics of the processes though which they are produced, Giroux has extended educational inquiry focusing on everyday literacies. Giroux's work on public pedagogy is a particular vein of analysis in this work that is concerned with popular knowledge in the classroom. As such, I briefly refer to this line of his inquiry. Giroux (1988) began his work on the role of popular knowledges in education through calling for a focus on the critical analysis of everyday life as a form of pedagogy. This analysis is to be coupled with popular cultural forms and used for their incorporation into school-based practices of teaching and learning.

In *Teachers as Intellectuals: toward a critical pedagogy of learning* (1988), Giroux argues for the importance of cultivating critical awareness of popular culture through schooling. In so doing, he draws attention to students' tastes in popular culture as a site of critical importance for teachers, stating:

> [S]earching out and illuminating the elements of self-production that characterize individuals who occupy diverse lived cultures is not merely a pedagogical technique for confirming the experiences of those students who are often silenced by the dominant culture of schooling; it is also part of a discourse that interrogates how power, dependence, and social inequality structure the ideologies and practices that enable and limit students around issues of race, class and gender. Within this theoretical perspective the discourse of lived cultures becomes valuable for educators ... it can also be used to develop a critical pedagogy of the popular,

one that engages the knowledge of lived experience through the dual method of confirmation and interrogation.

(Giroux 1988: 106)

In this extension of the arguments advanced by Hoggart and Williams, a critical pedagogy of the popular is thus characterized as a classroom-based process of cultivating students' awareness of their knowledges of, and pleasures in, popular culture. When a young person is involved in composing a dance routine or a pop song they are required to draw on their knowledges of, and tastes in, popular culture – although critical reflection on these tastes is not necessarily a constitutive feature of these practices of composition.

Writing with Freire (1989), Giroux extends this discussion of pop culture as pedagogical[21] to introduce an emphasis on the ways race and class are performed through taste. Working with and incorporating the popular cultural tastes of students from marginalized and excluded social groups thus becomes one way in which students from socially disenfranchised or minority groups can be brought into processes of mainstream schooling. School dance curricula and many extra-curriculum youth dance projects offer examples of the amalgamation of popular cultural forms into processes of teaching and learning. This inclusion of popular cultural forms in youth dance practices is not necessarily a process designed to enrich students' critical awareness of their own taste as much as it is an example of an educational process that mobilizes student knowledge and student taste as youth voice. These aspects of young people's lives are made core to processes of teaching and learning through the arts.

Later, Giroux (1994a) refines the act of "doing" cultural studies as a process fundamentally concerned with addressing youth through popular methods of teaching and learning. In his essay "Doing cultural studies: youth and the challenge of pedagogy," Giroux argues that despite the popularity of cultural studies as a subject area at tertiary level, its methodologies and the textual forms with which it is concerned have rarely been utilized in school curriculum reform (Giroux 1994a: 278). He argues that cultural studies can help in developing "understanding[s of] ... the ways in which our vocation as educators supports, challenges, or subverts institutional practices that are at odds with democratic processes and the hopes and opportunities we provide for the nation's youth" (Giroux 1994a: 279). Both the failure of cultural studies to seriously consider questions of pedagogy and the failure of discourses of education to use methodologies and texts pioneered in cultural studies need to be addressed

if democratic education, as a project advanced through everyday and popular literacies, is to succeed. The study of youth arts practices in and out of schools, then, might advance just such an agenda of cross-disciplinary development as a means of better understanding youth voice. Thinking about the little publics that young people make through their arts practices is one way this can occur.

2 Assemblages of governance
Moral panics, risk, and self-salvation

In a Manhattan alley, over-produced, tinny pop music accompanies a group of cleanly dressed, well-presented young black men dancing and politely "grooving" in a well-lit spot. One boy hand-spins, another back-flips on a mat. The group respectfully side-step and click their fingers as they watch each other taking turns in the middle of the dancing circle. They are supposed to be typical "boys from the hood," although their jackets and bandanas are glowing white. Their cornrows are neat. They look clean, happy, and friendly. Some of them wear gold chains. Their dance has a non-competitive feeling, which gives the impression they are a funky group of friendly, middle-class young men. Their music and style catches the eye of a slight, tanned part-Latino woman in her early twenties. She's not "black," but has sexy "honey-colored" skin. Her name in the film is Honey Daniels. She's also well presented: conventionally attractive and dressed in a popular urban streetwear style. Accompanied by her friend, who is darker than she is (and more assertively sexualized – the friend is wearing an outfit that reveals a large amount of her carefully crafted black female body), "Honey" approaches the dancing boys. She's attractive and she knows it. She addresses them in relation to their dancing: "I like that: you guys should come to my class."

"Your class?" A "cute" young dancer with cornrows looks her up and down and acts like he's trying to show an attitude. "Yeah, I teach hip hop at the Center," Honey states proudly, encouraging them to come. "The *Center*?" cute cornrow replies, in his very best attempt to act like a boy from the hood with attitude. The other young men fall on top of each other, laughing. Why would they take their dance from the street to the youth center? Youth centers are where people who can't already street dance learn how. They are

places where those who can't make it on the streets go for help. The scene is well choreographed. If a group of boys could be said to fall on each other in a polite way, these boys do. Honey teaches hip hop at her local youth center, which is struggling to find enough funding to keep going. She does get the boys down to the center, and she successfully organizes a performance for her East Harlem community to raise enough money to keep the center going. Saving the black kids on the streets through hip hop is part of Honey's mega sex appeal and apparent self-conviction. Her mother cautions her about her keenness to engage with supposed "street culture," warning that "hip hop can't take you the places ballet can," but Honey, who is "authentically" in love with "street culture," can't give up her desire to dance the moves that the film calls "hip hop." They actually look pretty much like contemporary popular dance circa 2003 with a few top rocks thrown in. But they effectively sell the idea that Honey is saving black Harlem boys through dance with enough commercial sex appeal to be a box-office success.

Released in 2003, *Honey* is a North American mainstream chick-flick that capitalizes on all there is to sex up about the cultural stereotype of saving black kids at risk of educational failure through hip hop. Honey Daniels is supposed to be headstrong – she choreographs as well as dances (which means she's a thinker) and she refuses to sleep with her white, sexist producer. The pitch of the film clearly worked at the time of the film's release. It had international box-office success. YouTube is peppered with self-made clips of teenage girls performing choreography from the film. They want to dance just like Honey Daniels – in fact, they may well all want to be Honey Daniels. The film shows Honey choreographing for Missy Elliot,[1] starring as a lead dancer in mainstream pop film clips, and saving a youth center in crisis, while maintaining the figure of a fashion model, holding down a job, and enjoying an active social life. *Honey* is an example of the mass appeal of the idea that the arts, especially dance (which in this instance is hip hop dance for black kids), keep youth off the street. The film doesn't actually feature as much hip hop as popular contemporary dance, and as the vignette above illustrates, it is very mainstream. The kids are clearly not living in poverty, but the East Harlem setting obviously worked well enough in viewers' imaginations to sell the idea of poverty. Too much grit would have detracted from the glossing of the popular beliefs around which the film is based.

This chapter explores the dominant media, educational, and cultural logics assembled in the idea that hip hop can save black kids

on the streets. I characterize assemblages of governance composed of discourses of moral panic, educational risk, and salvation through the arts that manage select demographics of youth. Arts are often positioned as a means of redeeming the young folk devil or at-risk subject. As such, they are delivered as reflexive projects of "self-salvation": thinly veiled imperatives for what, after Foucault (1976, 1983), we might call neoliberal[2] governance. The theoretical framework of "the assemblage" as developed by Deleuze and Guattari (1980: 80–9, 333–4) offers a way to understand these connections between moral panic, risk, and youth arts. Assemblage is the English translation of the French word *agencement* and is used to explain how any given idea can only exist in relation to specific connections with other concepts. Connections between adult media moral panic and perceptions of youth risk are often intimated in the premise that the arts are a means of value adding, improving, or occupying specific demographics of youth. Thinking through this connectedness, we can see that by locating particular youth in discourses of moral panic, risk, and redemption through arts, we simultaneously reproduce young people as occupying positions of social marginalization. While clearly the answer is not as simple as avoiding conversations about disadvantaged youth, it is important to develop an awareness of the politics of these conversations. Through troubling the "taken for granted" nature of assemblages of governance, there is the possibility to make new assemblages of thought through which the lived experience of marginalized youth might come to be known, and their arts practices valued.

My analysis in this chapter moves away from the discursive tools through which young people are appropriated into stable population categories in favor of critiquing arts interventions as techniques of reflexive governance which can be read as responses to mediatized moral panics. Thus, my analysis becomes a political critique of risk that problematizes youth arts programs as "techniques of regulation that visit new forms of responsibility on young people" and which refuses "risk as signifying individual pathology or deficit" (Kelly 2001: 31), focusing instead on the ways risk discourses are educational and psychological articulations of moral panic. I critique the ways risk has become "an important indicator in a grid of governmental intelligibility" of young people (Tait 1995: 125).

While *Honey* is a mainstream, "chick-flick" example of the marketability of assemblages of governance, the actual assemblage of ideas is a dominant cultural logic that shapes the field of adult-run youth arts. Thousands of youth arts workers and secondary school

dance teachers are required to work hard to make a living from this dominant cultural logic, consistently negotiating lines between the needs and tastes of young people and pre-existing opportunities for social visibility, which are formed partly through cultural stereotyping. The ideas of moral panic, risk, and salvation through the arts might already ring true for many readers. For those who are new to the terms moral panic and risk, I explain them as the chapter progresses. I begin with the idea of moral panic.

The idea of moral panic has been part of academic discourse for 40 years. It is both a contested and an often-used notion. Media moral panics, especially about young people, are now a constitutive part of life for most. One can hardly access the internet or leave the house without encountering a form of them. Scholarship on this topic is so well established that I write about it partly from a sense of duty. Any discussion of youth arts in and out of schools that involves working with a demographic of youth who might be considered at risk needs to acknowledge the fact that in contemporary media, risk discourses are closely interwoven with narratives of moral panic. The interrelationship between the two often characterizes and racializes particular groups of young people in ways to which the design of youth arts projects specifically respond.

British sociologist Jock Young coined the term "moral panic" in 1971 (McRobbie and Thornton 1995: 560) in order to describe the British media's responses to youth drug culture. Stanley Cohen's famous *Folk Devils and Moral Panics: the creation of mods and rockers* (1972) further develops the idea through his argument that since the 1950s there have been multiple public "moral panics" associated with youth, which are exemplified in the British media's coverage of the discord between mods and rockers in the 1950s. This said, others have contended that media moral panics ostensibly started earlier than this: that they were a social phenomenon which focused on politics and land, religion, or gender, until the invention of childhood in the 1800s, at which point a moral panic about children focused on the act of making the "child."[3]

Moral panics are performances of ideology and hegemony – they are designed to characterize a dominant belief system and are a way groups with power in society work to maintain hegemony. Explaining how it is that moral panic is produced through the media, Cohen states:

> [A moral panic can be said to have occurred when a] condition, episode, person or group of persons emerges to become

defined as a threat to societal values and interests; [and] its nature is presented in a stylized and stereotypical fashion by the mass media [who then] ... devote a great deal of space to deviance: sensational crimes, scandals, bizarre happenings and strange goings on.

(1972: 9–17)

This sensationalization of deviance is one of the ways moral panics work as a form of social regulation. McRobbie explains:

[Moral panics] are a means of orchestrating consent by actively intervening in the space of public opinion and social consciousness through the use of highly emotive and rhetorical language which has the effect of requiring that "something be done about it."

(2000: 183)

Moral panics thus contain and critique cultural and subjective formations that do not necessarily serve "state interests." So, in order for something to be a moral panic, it needs to be *mediated*: the mass media – and new media – including television, newspapers, films, music clips, YouTube, mobile phones, and vernacular technologies, are integral to the production of moral panics. To the extent that media make the stories they tell, this process of mediation is important in any contemporary discussion exploring moral panics and their operation as a form of social regulation, as the process of mediation constitutes part of the hegemonic nature of panic discourses. Media is ubiquitous in everyday life, and so are panic discourses about select demographics of youth.

Hall and Jefferson (1976: 35) famously argued that in the 1950s moral panics focused on working-class youth. The 1950s also saw the emergence of "teenage" life and teenage "countercultures," and Cohen specifically examined moral panics that developed in response to, and were associated with, teen countercultures. For Cohen, countercultures exemplify cultural formations and subjectivities characterized by deviance. He goes so far as to state:

The major contribution to the study of the social typing process itself comes from the interactionist or *transactional approach* to deviance. The focus here is on how society labels rule-breakers as belonging to certain deviant groups and how, once the person is

thus type cast, his acts are interpreted in terms of the status to which he has been assigned.

(Cohen 1972: 12)

The transactional approach to deviance argues for "primary" and "secondary" deviance. To state it simply, primary deviance is when a young person does things that cause trouble, but which don't change the way they think of themselves. Cohen doesn't regard primary deviance as socially significant because the "deviant" behavior is not part of the young person's social identity. However, Cohen does regard what he calls "secondary deviance" to be "socially significant" – this is what Cohen sees in the mods and rockers subcultures.[4] Secondary deviance is "when the individual employs his deviance, or a role based upon it, as a means of defence, attack or adjustment to the problems created by the societal reaction to it" (1972: 14). In other words, in instances of secondary deviance, acts of rebellion inform the ways that young people feel about, and publicly characterize, their social identity. This characterization is then taken up by the youth in question as an attempt to justify the social disdain directed towards them. Cohen explains the significance of secondary deviance, and the ways it works, stating:

> The deviant or group of deviants is segregated or isolated and this operates to alienate them from conventional society. They perceive themselves as more deviant, group themselves with others in a similar position, and this leads to more deviance.
>
> (1972: 18)

As suggested by the multiple references to "more" deviance, Cohen conceptualizes the relationship between social formations and "delinquent" youth as a "spiral" of deviance, or a process of *deviance amplification* in which subcultural formations are constituted by practices of young people self-identifying as deviant and acting rebelliously. Moral panics are based around these notions of "deviant" identity and work to amplify this deviance. The impact of this amplification extends beyond individuals' lives and affects communities:

> [W]hole or part of a community must be affected, a ... segment of the community must be confronted with actual or potential danger, there must be loss of cherished values and material objects resulting in death or injury or destruction to property.
>
> (Cohen 1972: 22)

The 1960s saw the production of moral panics associated with middle-class countercultures in the United States and Britain and, alongside a rise in migration, moral panics about youth became increasingly racialized.[5] Australian moral panics have been, and still often are, performances of a racist ideology, in which Aboriginal, black (often refugee or migrant), and Asian families are portrayed as deficient (Khun 2007). For example, media coverage of the Northern Territory emergency response intervention[6] highlighted the rationale (which partly drove the intervention) that Aboriginal youth needed to be stopped from having underage sex and sniffing petrol (see Cunneen 2008) and protected from organized pedophile rings which, upon investigation, were never found to exist (Kacha 2009). Black refugee families have been depicted in Australian print media (e.g. McManus and Packham 2007) as struggling because of absent fathers, or as fostering a culture of violence (Scheikowski 2010; Mickelburough and Mawby 2010), whereas Asian families are typically or popularly seen as being too repressive. Popular media representations of Asian families often feature overly strict parents trying to control their children (for a popular cultural critique of this stereotype see *Slanted Magazine* 2011). So, moral panics have classed and racialized dimensions, and often these dimensions serve to characterize specific demographics of youth through notions of deviance and deviation from an assumptive norm. In what follows, I discuss the ways Aboriginal and Sudanese Australian youth have become figureheads around which racialized moral panics are constructed.

Australian black panics: Strategies for public governance

On 13 October 2009, the national *Australian* newspaper published a story titled "Indigenous kids better off in jail." The day beforehand, the South Australian Attorney-General Michael Atkinson had stated:

> This hard core [of criminals] needs to be put behind bars and kept there. We are dealing with an evil phenomenon ... rehabilitation is not going to do anything. We have to keep them away from society as long as we can.
>
> (Owen and Nason 2009: online)

Terms such as "evil phenomenon" and the suggestion that "we have to keep them away from society" are but one of many possible illustrations of the fact that in Australia, Aboriginal Australian young people have become sites for the production of racialized

moral panics. This was exemplified in media coverage of the Redfern riot[7] in Australia in 2004, which became a moral panic about the uncontrollable nature of Aboriginal youth. Indeed, as Cunneen has noted, the use of the term "riot" can be seen as an instance of moral panic discourse:

> The Royal Commission into Aboriginal Deaths in Custody ... noted the increase, during and after the 1988 Bicentenary, in the use of the word "riot" in relation to confrontations involving Aboriginal people. An analysis conducted for the Commission of the *Sydney Morning Herald* from January 1987 to April 1990 showed that 40 per cent of all references to the word "riot" within Australia were related to Aboriginal people (Johnston 1991: (2)186).
>
> (2008: online)

A contemporary example of racist moral panic about Australian Aboriginal youth can be found in the Facebook group titled "Aboriginal youth – WA is sick and tired of your violent crimes – ENOUGH!!!," which can be seen as part of the "societal control culture" which Cohen partly characterizes as articulating through "action groups" (1972: 85) whereby "members of the public, acting as informal control agents, brought pressure to bear for rule-creation" (1972: 113). The page describes the group as having the following responses to, and opinions of, Aboriginal young people:

> We can't win. We feel afraid because we face violence everyday and the perpetrators are more than likely young Aborigines. When we address it, we are labeled racists so we don't address it and it spirals out of control as it has for decades!!! [sic] ... I have friends from New York and London that feel safer riding the tube or the subway than they do the Perth train network ... I am one of thousands who have been violently attacked merely because I am other than Aboriginal. It's violence at epidemic proportions and its only getting worse. They mug and attack the elderly, the disabled, the pregnant, children – no one is safe from their lack of empathy or sympathy for others. They steal, they rob, the [sic] kill and they maim the innocent people of Perth.
>
> (2011: online)

These sensationalist passages and their unjustifiable claims are indicative of the tone of all the writing on the group's Facebook page, which clearly displays definitive elements of moral panic discourse. Moral indignation and hostility are plain in the characterization of "Aboriginal youth" as constituted by a "lack of empathy or sympathy" and the separation between "Aboriginal youth" and "the innocent people of Perth." Further, the actions of "Aboriginal youth" are described through deviance amplification: they create situations that are "out of control" (2011: online) and the threat that this group of young people pose to society is unconditionally exaggerated through statements such as "[i]f we keep turning a blind eye to the problem for fear of seeming racist, this problem will never have a solution and like the last 30 years will continue to spiral out of control" (2011: online).

Blagg agrees that the perspectives of deviance amplification, folk devils, and moral panics

> have obvious explanatory value in relation to the stereotyping and labelling of Aboriginal youths as offenders. Aboriginal youth are highly visible in public space and vulnerable to over-policing. Their extreme visibility and membership of a problem group, marks them off as targets for heavy street policing ... Moreover, their deviance is highly newsworthy, [to the extent that] coverage of Aboriginal youth issues focuses on criminality ... [and is continually re-characterized or recreated through] rich and abundant white urban myth and folklore.
>
> (2008: 59)

The passage from the Facebook page replicated above offers an excellent example of exactly such racist myth and folklore – suggestions such as "I have friends from New York and London that feel safer riding the tube or the subway than they do the Perth train network" show us how white Australian people's "everyday stories" are recruited to support moral panics – or, really, disaster narratives – about Aboriginal youth. Age and race are constitutive features of the panic discourse detailed in the above passages taken from Facebook: they are the categories in relation to which the group is defined (the Facebook page is called "*Aboriginal youth* – WA is sick and tired of your violent crimes – ENOUGH!!!!), and being "other than Aboriginal" is stated as the cause for the violence perpetrated by "Aboriginal youth."

Cunneen (2008) characterizes the moral panics over race surrounding Australian Aboriginal people without a focus on youth, while clearly articulating the racialized nature of these panics. He traces the media production of young aboriginal "folk devils" in Australia from the 1980s onwards, although likely this practice predates the texts Cunneen considers. His analysis of the Redfern riot expertly illustrates the ways Australian media link young aboriginal identity, violence, and crime.[8] As Cunneen and Blagg show, the language of newspaper and media reporting related to Aboriginal Australians not only focuses on race but also implies that criminality and violence are defining features of the demographic.

More recently, black panics in Australia have been produced in relation to Sudanese refugee youth. The following quote offers an example of, and belongs to, an existing moral panic discourse surrounding refugee young people in Australia (Windle 2008). It is taken from one of many newspaper articles that can be used to exemplify the hyperbolic nature of media reporting relating to Sudanese young people.

> The death of Daniel came a world away from civil war and the struggle for life in refugee camps. However, his death has again raised concerns about how young African refugees, especially from Sudan, are integrating into Australian society.
> (Lower 2008: online)

The statement that the incident has "again raised concerns" about "young African refugees" marks out youth and race as signifiers of a spiral of deviance. Moral panic is clearly constituted here through the creation of "them" and "us" in the respect that Sudanese young people are separated from "Australian society." Another example of this phenomenon can be found in an article from the tabloid publication *The Herald Sun* (Mickelburough and Mawby 2010), the headline for which reads "Violence a way of life for some Sudanese." In an incredibly alarmist tone, the article explains: "Sudanese-born Victorians are the most violent ethnic group in the state, police figures show." Problems with social integration are cited as one reason why Sudanese Australians are the cause of such social trouble – the article suggests that "many Sudanese had fled from armed conflict and struggled to adapt" as "it's a way of life for them to carry weapons" (2010: online). Indeed, the authors go so far as to include a quote from a police officer comparing refugees to dogs. The officer in question describes the relationship between Sudanese people's attitudes and

culture as "dog eat dog . . . their respect for police and human life is different" (Mickelburough and Mawby 2010: online). In the context of the article, "different" is a euphemism for "compromised" or lessened.

Windle's (2008) research on this area shows us that moral panic discourses are indeed a means by which refugee young people are characterized (and gendered and racialized) in Australian popular culture. His analysis illustrates ways the media takes up a primary, rather than secondary, reading of deviance in relation to Sudanese youth, in which deviance is constructed by and through media narratives rather than through the Sudanese subject's self-identification as deviant. My consideration above of the media texts through which moral panic about Sudanese people in Australia is constituted illustrates media discourses that are concerned with what Cohen calls primary deviance: the young people in question do not self-identify but are being identified as deviant. As my discussion of the dance practices of Sudanese boys in chapter four makes plain, those involved in my study certainly did not identify as deviant.

Windle further argues that there are "specific patterns of racialization" (2008: 553) that occur in Australian media through which African youths are characterized. He suggests:

> [T]he incidents involving African refugees and surrounding attention reveals the adaptation of pre-existing institutional racism and racialising narrative frames to a new target in Australia. The reception of the incidents is somewhat distinctive, coming in the context of an election campaign in which the incumbent government, struggling in the polls, had previously drawn electoral gain from "dog whistle"[9] politics in similar circumstances.
> (Windle 2008: 554)

Taking up Cohen's argument that moral panics around youth were given a particular form with the creation of the mods and rockers subcultures, Windle extends this exploration of articulations of moral panic in relation to Sudanese young people. He characterizes forms of moral panic discourse attached to the young Sudanese body. These are, respectively, the establishment of racializing narratives of urban decay and violence, the suggestion of a failure to integrate into "mainstream" (white) culture, the depiction of traditions of violence, the characterization of dangerous youth, and the definition of a "problem group" – especially a problem group of men. These defining features of moral panic are also visible in the media examples

examined above. Such positioning is significant in the respect that it illustrates a dominant means through which Sudanese people living in Australia are positioned in the national cultural imaginary.

Media moral panics suggest that Aboriginal and Sudanese people living in Australia are a social disadvantage: they are a threat to peaceful forms of social cohesion and do not have social value. As performances of a dominant cultural position (the Australian black panic discourses examined above are all characterized through examples taken from mainstream and highly publicly visible media), these panic discourses can be seen as one part of what Cohen calls "control culture" (1972: 85), a form of social governance developed as a strategy to manage the "folk devils" which media panics produce. In his discussion of moral panics surrounding the mods and rockers, Cohen argues that the social control culture which developed as a strategy for cultural governance was composed of three main strategies or branches: the police, the courts, and informal action at the local level (Cohen 1972: 85). Extending this argument, Davis (1997: 249) also asserts that moral panics are employed by governments to engineer social unity through the creation of a "common enemy" who is positioned as either "a threat to public order" or "a drain on the taxpayer's dollar." Moral panics, then, constitute one means through which Aboriginal and Sudanese Australian young people are socially controlled in Australia. These mediated moral panics find an educational articulation in "risk" discourses, which are partly constituted through curriculum knowledges and particular forms of research on youth at risk. These different knowledges can, respectively, be considered public, institutionalized, and individual forms of governance.

Risk discourses: Educational and psychological articulations of moral panics

Within psychological, sociological, and educational policy discourses, Aboriginal and Sudanese Australian young people are often considered as being at risk. There are many things these young people are seen to be at risk of, such as educational failure, teenage pregnancy, juvenile delinquency, obesity, drug use, early death, and poverty. There are almost as many ways these categories are thought to intersect, and there is not a singular agreed-on definition for "at risk" as a term. The origins of the term remain uncertain, although the concept has roots in medicine,[10] psychology, and education. Though it has arisen from different theoretical traditions, dominant descriptions

of risk, which appear across medicine, psychology, and education, are quite similar. Each discipline approaches the identification of "at risk" from a deficit model that locates a social problem in the individual or family.

In educational literature, the term "at risk" has increased in popularity since the mid-1980s (see the work of Cuban 1989; Dryfoos 1995; Ralph 1989; Swadener and Lubeck 1995).[11] Discussing the origins of the "at-risk" label in relation to schooling and urban school reform, Cuban (1989) argues that it was used interchangeably with labels of poverty and being non-white. The description of at-risk students can be traced back almost 200 years, to when members of the New York Free School Society asked the state legislature to create a school for children from impoverished families because of the adverse outcomes these children would face without some sort of public intervention. For almost two centuries, poor children, who were often non-white and/or from non-dominant cultures, were perceived to be "at risk" because of the financial drain they posed to society. This fear of increased state spending on welfare and prisons resulted in the establishment of public schools and the implementation of laws for compulsory schooling. Through educational discourses, risk was located within the individual or family, rather than society or culture. What is implicit in this characterization of risk is the impetus for society to take control of the individual or family who is possibly at risk, in order to avert future costs to society.

Educational literature often uses "risk" to describe students who are statistically likely to leave secondary school early, or to refer to students who are not acquiring the skills necessary for successful transition into the workforce. Sometimes the term is used in reference to students with learning problems that limit their future career choices. Psychologists, social workers, and counselors use the term to describe children and youth who are seen as having the potential to develop emotional and behavioral problems.

The therapeutic and medical heritage of risk as a term means that risk discourses are characterized by their emphasis on the individual. This emphasis is reflected in the psychological literature regarding risk, childhood, and adolescence. For example, Gore and Eckenrode (1994) suggest that risk has been routinely investigated by focusing on different points in an individual's psychohistory, such as stressful life occurrences, situational triggers, and critical singular events in youth (also see Cuban 1989). Gore and Eckenrode show that while psychological research on risk often explores matters beyond the individual, as exemplified when familial mental health becomes

an object of study, such departures occur from the perspective of highly individualized research. Implications for or upon individuals remain of paramount concern, although as Cuban (1989) has shown, "at-risk" students are largely those from socially marginalized or difficult cultural or familial backgrounds. The individuation of risk, then, seems to require a disavowal of the context in which the young individual's life has meaning outside dominant educational systems.

In the literature on developmental psychopathology, understandings of risk are tied closely to the notion of risk "factors," or variables, which are understood as things which "if present, increase the likelihood of a child developing an emotional or behavioral disorder in comparison with a randomly selected child from the general population" (Rae-Grant *et al.* 1989: 262). This subordination of broad social, cultural, and economic factors to an investigative focus on the individual case transparently shows the way risk discourses subordinate political critique to a medico-therapeutic desire to cure the patient.

As discussed earlier in this chapter, moral panics thrive on the attribution of deficits, impairments, or delinquencies to a demonized figure who becomes characterized as a "folk devil." At the very heart of this characterization is an anonymization and deindividualization of the deviant young figure. For example, all Western Australian Aboriginal young people become the same potentially violent criminal. The media examples discussed earlier in this chapter show how this mediatized process of demonization relies heavily on the characterization of demographics through totalizing language about youth "populations." Such characterization is exemplified through phrases like "Sudanese youth" or "Indigenous youth." As such, risk discourses articulate moral panics through a seemingly paradoxical elision: the deviant individual is subsumed within the deviant population, and vice versa. Through this "populationization" of the individual, the stereotypes attributed to a population are transferred generically to those young people who are identified as being within the boundary of the population for the purposes of the moral panic. This generic extrapolation of knowledge across whole demographics expands the discursive authority of moral panic discourses, as it presents as a closed system of knowledge: a totalizing discourse.

Such expansionism illustrates another way moral panics utilize notions of risk. In addition to pathologizing the individual, the expansion from the individual to a population works to secure the moral authority of the discursive construction of population knowledge at a point beyond critical scrutiny. The end result is that the

Assemblages of governance 55

asserted self-evident nature of risk discourses enables youth moral panics by understanding targeted groups of young people as little more than endless sets of crises. As Tait has argued:

> [T]he employment of "risk" has multiplied the possibilities of government... the reach of risk is endless. Nothing remains outside its territory, and hence nothing remains beyond government intervention. Since "risk" can be legitimately found anywhere, there is therefore no-one who is not at risk of *something*.
> (1995: 128)

Risk has become "an important indicator in a grid of governmental intelligibility" of young people (Tait 1995: 125). Foucauldian reflections on governmentality further illustrate the ways moral panics contribute to the governability of society through the deployment of strategies for the attribution of risk (Kelly 2001). As Kelly and others (Lupton 1999; Tait 1995) have argued, the disintegration of key institutions of modernity (such as the welfare state) in the face of economic and cultural globalization and the rise of transnational forces (such as multinational corporations, NGOs, the IMF,[12] and so on) have contributed to shifts in techniques of subjectivation and governance. As previous sources of solidarity have lost momentum, reflexive individualization has emerged as a key form of governance. Drawing on Foucault and Beck, Kelly argues that at-risk discourses exemplify the way young people are being disciplined into practices of governing themselves. Extending Kelly's critique of risk as a "metanarrative in an age of 'manufactured uncertainty' " (2001: 23), I want to suggest that risk discourses produce young people in similar ways to moral panic discourses. Indeed, the cultural logics generated by moral panic discourses are part of what Kelly calls "the contemporary 'conditions of possibility' that enable youth at-risk discourses to function as powerful truths (Henriques *et al.* 1984)" (2001: 23).

Kelly observes that "discourses of youth at-risk ... tell particular truths about the future of the nation, the chances of securing economic well-being for all (Roman 1996), and the uncertainties associated with globalizing 'economies of signs and spaces' (Lash and Urry 1994)" (2001: 28). The logic of the argumentative link between risk and moral panic is made clear by the fact that moral panics are also discursive structures energized by – and created to respond to – persistent anxieties about the future. The media and online accounts of Sudanese and Indigenous young people discussed earlier provide lurid illustrations of the way white commentators invoke racialized

others to rehearse their concerns about national identity and the distribution of resources. Such broad cultural anxieties about citizenship and access to resources are managed explicitly through the ways that youth arts programs perform modes of governance established within risk discourses. An example of this is the act of making at-risk youth into "healthy" young subjects, which is one of the functions of the REC discussed in chapter one (although the REC also works with youth not considered at risk).

Arts programs run for youth by adults can often offer an extension of the ways at-risk discourses responsibilize their subjects by demanding that they become managers of their own "DIY project of the self" (Beck 1992: 75). Indeed, as Tait has argued, a characterizing feature of the emergence of the "at-risk youth" category, as opposed to the category of the delinquent or dangerous youth, is that it rationalized, and continues to rationalize, the expansion of policies and systems of prevention (1995: 126). The at-risk category foregrounds the liminality and volatility of contemporary notions of youth. Furthermore, it directs public attention on young people towards the privileged problematic of keeping risk at bay. Foregrounded in this way, the work of risk avoidance requires resources, tools, and expertise.

As the ethnographic study that informs this book is based on research carried out with Sudanese and Aboriginal young people, as well as low-SES white and multicultural youth, it is important to reflect on the racialized nature of risk discourses in the context of Australian moral panics about Sudanese and Indigenous young people. These reflections raise questions about the integrity of definitions of risk in the literature. For example, McWhirter *et al.* describe the "at-risk" term as being used "to denote a set of presumed cause-and-effect dynamics that place the child or adolescent in danger of negative future events" (1998: 7). Here, the child becomes a universalized, common figure whose risk status is determined by that to which the child is subjected. However, as is made obvious by the racializing accounts of Sudanese and Indigenous young people in the Australian media, common events, practices, and behaviors do not visit the same at-risk status on young white people (see also Rose 1996, cited in Kelly 2001: 23). As this point demonstrates, a problem with much of the risk literature in the field is that it presumes the term "risk" is attributed evenly and dispassionately to all young people, based on some form of a universally agreed-upon meritocracy (Leahy and Harrison 2004; Leahy 2012).

There are two key limitations of this understanding of risk and youth, or the notion that risk status is determined by what happens

to a subject. The first is that it relies on a liberal notion of subjecthood in which all young people are plotted at the same point on a conceptual graph of life and are moved up or down the graph based on their experiences. This struggles to account for the differences in the classification and treatment of young people who perform similar kinds of "deviant" behavior but occupy different racial and class positions. The second key limitation, which helps to explain the first, is that mainstream notions of risk and youth treat risk behaviors as self-evident in their meaning and affirm the diagnosis of risk as a stable, consistent technique of analysis. However, as the moral panics discussed earlier make plain, the interpretation of risk is influenced by a broad set of national, cultural, economic, social, and racial anxieties.

This failure to acknowledge the variable productions of notions of youth and risk means that much contemporary research cannot account for the role risk discourses perform in moral panics, nor for their systematically racialized and classed production of different understandings of youth and risk. Acknowledgment of the ways these different understandings are contingent on very particular knowledge structures is also elided through the truth claims embedded in the objective position crafted through behavioral and socio-psychological accounts of youth at risk.

Discourses of youth at risk in contemporary Australia, then, articulate through a central paradox. On one hand, risk is understood through a focus on the individual that de-emphasizes the structural contexts enabling the risk and diminishes the responsibilities of the state and systems of economic production and distribution. At the same time, though, risk becomes visible through popular, mediatized wholesale depictions of "at-risk" populations, as exemplified in the above discussion of media moral panics surrounding Indigenous and Sudanese youth.

Individual, mediatized moral panics mobilize and make legible understandings of risk for a "majority" or "mainstream" culture by producing exotically dangerous "types" which are clearly segregated from the mainstream in the popular imaginary. As postcolonial scholars have long noted, the role of skin color and racialization is put to work through the mediatized process of imagining popular cultural stories of risk and salvation, them and us (Hooks 1996). Moral panics are thus positioned in situations of power through risk discourses that implicitly assert and stabilize the normative and disciplinary fiction of "mainstream" society as other than deviant.

As Peter Kelly (2001) has argued, a consequence of the "truth of youth-at-risk" is not only its focus on individualization and

58 *Assemblages of governance*

responsibilization, but also the fact that the focus on risk determines understandings, expectations, and interpretations of the young subject. Kelly explains:

> the truth of youth at-risk rehearses, in part, the historical truths of youth as delinquent, deviant and disadvantaged (Swadener and Lubeck 1995). However, a "dangerous" (Foucault 1983) aspect of the truth of youth at-risk is that, potentially, every behaviour, every practice, every group of young people can be constructed in terms of risk (Tait 1995).
>
> (2001: 23)

Research which is inaugurated under, and accepting of, the risk discourse is constrained by the way this acceptance marks a virulent naturalization of risk as a key pre-condition for the legibility and visibility of young subjects in every sense, including the constitution of young people as research subjects. The employment of risk discourses occludes from critical view the operation and effects of risk discourses themselves. This means the governmentalizing technologies that are wrapped up in the articulation of risk routinely structure research with, and about, at-risk youth. Young people who are constituted within these discourses come to be the necessary subjects of such research. Without an analysis of these technologies, research risks contributing to and looking at only the effects of a system of production of "at-risk youth," and not being able to identify the ways these subjects are produced.

Excluding from analysis – and, indeed, conceptualization – the broader context which produces at-risk young people creates a methodological circularity in which the at-risk youth are themselves held to account for the risk. Research conducted in this way becomes another technique in the array of neoliberal governance measures, replete with its characteristics of individualized responsibility and a diminution of the responsibilities of the state (Beck 1992). The discussion of the ethnographic research in subsequent chapters of this book is framed as a conscious departure from the role of "experts," as critiqued by Kelly, as people who engage in the work of responsibilization and monitoring (2001: 30–1). I seek to distance myself from these prevailing research approaches in relation to "at-risk" young people, looking to theoretically reframe the ethical and methodological difficulties accompanying the role performed by risk-focused research by offering new research narratives in the existing

risk-focused research on Sudanese and Aboriginal refugee youth in Australia.

I now turn to consider the proposition that many youth arts programs run by adults for youth can be read as an extension of the way that at-risk young people are constituted around reflexive projects of self-salvation. The new modes of governance presented by the contemporary operations of the risk discourse demand new industries, economies, and knowledges and a battery of supporting interventions to materialize and sustain them. Youth arts can be one of these technologies of support. This recalls Kelly's observation that "the construction of new problems" is linked to "the marketing of new solutions" (2001: 20). The next section of this chapter investigates youth arts as just one such solution within such an emerging economy. By acknowledging youth arts as an articulation of emerging modes of governance, my analysis becomes a political critique of risk that problematizes youth arts as a form of social and aesthetic regulation that places responsibility on young people to become readable through dominant popular aesthetic tropes.

Youth arts as self-salvation

The above discussion of moral panics and risk discourses as ways particular groups of young people come to be characterized and publicly known, and through which certain forms of young subjectivity are constructed, provide tools for reflecting on youth arts as a form of self-salvation. The first way this can occur is through the use of youth arts programs as sites of reflexive governance. The second is by using youth arts programs as sites through which to hold up to scrutiny the role performed by risk discourses in moral panics regarding Sudanese and Indigenous young people.

Research conducted through youth arts is characterized by familiar methodological and conceptual foundations: namely, the notion that at-risk young people are the proper subjects of youth arts projects. A project's rationale and evaluation typically focuses on the extent to which the project improves the health and wellbeing of young people at risk. In a review of arts and social exclusion literature, Jermyn (2001: [4.1]) considers the impact of arts and social benefits. The most mentioned benefit of participating in the arts appears to be self-confidence and better education (Jermyn 2001: [4.2]). The review lists a range of "[c]laimed impacts of the arts" in which benefits at both individual and community levels are listed, some of which directly result from participation and others which would

be considered secondary – for example, learning new skills and increasing confidence and, thus, employability (Jermyn 2001: [4.2]). The review indicates that through arts projects, young people can accrue much-needed social capital (Jermyn 2001: [4.2]). Key benefits for the individual are suggested as "[i]ncreased self confidence" as well as creative and non-creative skills including communication and organization (Jermyn 2001: [4.4]). Nodding to the emerging science of "risk prevention," which I cited earlier as accompanying the formation of the at-risk young subject, Jermyn suggests that "[t]he attainment of these sorts of outcomes by individuals may represent progress towards harder social inclusion outcomes such as employment or education and [as such] are pertinent to this enquiry" (Jermyn 2001: [4.4]). Information concerning individuals is gathered from "small-scale surveys of arts participants and/or . . . from observation or interviews" (Jermyn 2001: [4.4]). Jermyn acknowledges that measuring highly subjective factors such as increased self-confidence and reliance on self-assessment will always be difficult. Alternative demonstrations of self-confidence, such as education or employment (Jermyn 2001: [4.4]), are often more accurate forms of measurement. Jermyn justifies the research agenda that accompanies the project of measuring young people's acquisition of social capital through involvement in youth arts projects by explaining: "the core idea behind the notion of human capital is that developments in people's education, skills and attributes can increase their personal or collective effectiveness" (2001: [4.4]).

Measurement, quantification, and standardization of risk and its attendant variables are, then, integral components of the responsibilization and individualization which accompanies the design and delivery of the arts programs surveyed by Jermyn. The review reflects a widespread focus on improving health and wellbeing in research conducted through youth arts. The provability of the success of youth arts projects in these terms can only be understood in terms of broad wellbeing as represented, for example, by data describing educational participation and attainment. These means of measurement are a long way from the notion that aesthetic forms articulate youth voice. Rather, they are means by which to ensure the governance of youth considered "at risk" within educational discourses.

Research surrounding youth arts too often recreates exactly such governance. Studies have found "a link between educational attainment and arts participation" (Jermyn 2001: [4.5]). Despite this, Jermyn's review also cites anecdotal evidence which appears to find that "increased well-being/self-esteem was directly related to

involvement with the art and not just with socializing or carrying out the physical activity involved" (Jermyn 2001: [4.7]). Yet this focus on technique is lost by the fact that, in broad terms, the review reflects the widespread view that youth arts programs yield benefits in terms of "social cohesion" and other "indicators of social capital" (Jermyn 2001: [4.8]).

The review reflects the popular governmental focus within youth arts research of desiring specific outcomes for particular populations, such as "mental health users" and "offenders" (Jermyn 2001: [4.7; 4.6]). Jermyn discusses evaluations of arts projects in prisons, including the consideration of a dance project, arguing that the results of such projects include an increased ease in approaching other group members, increased trust, and a greater likelihood to "take a problem to fellow group members" (Jermyn 2001: [4.6]). Expanding on this focus on particular populations, the review highlights another key refrain of much research in this field through its discussion of the benefits of arts to at-risk geographies: the "arts have an important role to play in the regeneration of economically, socially and culturally disadvantaged areas and in supporting community development" (Jermyn 2001: [4.9]). Literature regarding "the arts and regeneration" in underprivileged areas is also canvassed: suggested benefits include improvement in an area's image, economic investment, and community development (Jermyn 2001: [4.9]). Clearly there is a sense, in the literature on youth arts programs run by adults for disadvantaged youth, that the young people involved are in some way being saved from the problems of their existing lives. Art is cast as a mode of redemption and self-improvement.

The key themes which Jermyn identifies in the extensive survey of youth arts research also run through a recent Australian study. The "Risky Business" project in urban and rural Australia sought to address "the qualities of effective diversionary programs for "at risk" young people and the social impact of the creative arts" (O'Brien and Donelan 2008a: 171). Here we find another instance of self-improvement being read as a signifier of the value of youth art. Specters of neo-liberal governance haunt such sentiment. The authors state that "[t]he data indicates that the young people who engaged with particular arts programs gained significant personal, social and artistic benefits" (2008a: 172). Through their discussion of this study, O'Brien and Donelan also provide a timely reflection on the expansion and increase in the popularity of arts methodologies as popular research methods for engaging "marginalized" young people. The increased volume of arts-based research with at-risk young people

has led to the development of a burgeoning research field exploring some of the methodological issues emerging from this work. Analyzing "Risky Business," O'Brien and Donelan reflect on issues relating to the recruitment and retention of research subjects, the need for artists to have a political commitment to working with at-risk populations, and the key role performed by the public dissemination of the "arts product as a culmination of each program" (2008a: 172).

Their discussion of the "Risky Business" study considers some of the ethical and political motivations of those involved, summarizing that some practitioners held "a belief in the arts to effect individual and social change" (O'Brien and Donelan 2008a: 175). Indeed, O'Brien and Donelan substantiate this belief through their discussion of project outcomes, which include increased confidence and a perception of the self as artist, and the importance of giving young participants a voice "to give readers a sense of the diverse life histories, subjectivities and experiences of those within the arts programs" (2008a: 179). These findings are representative of other similar studies, bringing to the fore the key elements of identified success and self-improvement that have helped make arts-based methodologies popular.

Of significance in relation to my concerns here is the fact that O'Brien and Donelan provide an insightful reflection on the motivations of the artists involved, particularly "the desire to 'empower' young people" (2008a: 181). They state:

> We noticed that for many of the artists their pre-existing beliefs in the efficacy and benefits of the arts for troubled young people circumscribed their responses as reflective practitioners. It seemed to us that belief in the transformative power of the arts locked artists and community workers into an unwavering position of advocacy that prevented them reflecting critically on the young people's responses to the arts programs and the difficulties they encountered.
>
> (O'Brien and Donelan 2008a: 183)

The authors also share their concerns about the ethics of the public dissemination of the "art product" and its attendant public exposure, raising worries about placing young people on display before "privileged spectators exposed to social disadvantage" (O'Brien and Donelan 2008a: 189). They question how and why "it was ever ethically appropriate for vulnerable young people to mark themselves by publically revealing their social disadvantage and

legal transgressions" (2008a: 187). They conclude by considering "whether the desire to 'do good' obscures both the most efficacious approach to arts interventions with youth 'at risk' and our understanding of the artistic and instrumental benefits or disadvantages of this work" (O'Brien and Donelan 2008a: 189). They suggest the challenges in this work include "the burden of ethical and moral responsibility to do more than just good" (O'Brien and Donelan 2008a: 190). This recalls the earlier discussion of Peter Kelly's work, and it extends his critique of risk discourses by examining the conditions of possibility for enabling such discourses, namely through the mobilization and mediatization of moral panics. O'Brien and Donelan's concluding wish to do "more than just good" is an invitation to not simply assist those at risk by using the arts to support them in becoming socially engaged, healthy, and skilled, but to dismantle the system that produces the risk.

On the back of the rise in popularity of arts-based methodologies, emerging methodological and critical literature has begun to highlight some of the constraints implicit in arts-based research methods constituted around a priori assumptions in terms of risk and youth. All methodologies reflect particular views of the world and, as the "Risky Business" conclusions suggest, arts-based methodologies routinely naturalize contemporary understandings about youth, risk, art, and salvation and, indeed, tend to craft a narrativized relationship between these ideas. Recalling my earlier discussions focusing on the emergence of the at-risk category alongside new modes of reflexive governance, it is important to reframe arts programs run by adults for youth (and arts-based methodologies used in research about youth) as a technology which serves to occupy and order subjects in terms of the interests of neoliberal economies. This act of governance is a far cry from the activation of young subjects in the spirit of transformative power that is often attributed to at-risk youth arts practice. Seen from this perspective, youth arts practices emerge as sites for the active management and control of problem youth populations.

Helen Cahill explains exactly how approaches in youth arts interventions become part of creating systems of governance. She argues that youth participating in interventions "were more likely to engage in problem behaviors and to experience negative life outcomes than those with similarly indicated needs who had not been assigned to the intervention" (2008: 15). Reflecting on Dishion's theory of "deviancy training" and notions of "peer contagion," Cahill notes that "at-risk" youth continue to be grouped together for interventions, in spite of the fact that such approaches have been shown

64 *Assemblages of governance*

to increase youth delinquency (2008: 15–16). Cahill raises concerns about the reflexive focus of arts-based methodologies, stating: "[i]t is not necessarily therapeutic to pay heightened attention to one's self, however many arts and education projects assume that the self is the natural object of focus" (2008: 22). Drawing on narrative therapy techniques, Cahill argues that a more effective approach would be to consider focusing on developing alternative narratives and new possibilities: "[S]eparating the person from their story as the means through which to assist the person to 're-author' their life" (2008: 22). Linked to this is Cahill's critique, after Michelle Fine and colleagues (2003), of researchers' attractions to "bad" stories. These stories can be employed as a means through which to

> think critically about the practice in some arts-based interventions whereby youth "at risk" are invited to play out their defining story. [Through such stories we can] … question whether it is necessarily therapeutic to play and replay a victim story, as this may reinforce the story as defining one's identity. This is not to diminish the reality of the traumatic events that many have encountered, but rather to ask which version of the story is being told, and if it leaves room for a possible future in which the person is not defined by this aspect of their story.
>
> (Cahill 2008: 23)

Cahill's analysis, when seen through the prism of my interests here, highlights the ways youth arts programs run by adults, and many arts-based methodologies, require a form of "rehearsing the self" and intervene in processes of self-construction in ways that are supposed to lead to self-improvement, but can result in recreating at-risk subjects. These processes of intervening in one's self through arts also elucidate the fact that the self identified by the arts program is centered on the deficit or risk which qualifies the subject to participate in arts programs. Progressing Cahill's critique, it seems that such observations are indicative of the way that arts-based practices explicitly model reflexive forms of governance and discipline subjects' knowledge of themselves in terms of their own disempowerment. As a disciplining technology, youth arts may, in fact, be a structured process through which young people re-learn what Cahill calls "a fundamentally disabling lesson" (2008: 24). Cahill concludes:

> [W]e must challenge existing discourses about the role of youth and, in particular, the assumptions that may come with the label

"at risk." This requires an act of imagination on the part of the program developers, and a certain willingness on their part to risk working beyond the traditional modes of provider/recipient that underpin dominant models within health and education traditions.

(2008: 26)

Cahill's call for a wholesale reexamination of the at-risk youth arts project speaks to the key concerns I have outlined in this chapter. Youth arts programs and arts-based research methodologies targeting at-risk young people are structured by dominant cultural logics of moral panic, risk, and self-salvation which come together to obscure structural and political accounts for disadvantage, preferring instead to hold young people individually accountable for the disadvantages they face.

Research regarding at-risk young people often problematically replicates prevailing neoliberal logics of individualization, responsibilization, and the naturalization of deficit. Arts-based research with youth or adult-run youth arts programs recreate these at-risk youth as the proper subjects of their practice. The ethnographic fieldwork and case studies on which this study draws and which I detailed in the introduction are presented in ways that attempt to open up discussions of youth arts and arts-based research outside the idea of the youth arts project as a disciplinary technology.

In outlining the assemblage of dominant cultural logics against which my analysis of the ethnographic research and case studies is positioned, I write against the grain of the naturalizing tendencies that are evident in the dominant discourses of research on marginalized youth. All research and, indeed, arts project design which is concerned with research on young people at risk must scrutinize its own performance within the broader interplay of governmental discourses of moral panic, risk, and salvation. While the subsequent chapters in the book provide thematized theorizations of the ethnographic fieldwork and case studies, rather than a set of explicitly methodological reflections, they outline my concern with the practice of doing arts-based research with young people in ways which do not reinscribe deficit discourses. I look to articulate some ways the arts practices of young people reconfigure images of particular demographics of young people in manners that are unique and of political utility. This type of research and analysis looks to move beyond the

presumptive work performed by popular methodological and theoretical invocations of panic, risk, and salvation. I begin this discussion with a consideration of young Sudanese refugee and migrant women living in Australia and their production of a publicly visible version of femininity within their community.

3 Tradition, innovation, fusion
Local articulations of global scapes of girl dance

In an urban warehouse, a lithe body cartwheels in front of a neon sign. Girls – on closer inspection, are well-presented women dressed as girls – lounge about the room. They pop gum, relax in front of a fan, chat on their mobiles. The feeling of a high school musical is modified only slightly by the clean, dull aesthetic of the warehouse. It's urban cool meets high school musical: the stage for the film clip of the pop band The Pussycat Dolls' (TPD) single *Beep*. Nicole Scherzinger, the lead singer of the group, is a Hawaiian American woman. She has kept the appearance and affect of youth but has augmented youthful shyness with great self-confidence. Punctuated by brief camera shots to an African American man with dreadlocks (a popular rapper known as "will.i.am") who alternately works the turntables, rides a pushbike indoors, and raps, the film clip for *Beep* showcases the band members' dance skills and muscular midriffs. The Dolls' lean bodies krump,[1] body roll, and keep impeccable timing across tightly choreographed routines. They are physically and kinesthetically adept. The slender and flexible nature of their physiques is remarkable. Their body shapes are very similar. The film clip offers its viewers four minutes and nine seconds of popular, contemporary girl dance. It showcases the fact that the group is composed of dancers-turned-singers – their website sells them through stating:

> Dismissing them as a quintet of Frederick's of Hollywood models with mics would be a major mistake. Almost immediately upon its 2005 release, their super-catchy first single, the global smash "Don't Cha" (altogether now: "Don't cha wish your girlfriend was hot like me?! Don't cha?!"), proved that these post-feminist Pussycats were a Fancy Feast for the ears as well as the eyes. And we're talking a lot of ears!
>
> (Universal Music Group 2011: online)

The narrative of post-feminist empowerment through bodily "self-respect" is a core marketing strategy employed by TPD, and it is blended with discussions of ethnic pride and the celebration of racial diversity in much of their press. For example, their role as the poster girls for the American gym group Bally Fitness is advertised on the Bally website with the statement that the gym chose TPD as their ambassadors "because of their massive appeal and ethnic diversity" (Winnaman and Associates 2011: online). Media commentary on the group often highlights or "sells" this apparently evident cultural diversity. TPD are known for having different ethnic heritages: for example, *Reality TV World* tells us that

> [t]he group is one of the most commercially successful new acts to appear ... they are also known for their range of ethnic backgrounds, which include Filipino, Hawaiian, African American, Mexican, English, French, Chinese, Israeli, Indonesian, Dutch, Russian, Polish, Japanese and Irish ...
>
> (2011: online)

Through such statements, the group position themselves within a media landscape of non-white feminine bodies.

This chapter explores an intersection between local and global mediascapes of non-white feminine dance. The Pussycat Dolls' song *Beep* marks this intersection through branding a multiracial femininity that sells partly because it erases the embodied differences that it supposedly cites. While TPD celebrate ethnic diversity, their bodies certainly are not diverse. As such, TPD endeavor to imagine, or at least market, the non-white female body at the center of popular "girl culture" in ways that are naïve, yet can be considered as serving a political purpose, through locating non-white women in a prominent position in popular media texts aimed at younger female consumers. *Beep* offers an example of the importance of the cultural meanings of popular cultural texts in processes of youth arts work, as it is a song that was given prime importance in the out-of-school site in which I ran a dance program for a group of young women living in Australia as migrants or refugees from Sudan. Through the example of this song, in this chapter I consider the meanings attached to popular cultural texts such as music and video clips in youth arts practices, and the importance that these meanings had in young Sudanese Australian women's lives as a way of mediating the local and the global, their motherland, and their new home. *Beep* is a popular pedagogy of non-white feminine dance and the ways the young women discussed

in this chapter employed the song as a choreographic resource illustrate how everyday, ordinary literacies play important roles in the arts practices of young people.

I utilize Appadurai's concepts of ethno, media, and ideoscapes to show different dimensions of the young women's consumption, interpolation, and reproduction of *Beep* as representative of the importance of popular cultural texts in youth arts practices. As I have explained elsewhere (Hickey-Moody 2011; Kenway and Hickey-Moody 2008), Appadurai identifies five dimensions of global cultural flows, which articulate as "scapes." Respectively, these are: financescapes, technoscapes, ethnoscapes, mediascapes, and ideoscapes (Appadurai 1996: 33; 2000: 95). He explains:

> The suffix *–scape* allows us to point to the fluid, irregular shapes of these landscapes, shapes that characterize international capacity as deeply as they do international clothing styles. These terms with the common suffix – *scape* also indicate that these are not objectively given relations that look the same from every angle of vision but, rather, that they are deeply perspectival constructs, inflected by the historical, linguistic, and political situatedness of different sorts of actors.
>
> (1996: 33)

Through these three scapes, Appadurai (1996, 2000) considers the global mobility of people, images, styles, and things. I employ the notion of ethnoscape to foreground the roles that the movement of stabilities of "birth, residence and other filial forms" (1996: 33) play in crafting the elastic histories but often brittle present living conditions of migrant and refugee youth. Community and networks of kinship are trans-national as well as local for such young people, and the complexities of mediating such "warps" are evidenced in their arts practices and captured through the concept of ethnoscape – the "landscape of persons that constitute the shifting world[s]" (1996: 33) of the migrant and refugee youth involved in my research. Mobile and stable populations fold together to make up ethnoscapes and as such, the idea is partly built around an acknowledgment of the divergent cultural pasts that accompany mobile populations.

Appadurai has developed this idea to articulate the embodied histories, emotions, and imaginations which are of importance because "as nation-states shift their policies on refugee populations ... moving groups can never afford to let their imaginations rest too long, even if they wish to" (1996: 34). The concept of ethnoscapes reminds

us that globalization moves histories, along with bodies and their cultures. The ethnic landscape in which refugee and migrant youth are positioned at any given time can be brought into focus through this idea. The young women involved in the ethnographic research are part of a particular ethnoscape: their families have moved from the war-torn areas of South Sudan as part of a wave of refugee migration from this area across the globe. Like other young women and girls who went to America, Canada, and the UK, these refugees and migrants were escaping the violence in Darfur and looking to weave their cultural histories into their multicultural presents.

The roles played by different media in articulating ethnoscapes, or shifting landscapes of people, are brought to the fore by Appadurai's concept of mediascapes. He explains:

> What is most important about these mediascapes is that they provide (especially in their television, film and cassette forms) large and complex repertoires of images, narratives, and ethnoscapes to viewers throughout the world ... [which, for viewers, means] [t]he lines between the realistic and the fictional landscapes they see are blurred, so that the further away these audiences are from the direct experiences of metropolitan life, the more likely they are to construct imagined worlds that are chimerical, aesthetic.
> (Appadurai 1996: 35)

Mediascapes are a means through which we can understand how it is that those at the periphery of dominant cultural formations, such as migrant and refugee youth living in Australia, imaginatively enmesh themselves within more dominant social networks. TPD can be read as occupying a particular position in mediascapes of non-white femininity, as they possess a particular cultural significance that pertains to the discourses celebrating cultural diversity that surround their fame. This is why they appealed to the young women involved in the ethnography.

Ideas of mediascapes and ethnoscapes thus offer a means of contextualizing the ways popular cultural texts inform the imaginations of young people and speak to, as well as reflect, ever shifting communities in the contemporary globalizing world. They provide useful tools for thinking about the tastes and pleasures of young people involved in arts practices that can be taken up outside the parameters of this study. They also provide a context in which to read the sentiments of ethnic diversity and feminist activism espoused by TPD. Like thousands of other youthful non-white female fans

Tradition, innovation, fusion 71

across the globe, the young migrant and refugee women involved in the ethnography wanted to be like TPD: they desired cultural visibility and TPD appealed to their sense of belonging to a global community. Along with figures such as Beyoncé[2] and Shakira,[3] TPD offer access to an imagining of fame and a sense of being part of a dominant culture through generating a mediascape of sexy, applauded, non-white femininity. As ways of interceding and articulating ethnoscapes, mediascapes are "closely related landscapes of images" (1996: 35) created by electronically distributed newspapers, magazines, TV stations, and film production studios. Appadurai further explains that:

> "Mediascapes," whether produced by private or state interests, tend to be image-centered, narrative-based accounts of strips of reality, and what they offer to those who experience and transform them is a series of elements (such as characters, plots and textual forms) out of which scripts can be formed of imagined lives, their own as well as those of others living in other places. These scripts can and do get disaggregated into complex sets of metaphors by which people live (Lakoff and Jbhnson 1980) as they help to constitute narratives of the "other" and proto-narratives of possible lives, fantasies which could become prolegomena to the desire for acquisition and movement.
> (1996: 35)

Mediascapes thus constitute, and are partly constituted by, dominant discourses about the social groups they come to represent and articulate. TPD belong to a global mediascape (Appadurai 2000: 95) of popular girl dance – a landscape[4] of images and ideas that come together to constitute the ways dancing female bodies are known. They also attempt to speak to ethnoscapes of cultural diversity. In contrast to mediascapes, ethnoscapes are more "directly political and frequently have to do with the ideologies of states and the counter-ideologies of movements explicitly oriented to capturing state power" (Appadurai 1996: 36). They bring together an array of symbolic keywords, political ideals, and values. Appadurai further characterizes ethnoscapes as

> landscapes of persons who constitute the shifting world in which we live: tourists, immigrants, refugees, exiles, guest workers, and other moving groups and individuals [that] constitute an essential feature of the world and appear to affect the politics

of (and between) nations to a hitherto unprecedented degree.

(2000: 95)

As I go on to illustrate, ethnoscapes and mediascapes have an enduring relationality that is political and is refracted in local ways.

Together, ethnoscapes and mediascapes perform ideoscapes – imagined worlds that are scapes of ideas. Ideoscapes constitute frameworks for thinking about how people experience belonging and make culture. They are social ideologies, or

> concatenations of images, ... [that] are often directly political and frequently have to do with the ideologies of states and the counter-ideologies of movements explicitly oriented to capturing state power or a piece of it. ... [I]deoscapes are composed of elements of the Enlightenment world-view, which consists of a concatenation of ideas, terms and images, including "freedom," "welfare," "rights," "sovereignty," "representation" and the master-term "democracy." The master-narrative of the Enlightenment (and its many variants in England, France and the United States) was constructed with a certain internal logic and presupposed a certain relationship between reading, representation and the public sphere.
>
> (Appadurai 1996: 35)

As this passage suggests, ideoscapes are ideas that bind various social formations, and belonging to them can be thought to comprise a form of global citizenship. For example, the idea of performing arts being "good" for young people is constitutive of some of the little publics of youth arts that I describe in chapter one. Ideas of nationality, sovereignty, and religious beliefs are the typical examples to which Appadurai refers in characterizing ideoscapes (1996: 35–8). Ethnoscapes, mediascapes, and ideoscapes are closely related and offer a way through which we can see the everyday life experiences and desires of young people as constituting, and being constituted by, broader political landscapes. Exchanges between ethnoscapes and mediascapes are also exchanges between the local, national, and global:

> Lived cultures of ethnoscapes are reconfigured in global ideoscapes (moving political ideas) and mediascapes (moving electronic images). These "scapes" come together to form imagined worlds. Such worlds are "multiple [and] ... constituted

by the historically situated imaginations of persons and groups spread around the global" (Appadurai 1996: 2).
(Kenway and Hickey-Moody 2008: 95)

Mediascapes – such as that of popular, non-white girl dance, constituted by TPD amongst other acts – are thus significant in the respect that they comprise, and are partly constituted by, dominant discourses about the social groups they come to articulate and represent. They can change communities through facilitating new forms of belonging and they provide frameworks for imagining and performing alternative modes of citizenship. Mediascapes are ways social groups become known within communities and through which communities come to know themselves.

As demonstrated in chapter two, mediascapes about young people, especially non-white young people, can too often generate images of such youth as folk devils. Such images then become part of cultural logics that support institutionalized discourses contending these young people might be "at risk" of educational failure, or may be perceived as the cause of social problems. To the extent that such neo-panic narratives figure as prominent discourses of non-white youth, interventions that celebrate such bodies are clearly needed. In such a context, media texts that appreciate symbols or figures of young female ethnic diversity are an especially welcome intervention in dominant discourses of non-white youth in Australia, because of the ideoscapes of multi-racial celebration and inclusion they advance. As I have suggested, mediascapes are also forms of popular and public pedagogy; in what is to follow, I explore some of the ways *Beep* operated as a popular pedagogy in my own dance classroom.

Giroux's contention that popular cultural texts play "a central role in producing narratives, metaphors, and images that exercise a powerful pedagogical force over how people think of themselves and their relationship to others" (1999: online) ties into Appadurai's suggestion that ethno- and mediascapes shape the ways social groups become known within communities and come to know themselves. To the extent that ethno- and mediascapes inform "how people think of themselves and their relationship to others" (Giroux 1999: online), they can be considered a form of public pedagogy. The pedagogies effected by ethno- and mediascapes in the dance workshop program I ran for the young Sudanese refugee and migrant women were characterized through themes of intergenerational pedagogies of tradition, corporeal practices of innovation, and cultural fusions that resulted

in writing figures of young femininity into the ideoscapes of the local Sudanese refugee community.

Tradition, innovation, fusion

The process of designing the dance workshop program unfolded in relation to a selection of cultural texts (music, dance practices, film clips, and video recordings of rehearsals) that performed pedagogical functions and articulated the various ethnoscapes and mediascapes that inform the identities and experiences of the participants. The texts involved, and the process of designing the dance workshop program, gave very different perspectives on cultural traditions and constituted a form of cultural fusion which led to the young women writing themselves into the ideoscape of their local community through what I go on to theorize as "minoritarian girl power."

Unexpectedly, the workshop group began with a focus on traditional Sudanese dance and music knowledges and practices. This focus came from older women and clearly served them as a means of keeping their history alive and their homeland close. Appadurai reminds us that "the homeland is partly invented, existing only in the imagination of deterritorialized groups" (1996: 49). For these women, dance offered exactly such a medium of invention. Such a traditional focus was partly unexpected, because the group was originally planned as a dance group for young women. The planning and consultation that I undertook in preparation for the workshop series involved focus groups with the young women[5] and had not involved contact with adult women. The younger women were incredibly enthusiastic about the prospect of participating in the dance classes. I got to know them by joining in with their involvement in a jewelry-making workshop once a week for a month. I then ran three focus groups in which I explored what they wanted from a dance program and facilitated the process of gaining ethical consent. This process was time-consuming and not ethically straightforward, as the participants were not literate in English and, on sending the forms home for examination, I discovered that this was also the case for their parents. The community organization through which I ran the workshop series held weekly literacy and numeracy classes that were open to the public and were designed to address this need for literacy education; however, the university ethics committee clearance form was not legible to most participants or their families. As I noted in the introduction to this book, I had consent forms translated into Dinka for the mothers to sign, and this process inadvertently spread the word

about the dance program. The young women were very excited about dancing and so were their mothers.

The focus groups proved very difficult tools for planning workshops, as the young women did not have English words to express their desire to dance in certain ways. This made it hard to pin down genres verbally. Here, media texts became instructive – the participants brought in CDs and used my computer to show YouTube clips so we could share understandings of what they wanted to listen to and how they wanted to dance. Age differences, the young women's shyness, and verbal language barriers affected our communication (for example, their English was broken and I have no understanding of Dinka). I trusted that, through the process of running the dance workshops, questions around dance styles, musical genres, and the structure of the workshops would be resolved.

The first day of class presented me with a plethora of issues. The group unexpectedly began as more than thirty women, of a broad range of ages. Word had got out. Mothers, aunts, and other women of the local Sudanese Australian community wanted to dance. The exact nature of how the women involved wanted to dance differed. Traditional dance forms were of great interest to the mothers but of less interest to the younger women and girls. The older women had extensive, practical knowledge about traditional Sudanese and Egyptian dance styles and music. They brought music to class and taught me, and the younger members of the group, their folk dance practices. This process illustrated the two generations' different investments in dance as a kind of recreation, a form of cultural history, a creative practice, and a fitness activity. Sudan has a unique musical culture that extends into traditionally gendered dance practices. Because the constitution of the Sudanese population is very diverse (with five hundred-plus ethnic groups spread across the country), the North, East, and West African music and dance styles that constitute a mixture of African, Arab, and Sub-Saharan traditions fold in to provide resources upon which women learning dance in Sudan can draw. These knowledges are passed on practically and orally. While many Sudanese dances can now be seen on YouTube and other online forums, there is little literature, at least in English, detailing the nature of these dances.

Most of the women involved in the ethnographic work hailed from South Sudan, an area with a strong tradition of folk music that reflects the diverse cultures of the region. I wondered if the controversial history of music and dance in South Sudan might have informed part of the older women's desire to dance: cultural heritages

such as music and dance have been contested terrains in South Sudan.[6] The traditional dance knowledges and practices of Sudanese women's dance thus formed much of the content of the beginning of the workshop program, but this desire to dance as a way of keeping history alive and bringing past and present together was not shared by the younger members of the group. As Appadurai (1996: 49, 55) reminds us, "[d]eterritorialization ... affects the loyalties of groups ... [as] the link between the imagination and social life ... is increasingly a global and deterritorialized one."

As the leader for the series of dance workshops, I was presented with a problem. Not only was the initial group too large to be able to successfully facilitate (for example, we had to practice our folk dance on the oval, as the group was too big to dance in the hall); also, the desires of the group members were too diverse to successfully plan an agenda that would meet the needs of most participants. The older women wanted to pass on and celebrate tradition, while the younger women wanted to create particular kinds of contemporary non-white femininity through dance. After initially running very large classes I realized that I needed to construct more defined boundaries through which to run the workshops. Upon further consultation with the group, and in collaboration with the community education organization through which I was running the workshop series, we decided to orient the workshops towards a performance outcome. I reminded the participants that the workshops were supposed to be for younger women. In so doing, I was able to refine the membership of the group substantially.

The newer, svelte group consisted of eight young women who were living in Australia as migrants or refugees from Sudan and who wanted to devise a dance to be performed at a forthcoming community event. The event was an end-of-year celebration for the local Sudanese migrant and refugee community living in Melbourne and the young women asked to perform their work. A more accurate description of the young women's investments in the process might be to say that they wanted me to devise, and they wanted to perform, a dance piece. However, I was especially keen to mobilize their innovative corporeity – their capacity to fuse new and old dance styles through dance practice. The younger women were interested in Western contemporary popular music and dance, but they drew on their knowledges of Sudanese dance in their movement styles. For example, they would incorporate footsteps and handclaps featured in traditional Sudanese dance styles with the body rolls and krumps they learnt from the screen.

As a people who bring together the North and South, the Dinka in South Sudan have developed their own contemporary folk music, and have been part of a broader movement of Sudanese youth who are mobilizing hip hop music as a vehicle for developing awareness of the social issues which trouble the South. The young women involved in the ethnography enjoyed listening to Sudanese contemporary popular music, especially hip hop and pop, as well as commercially popular Western artists, such as Shakira, Beyoncé, and TPD. They would bring in burnt CDs featuring contemporary Sudanese pop alongside Beyoncé and then dance, fusing contemporary South Sudanese movements and Beyoncé-styled body rolls. As such, the dance practices in which these young women were invested were quite different from the folk dance styles that captured the hearts and imaginations of the older women. It seemed to me that the younger women especially liked Shakira, Beyoncé, and TPD because these female celebrities each offer popularly applauded, well marketed articulations of non-white femininity that come into the public sphere through dance practices which often cite non-Western traditions. These mainstream female figures form part of what, through Appadurai, we might think about as a global mediascape of non-white femininity.

The girls' choice of *Beep* as the track to which they wanted a performance piece choreographed seemed evidence of their investment in media that constituted scapes of popular non-white femininity. Through becoming like TPD, they both imaginatively folded themselves into mediascapes of femininity and developed a performance piece that offered them an unusual level of visibility in their community. The ways this process occurred led me to notice the young women's focus on visuality and femininity and also facilitated interesting personal negotiations about the politics of femininity. I felt unsure as to whether or not TPD could actually offer a means through which to develop the self-esteem of the young women, because TPD operate within such ostensibly narrow parameters of feminine embodiment. In spite of my ambiguity about our chosen media text, our process opened up readings of TPD in a couple of ways. Firstly, the participants' bodies provided sites that re-wrote TPD's dance moves by nature of their materiality, as the array of forms of female embodiment that were presented by the performance ensemble featured radically different corporealities to those of any given TPD member. Secondly, as I go on to discuss, I encouraged partner work and facilitated some development of original material along with the incorporation of TPD's moves. This seemed like a desirable middle ground that met the needs of the dancers and addressed my own

concern to not overly exult TPD. The use of video technology was a core part of the choreographic process and constituted the means through which the dancers wrote themselves into the dancescapes of non-white femininity. Through video, global mediascapes of femininity crafted by TPD were folded into local recordings made in our community rehearsal space. These texts were then opened back out to the local public in a community showing of the dance.

Visuality and femininity

Visuality and visibility were incredibly important for the young women. Learning through looking and wanting to be seen mediated their knowledges of, and desires for, the reproduction of the female dancing body. The participants' desire to look at female dancing bodies on screens and to learn dance through watching brought the importance of visuality into the process from the outset. The film clip to *Beep* was a primary pedagogical tool for the dance class – the young women watched the clip and tried to dance like TPD. The song is specifically concerned with the objectification of the female body through the male gaze. The lyrics and the dance moves featured in the clip explore the pleasure felt by TPD when subject to men gazing at their bottoms.[7] Some of the young women from Sudan were concerned with appealing to the heterosexual male gaze; part of this was a desire to be and feel sexy, but the young women were also more broadly interested in the pleasure of movement, and in being part of a group activity. They were particularly invested in the idea of, and the disciplinary pleasures associated with, "learning steps" in order to "get the dance right." This was interesting to me in terms of their experiences of self-worth and achievement in relation to their desire for certain kinds of subjection as learners. The girls really wanted to be instructed and they derived great pleasure from explicit tuition.

As someone who practiced for many years in community cultural development, I am generally not interested in dictating "steps" as a choreographic method. I have been trained to focus my interest on performance pieces in which young people devise their own movement material, which is then choreographed into performances in collaboration with dancers. However, as my ethnographic research shows, such a process-based methodology is simply not pleasurable for some young people. Based as they are around processes through which participants devise their own dance moves as physical explorations of particular themes, community cultural development methodologies do not involve teaching pre-existing choreography.

Rather, they are explorative, and the performance texts they create obviously differ from the "popular" funk dance routines generally featured in mainstream film clips.

As much as possible, I worked with this group of young women in the generative, collaborative fashion I prefer, because it offers a lot of space for the personal input of participants. Dance movements devised by participants are expressions of the participants' lives, rather than being a matter of the participants learning moves made in someone else's life. The idea of self-expression through movement without learning dance steps that were not already popular wasn't great fun for the young women. In order to mobilize dance practice as a way of fitting in with mainstream representations of femininity, they wanted to learn what they thought was "real dancing." They wanted to do "dance steps" to TPD. I could see their point. As young women who had experienced much displacement and who occupied a culturally marginal position in their broad local community, they wanted to "fit in" with a mainstream, largely white, image of popular femininity. I was faced with a dilemma – while I wanted to give the participants the pleasure of feeling like they were "fitting in," as I have suggested, I also wanted to maintain what I would call my own integrity as a feminist; in this respect, I felt ambivalent about explicitly celebrating TPD because, while the members of TPD clearly derive great enjoyment from – and make a substantial amount of money out of – their carefully crafted version of femininity, members of the group do not offer as much scope for celebrating non-white femininity as I wanted to provide for the young women. To my mind, Michelle Obama or Oprah Winfrey constitute far more desirable non-white role models, because the kinds of femininity they espouse appear to have been produced more through a focus on the self's relation to self and less through a focus on the self in relation to the (hetero) sexualized gaze of the other as a source of pride and self-worth. This said, my primary concern was to provide the young women with an experience they enjoyed and to which they felt committed. They had clearly chosen TPD's particular dance style and music because TPD expressed the kind of women they felt that they would like to be.

In learning to teach TPD dance moves, I became aware that TPD occupy a particular position in contemporary mediascapes of "girl power," if we take this term to be emblematic of the contemporary adolescent girl cultures which have emerged alongside third-wave feminist[8] practices and debates since the mid-1980s.[9] YouTube is peppered with clips of girls performing dance routines to TPD's music[10]

and, as I discuss below, involvement in lived cultures of girlhood is a core marketing strategy employed by the band. In some other ways, TPD might be regarded as the antithesis of any claim to feminism – especially first- and second-wave feminism – in the respect that these movements have pioneered debates and practices about women's responses to commercial role models of femininity, and TPD embody exactly such a dominant, commercial model of femininity.

Even the group's name illustrates their commercialization of hyper-sexualized, mainstream, dominant forms of feminine embodiment: it brings together two symbols of a commodified femininity that have been crafted for, or reflect the desires of, the mainstream heterosexual male gaze: the doll (specifically, this doll would be a Barbie or Sindy) and the pussycat. Women dressed as stylized cats are classic figures of hyper-sexualized femininity and, perhaps as an extension of this, the abbreviation of pussycat is also employed as a euphemism for the vagina. Bringing the Barbie and the pussy together, a feminist cultural semiotics of the group's name could read it as "the vagina toys." While I consider the women performers who make up the group as the antithesis of first- and second-wave feminism, they often feature prominently in what we might consider to be mediascapes of girl power. For example, *The Washington Post* published an article exploring fashion in girl power written by one of the newspaper's staff writers, who compares TPD to the Spice Girls in order to suggest that the differences between the two bands show their illustration of different strands of "MTV feminism" (Givhan 2007: online). Specifically, the writer states:

> Consider the success of the Pussycat Dolls, who have embraced their inner stripper and the pleasures of slutdom. While the Spice Girls sang, "If you wanna be my lover, you gotta get with my friends/Make it last forever, friendship never ends," the Pussycat Dolls purred, "Don't cha wish your girlfriend was hot like me?/Don't cha wish your girlfriend was a freak like me?"
>
> (Givhan 2007: online)

According to Givhan, TPD represent "the Madonna philosophy, which advocated the power in a half-naked tush" (2007: online). Yet the nature of the "tush" which TPD celebrate is clearly very selective. TPD members have individual versions of a particular form of small, muscular, cellulite-free bottom. As such, one could qualify the suggestion that TPD "advocated the power in a half-naked tush" – they seem in fact only to advocate the power in

half-naked small, well-toned, cellulite-free bottoms. Clearly, I am skeptical about the extent to which TPD's mainstream, popular version of MTV feminism[12] might offer a range of young women any tools with which to appreciate, or connect to, their own body outside a strict set of parameters.

TPD's intervention in ethnoscapes of non-white femininity is not only limited, but also seems to be manufactured primarily for marketing purposes. While the group sells their "range" of ethnic backgrounds, as I have noted, they are all very slender; to enhance or further signify "difference," they have dyed their hair different colors. Some members have orange hair, others have blonde or black hair, and so on. In what is ostensibly a radical overcoding of the embodiment of racial difference, TPD have become branded as "diverse" although obvious signs of bodily diversity have been erased; the members do, however, have different hair colors.

McGee (2010: 7) discusses some of the problematics of TPD's success as icons of girl power "because of the ways that their particular musical, visual and dance-oriented texts embody public intimacies (Berlant 2008) by stimulating an always already exoticized feminism." McGee usefully acknowledges the role that TPD have played in de-politicizing the everyday cultural labor associated with multiculturalism, suggesting:

> While the group's multicultural performances provide contemporary examples of real life intercultural collaboration, their cultural politics remain unvoiced. Although multiculturalism has recently fallen from favour in academic circles, twenty first century media execs quickly recognized its profitability in the international arena of multinational, musical commodities. More recently, the widely branded term "multiculti," reflects current tendencies to dismissively abbreviate heavily-weighted cultural concepts. The term's flippant brevity also indirectly mimics what some view as an overly-commodified, "politically correct" performative gimmickry.
>
> (2010: 12)

The marketing link between TPD as de-politicized multicultural icons who offer us an example of "twenty-first century Orientalism" (McGee 2010: 11) and lived "girl power" as a culture is clearly strategic, and is examined by McGee in relation to third-wave feminism in her analysis of the group's "find your inner doll" campaign. In an early interview with the band, then-TPD member

Christina Applegate stated: "inside every woman is a Pussycat Doll" (McGee 2010: 14). This statement was taken up by the band as a marketing strategy, became a branding slogan, and later articulated into a reality TV show in which the band searched for a new member. McGee discusses the political utility of this slogan, acknowledging that it has done a lot for TPD in terms of their marketing and branding, but also canvasses the shallow nature of the sentiment of self-empowerment which lies at the heart of the project for women to find their inner doll through examining some of the aggressive, at times abusive, practices of embodiment associated with becoming a Pussycat Doll. McGee's mapping of the falsity of the empowerment narrative is instructive. She states:

> Since 2003's "inner doll" slogan branding, other feminist and new age sounding phrases began to crop up on internet blogs and interviews with various band members ... In reference to the female empowerment tip, Nicole [the lead singer of TPD] claimed that the Pussycat Dolls was "the next generation of girl power." In the same interview, "Red-headed" Carmit Bachar offered another explanation of doll power claiming: "it's essentially female power. It's having a sense of strength and confidence and self-expression of who you are."
>
> (Parentheses added 2010: 14)

The limited nature of this rhetoric is made plain by McGee (2010: 14), who notes that TPD's "public philosophizing about the nature of performing women began to change from new-age, self-help inspirational slogans and DIY determinism to assertions reflecting the culture of hyper-masculinized, media moguls." Not surprisingly, she points out that the reality TV show searching for the next great Doll showed women fighting with each other more than anything else and had fairly limited success when it came to finding new group members, because "the 'extreme' requirement to be athletic, fit, thin, beautiful, multitalented, and multicultural meant that very few women actually had the chance to express 'Doll Power'" (McGee 2010: 15).

In what I considered a fabulous contrast to the uniform physiques of TPD, members of the group of young women I worked with were physically very diverse and, unlike any members of TPD, were all very dark-skinned: they embodied rather than signified non-white femininity. The participants had been born in, and migrated from, either Sudan or Egypt and their ages ranged from five to sixteen.

Their bodies and personal styles were genuinely individual, although most were quite shy and used words sparsely. Their attendance, commitment to the rehearsal process, and obedience (in the respect that they endeavored, to the best of their capacity, to do what I asked of them) showed me that the girls were keen to dance. This said, the movement ranges and physical capacities of the young women varied greatly and, despite their enthusiasm, the physicality of actually getting some of the participants to dance entailed modifying choreography and finding quite simple moves that all the group members could perform.

As such, the choreography I taught the young women was very simple and did not entirely copy the dance moves in the TPD film clip. I encouraged the participants to devise at least some original movements and tried to bring together "steps" that the young women chose from TPD's film clip with these simple movements. This balance between generating and teaching choreography was important for me because I wanted to write the participants into the dance in as many ways as I could, but it was also a necessity, because not all of the participants could execute all the movements featured in the film clip. My decision to layer movements taken from TPD's dance routines alongside a few of the young women's own movements and other fairly simple actions was thus partly from necessity, but was also an expression of my desire to increase the participants' connection to, and investment in, their dance.

As our rehearsals progressed, the role played by visuality in the rehearsal process changed, although it remained an important aspect of choreographic development. Rather than continuing to watch other dances, such as TPD or Beyoncé, on the screen, we recorded our rehearsals with a video camera and employed videotexts of the young women dancing as a way of remembering, analyzing, and responding to rehearsals. I would record rehearsals from a tripod or, when possible, would enlist another free member of the community education group to record us. The girls' dancing bodies on screen reproduced, but also reworked, the mediascape created by TPD's film clip, as they cut themselves into the landscape of bodies and images that fascinated them by reproducing the moves they enjoyed. At the end of each rehearsal, our group would watch rehearsal footage to determine the "accuracy of the moves" and to plan refinements or improvements. The quality and tenor of movement were foci of importance here and our examination of these aspects of the movement was greatly aided by the use of the video camera: watching back over rehearsal footage, we had time to examine the dance moves and decide if we

wanted some moves to be stronger, others more sexy, others to remain playful. I sought to craft a dance that allowed the young women's femininity to articulate in different ways.

Through making sequences that brought together as many different movement qualities as I could elicit, I tried to facilitate a process through which the women were able to embody a multifaceted femininity. The rehearsal process was thus a consistent negotiation of the practical limitations of our resources, the participants' desires, their capacities, and my concerns as the director/choreographer. These negotiations occurred through, across, and about music, media, videotexts, and technologies. They wove mediascapes and ethnoscapes together to create a dance text that blended old and new knowledges through popular literacies and made new femininities.

The final performance piece was structured in three sections, which were designed to generate distinct senses of being the beginning, middle, and end of an event, so each section featured quite different movement qualities. These discreet sections also provided us with clear opportunities to use the space in different ways. The first part began on the floor and at the very back of the stage – or what, in theatrical terms, would be considered to be upstage. The girls sat side by side in a row with their backs to the audience, their bottoms on the left-hand side of their body and their legs bunched on their right. This was a "lounging" pose: their left hands were pushed to the ground to support them and they were leaning onto them. The music starting was their cue. *Beep* begins in a lilting fashion, and so the beginning moment of the dance was relaxed and slightly sultry. As the music's tempo increased, which happens quite quickly in the song, the young women rolled over their feet (to the right), to face the audience. This turn was in canon – they took successive cues from one another, turning one after the other. As soon as all the young women were facing the audience, they stood up together, in a line, with one hand on their hip.

We worked for a long time on the "moment" of the line assembling. It was a strong, sexy moment where they faced the audience directly and had a sense of being a group: being strong both individually and together. Once this "arrival" in the line had occurred successfully, they walked towards the audience. This walk was important to me, because I saw it as an opportunity for the young women to establish their sense of self as physically strong. It was also an opportunity for the girls to cover the entire length of the performance space fairly quickly: they were not runners, so this was the greatest amount of

movement through space that some of the dancers undertook in the performance. In rehearsals, to encourage strength and presence in this walk, I stood alongside the young women and stated loudly: "you are proud, you are strong, heads up, girls, walk with strength." Most of the women's natural walking styles saw them staring at the ground, so they needed direct advice on this matter. They certainly developed a proud, strong walk, which, as I've suggested, was also a bit sexy. They swaggered their hips, held their heads high, and moved through the space with strength and purpose. They arrived downstage, facing the audience, and then formed two lines facing each other, so that each young woman had a partner.

The pairs performed duets in unison. The duets were the same and were modeled as directly on TPD's choreography as the young women's physical capacities to dance would allow. I took moves from part of a group chorus dance routine featured in the *Beep* film clip in which TPD dance in a V shape, in unison, and translated these movements into duets in which they faced their partner and "danced off" each other, with a friendly if not slightly competitive air. After facing their partners, the girls krumped, body rolled, and articulated their shoulders, waist, and hips in circular movements like the TPD. They then turned in their two lines to face house stage left, where they toe-tapped and rolled their arms. This movement is a great example of the modified, simple kinds of choreography that I employed in sections to get the young women moving when they were not able to follow the film clip in its entirety, either because in the film clip the dance sequence cuts to a different moment which is not necessarily a dance move, or because the participants were not able to perform the choreography.

The middle section of the dance involved balances and weight shares. These took a considerable amount of time to teach, as the participants needed to develop trust in themselves, in their own bodies, and in each other, in order to carry the weight of others and to trust others enough to give their weight. For example, the young women formed a pyramid in which they balanced on all fours on top of each other. This demonstrated great trust and teamwork, as the participants were carrying each other's body weight and, more than this, were relying on each other for stability and support. They also performed small duets that involved weight shares. Often these were as simple as a lean, pulling on each other's arms, or taking a back-to-back rest, but some were more complex balances, such as one partner lying on the ground with both legs in the air and the other balancing on the base's legs.

In the final section of the dance, I dispersed the dancers on diagonal lines across the space, which meant that audience members could see each of them well, from a range of different angles. The young women each had three movements through which they explored low, medium, and high levels of space, holding a freeze position as the end point of the dance, to mark a closure. This was the section of the dance in which they were required to devise their own material; while it took longer to set the choreography for this sequence than for other parts of the dance, the rehearsal of this section provided interesting evidence that the process of devising one's own moves can be physically empowering. While the other sections of the dance were fairly easy to choreograph, in the respect that the process was largely based on following my instruction, they took hours to rehearse – partly because, as always, movement quality had to be layered into the work, but also because timing was especially crucial.

I gave them some directives, such as asking them to include a reach, a jump, or a roll, and also employed visual and emotional images (thinking about something that makes you happy, thinking about home, thinking about reaching out) in order to support the process of devising movement. However, once the movements had been developed and refined, this section of the dance ran incredibly smoothly and required less detailing for movement quality than other parts. This was because the movement quality was built into the nature of these movements for the young women more so than with the dance moves learnt from TPD or those that I had taught as a way of either keeping the dancers moving or linking sections together. It was of great interest to me that the freeze at the end was the part of the final section that required the most rehearsal – the timing and stillness needed more work than one might imagine.

As such, the final performance was a combination of movements that I encouraged the young women to develop as a way of skill building, and movements learnt from watching TPD on screen. We practiced every weekend for months in order to perfect the timing. A considerable amount of strength, teamwork, creativity, and care was demonstrated by these young women in executing their performance piece. Working together on a weekly basis was in itself a great achievement, and the fact that the girls learnt to weight share and were brave enough to develop their own dance moves, as well as to build a physical pyramid, somewhat appeased the guilt I sometimes felt about what I considered the possibly unethical nature of encouraging a group of young women to body roll like a member of TPD. As I have explained, I remained ambiguous about the

extent to which TPD could be seen as figureheads of empowerment or agency.

The final dance was performed in front of the girls' families, friends, and other significant leaders in the Sudanese migrant and refugee community at a large community Christmas event. This was the first time the dancers had performed in front of an audience. The performance was incredibly well received and, perhaps of more importance to me, the young women enjoyed performing. In spite of some of the contradictions and ambiguities that are embedded in the process of research I am theorizing, such as my own whiteness and the age and power differences between myself and the young women with whom I worked, their dance piece can be considered a performance of what, drawing on Deleuze and Guattari, I think of as "minoritarian girl power." Deleuze and Guattari use "minoritarian" to refer to a cultural position – a minority collective rather than a physical mass. They suggest:

> When we say majority, we are referring not to a greater relative quantity but to the determination of a state or standard in relation to which larger quantities, as well as the smallest, can be said to be minoritarian: white-man, adult-male, etc. Majority implies a state of domination, not the reverse. It is not a question of knowing whether there are more mosquitoes or flies than men, but of knowing how "man" constituted a standard in the universe in relation to which men necessarily (analytically) form a majority . . . the majority in the universe assumes as a pregiven the right and power of man.
> (Deleuze and Guattari 1980: 291)

As this quote explains, "minoritarian" is a description of a cultural position. The minoritarian stands against the majoritarian stance, or that which constitutes an analytic majority and which is assumed as a benchmark for the "power of man" (Deleuze and Guattari 1980: 291). This incorporeal body of power takes the analytic position of "average," and "standardized" and certainly does not reflect the collective of young refugee women with whom I worked. These women were minoritarian, or "minor," in terms of the patriarchal nature of their own Sudanese migrant/refugee culture (James 2010) and in terms of their membership of the dominant, largely white, Anglo Saxon Australian culture.

The significance of the fact that these young women performed at a community event, and did so with great pride, was considerable, as the participants were often very shy (although personable). Through performing at the end-of-year Sudanese community Christmas celebration, they physically wrote themselves into the ideoscapes of the local community. Mediascapes of non-white femininity were a core part of the popular literacy these young women mobilized in this process. Via their dance practice, the young women became part of how the community imagined itself in ways that marked a shift from previous local community imaginings. The local and global politics of their performance thus need to be considered when thinking about their achievement. While I have suggested that the globally distributed texts produced by TPD effect a radical overcoding of ethnic difference, to the extent that they advocate "the power in a half-naked [very slender, cellulite-free] tush" (parentheses added, Givhan 2007), the young women with whom I worked were not solely concerned with being overly "sexy" – they wanted to be sexy, but they also wanted to be strong and be part of a team, as the participants' investment in TPD was largely a concern with being part of a global community that celebrated a diverse range of feminine ethnicities. Through re-choreographing and restaging *Beep* both onscreen and in front of their community, the young women wrote race, femininity, and community into the Pussycat Dolls text. This happened through their bodies: their skins are black, many of them have voluptuous figures, and their trust work in building pyramids formed a literal minoritarian community of young women in front of their own larger community.

In many ways, the project of "teaching" young women to dance to TPD was politically and aesthetically challenging. It wasn't what I usually recognized as "feminism." Indeed, in most other contexts I would argue that women dancing to TPD really couldn't be considered a kind of feminism; however, I think in this instance it can be. The young women's bodies, movements, and pleasure in their own movement clearly demonstrated to me that this exercise in dancing negotiated a space in the middle of third-wave feminism in which moving to TPD was not necessarily only about pleasing men. The participants felt they were writing themselves into dominant mediascapes of girl power in terms of a text that celebrated ethnic diversity, and I felt like we achieved a huge amount through working together and, as a group, the young women becoming brave enough to perform in front of their community.

Youth arts as cultural production and a media of subjectivation

The ethnographic example of the young women dancing that I discuss above can be extended to advance an argument for thinking about youth arts practices as a form of what Paul Willis (1981) calls "cultural production," which is "a field of creative self-making of the subordinate class" (48). Cultural production is gender-specific and is a collective cultural process that is also a way of becoming a subject. Thinking about the cultural production of identity in this way and applying this frame to the process of "girl dance" that I discuss shows how dance practice works as a media of subjectivation, a technology through which gendered identity is produced. The process of subjectification that is effected through this practice of dance as a form of minoritarian cultural production speaks back to, or reframes, existing stratifications of social structure in culture. Willis explains:

> We should investigate the form of living collective cultural productions that occur on the determinate and contradictory grounds of what is inherited and what is currently suffered through imposition, but in a way which is nevertheless creative and active. Such cultural productions are experienced as new by each generation, group and person.
>
> (1981: 49)

These "determinate and contradictory grounds of what is inherited and what is currently suffered through imposition" articulate, in the case of the young women in my ethnographic research, through the inherited knowledges of their mothers, older women in the community, traditional dances and music, and through the imposition of war, leading to life lived as a refugee, between homes and traditions. Yet the active engagement of these young women with the intersection of inheritance and imposition at which they find themselves placed is clear: they brought together old and new scapes of non-white feminine dance through their taste and their movement practices. Those involved made culture, in the respect that they created their own weekly, local girl dance practice and, through performing, created new parts of their localized Sudanese migrant/refugee culture. They remade the ideoscapes or ideas of femininity and community to which they belong and made themselves as dancers, as publically visible members of their community. Perhaps most significantly in their own minds, through dance, the young women produced

themselves as members of a global mediascape of non-white women. In her chapter "Globalisms' Localisms," Dana Polan explores exactly such an interface between the local and the global in terms of cultural production and the geopolitical labor that arises when different scapes are brought together. Drawing on Polan (1996: 263), the identity work undertaken through dance by the young Sudanese refugee women can be considered an instance of a local contribution to a culture that is "globalist in several motifs that interconnect: [demonstrated by] a concern with movement and the ease of crossing fluid frontiers (whether these be the geopolitical limits between nations or the cybernetic." Through their dance, the young women brought together aspects of the nations from which they hail and aspects of those in which they now reside, alongside selective interpretations and re-readings of cyber texts that have achieved global fame through their representations of non-white women.

Thinking about youth arts practice as a means of cultural production through which minoritarian bodies write themselves into their local community imaginaries offers a productive alternative to the dominant conceptualizations of youth arts as a form of intervention which I examined in chapter two, as the girls' tastes and their embodied and kinesthetic practices of belonging are read – as was no doubt intended by the dancers – as part of a global machining of non-white girlhood. Here, dance is important not for fitness or educational purposes, but because it facilitates a process of belonging – it is a technology of becoming a person and a means of making a social face. The young women's tastes, styles, heritages, and bodies form core aspects of the practice of dance as a technology of identity, the effectiveness of which is clearly maximized by its personal nature. It is a practice written through and on the body. The dance piece effected local visibility and affected the young women's self-esteem in profound ways precisely because it was so embedded in their histories, emotions, tastes, and bodies.

The relationships between desire, cultural production, and subjectivation that are at the heart of my discussion of the young women's dance and their choreographic process have long been acknowledged as critical aspects of youth culture (Bennett 1999). As Bennett explains, taste – and, specifically, musical taste – is a political performance:

> In consuming popular music the individual is free to choose, not only between various musical styles and attendant visual images, but also how such choices are lived out and what they are made

to stand for. Moreover, in choosing certain musical styles and visual images, the forms of association and social gatherings in which young people become involved are not rigidly bound into a "subcultural" community but rather assume a more fluid, neo-tribal character.

(1999: 614)

The "fluid, neo-tribal" (Bennett 1999: 614) intersections of cultural history and contemporary globalizing circumstances were brought together through the musical tastes and dance styles of the young women with whom I worked. Mediascapes of non-white femininity were the form of popular literacy and the popular pedagogy of the dance classroom that effected these neo-tribal processes of subjectivation and cultural production. While the young women are marginal in their community in terms of gender because their community hierarchy is patriarchal (James 2010) and, in broader terms, because they are almost all refugees, their tastes make them part of a much bigger landscape of femininity and their dance affirms their status as citizens in the little public of their local community. Through Appadurai's notions of scapes, the coming together of this global landscape of ideas and images of non-white femininity and the local activism of the young women's work become intelligible as a form of global cultural citizenship. What I have called "minoritarian girl power" is a way of performing glocal[13] belonging to non-white female community and of writing the young female Sudanese refugee body into the consciousness of the local community.

4 Do you want to battle with me?
Schooling masculinity

The website for the North American hip hop festival *Scribble Jam* greets the viewer with an image of the back of a young, muscled man in black shorts, a t-shirt, and sneakers. His right hand on the ground supports his legs in the air: they rise in a V shape over his body. His left arm reaches up towards his feet. Clicking on the image brings it into motion. Music fills the air and breakdancing male bodies move across the screen. From the vantage point of a camera positioned very close to the floor, young men toprock,[1] downrock,[2] backflip, handstand, and headstand.[3] The website tells the viewer about the history of *Scribble Jam* and displays tour dates and links to music retailers associated with the festival, which ran annually in Ohio from 1996 until 2008. Through the event, up-and-coming breakdancers have been able to register to compete with established names in the field. The historical writeup on the website focuses on breaking: this is the chosen dance style of most of the young men discussed in this chapter. As well as showcasing breaking as a contemporary dance practice, *Scribble Jam* is the site of debates about authenticity that often occur in relation to hip hop (for example Lena 2006; Judy 1994). The movement has been popularly read (especially in North America) as an artistic expression of an activist cause that advocates for the rights of black people (Ogg with Upshal 1999).[4] A discourse of authenticity permeates the site and is made evident in statements such as:

> Scribble Jam brings the essence of true Hip-Hop culture to the masses at large. … [W]e go back in time, seeking to recapture the original spirit of the B-boys, DJs, Graff Artists and MCs who formed the genesis of this lifestyle we love so much.
>
> (*Scribble Magazine* online 2011)

"Essence" and "true" – adjectives both used in the quote above – are words that demonstrate the relatively unquestioned status

accorded to discourses of authenticity in hip hop. As a means of performing a genre that is inherently masculinized, hip hop methods bring authenticity and gender identity together. Through breakdance, "authentic" masculinity is produced and staged in forums that offer public visibility and valorization.

The production of an "authentic" masculine gender identity through breaking is a theme that connects most, but not all, of the stories of the young men in my research. For most of these boys, breakdancing became a way of producing and displaying "true masculinity" through battle. The name of this chapter is taken from a song line that incites the listener to fight with the phrase "you wanna battle with me?" (Fliistylz and Tenashus 2005). The line is taken from a track to which all the boys involved in my study liked to dance. The track is featured on the soundtrack to the film *RIZE*,[5] which the boys brought into the dance classroom as a resource. It offers one of many possible connections between authenticity and masculinity established through battle. This connection runs across the chapter: it was a motivating factor in the ways all the schoolboys moved.

Before I explore the regulation of masculinity and heterosexuality as an incitement to dance through discussing the located politics of the boys' dances, I want to make a disclaimer. While I talk about dance, this is not a chapter about dance scholarship. It is an analysis of the located politics of identity work that the boys undertook through dancing. For the schoolboys, including the socially and physically awkward students who were not "cool" or co-ordinated enough to break, dance was not a disciplinary area of study with which they were engaged. Through learning dance as a way of crafting battles, the boys took dance practice out of its broader disciplinary and scholarly contexts. In other words, rather than learning ballet, tap, and breakdance as different dance styles, along with a history of dance, the boys learnt to perform. Two of the three groups of schoolboys chose to do this through breakdancing. This partly reflects a broader athleticization of dance in Australian culture.[6] In the school, this athleticization and the curriculum focus on practical competencies came together to create a situation where dance offered a local vehicle through which masculinity was produced and parodied.

Within the classroom, movement became a means of shaping, but also satirizing, masculinity for all the boys who danced. The Sudanese boys who danced in the community education context proved an exception. Below I explore the significances of the boys' movement

practices in context. I do so via theoretical resources that give insight into the kinds of cultural work the boys undertook through dance. The school culture, and almost all the boys who danced, valorized breaking. Perhaps obviously, it is a practice that holds a considerable amount of cultural capital in contemporary popular youth culture (Ross and Rose 1994). The history of the hip hop movement as a vehicle of black activism also has important parallels with the school culture's investment in raising public awareness of Aboriginal Australian issues. As such, hip hop offered an accessible form of movement for most of the young men.

Not all of the schoolboys chose to break, but they did all structure their movement pieces around a battle. As a choreographic principle, the battle is emblematic of the school research context and the negotiations of gender identity undertaken by the schoolboys. In different ways, each of their dances was concerned with constructing and recuperating, as well as critiquing, masculinity. In the school, dance for boys was taught largely as a technology through which a kind of masculinity that was hegemonic in the located educational culture was crafted. It was one aspect of what Skeggs (1989: 485) refers to as "the processes of institutionalisation that legitimate and reproduce racism and sexism."

Out of school, the Sudanese boys in the community education setting chose to dance in hip hop styles, although they didn't want to perform in public or dance in structured ways. In response to these needs, I designed their workshop program in a way that did not involve working towards a performance. These boys chose to create space for dance practices that were pleasurable and private; that were explorations of subjectivity rather than public displays of identity. This choice was important. The Sudanese boys' creative dance practices constituted a counter discourse to the popular "black panic" media narratives of aggressive Sudanese masculinity that I discussed in chapter two. Indeed, their dance practices can be read as an embodied critique of these discourses.

I begin by discussing the schoolboys and their "battle dances," and then move to look at the Sudanese boys in the community education context. In the order in which I discuss them, the groups are:

1 Vocational Education and Training (VET[7]) students who mobilized their non-white ethnicities as a core resource that informed their dance. The median age of these boys was 15–16. These boys were called to "work" their ethnicity to perform the popular articulation of hip hop masculinity that was the figurehead for a hegemonic

pattern of cool in the school context. They did so quite successfully. The boys who were able to embody the hegemonic ideal of the (non-white) b-boy were afforded the luxury of being able to critique the school's use of particular movement styles and processes of schooling through their dancing.

2 Largely white, low-SES year nine boys who wanted to learn hip hop as a means of performing what Connell (1995) characterizes as "protest masculinity." The median age of this group was 13–14. They identified with the genre partly because of the choreographic principle of the fight: the aesthetics of aggressive masculinity clearly appealed. Their performances were more earnest than those of their older peers, who identified with breaking as a popular cultural form with cultural capital in and outside their school. While the older boys embodied breaking as a hegemonic form of gender identity and read hip hop as a signifier of success, the year nine b-boys read the genre differently.

3 A group of mixed-race year nine boys who were marginalized in the school culture and were socially awkward. The median age of these boys was also 13–14. These boys wanted to perform as wrestlers as a way of reclaiming, but also satirizing, their masculinity. Signifying protest in less contextually endorsed ways, they embodied what Connell (1995: 109–14) defines as "subordinated masculinity": they are the boys whom Lingard, Martino, and Mills (2009: 141) suggest are "unlikely to be welcomed into all school communities and indeed may feel like they do not belong." These boys were not interested in breaking, primarily because breakdance constituted the "parent culture" (Hebdige 1979: 127) of successful dancing masculinity in the school. Breaking also requires a level of kinesthetic competence that they did not possess. However, along with the other boys dancing at school, these marginalized boys had chosen dance as an elective, so on some level they wanted to be dancing boys. They also saw dance as an easy subject choice. They created a subculture of battle dance through wrestling.

4 Sudanese boys who practiced breakdance in the community education context. These boys' ages ranged from 6–17. They had an uninhibited style of breaking that differed markedly from the more self-conscious kinds of dance that were popular in the school. As I noted above, this choice was available because they were not obliged to perform in public in order to meet the assessment requirements of the school curriculum. Like the wrestling boys, the Sudanese boys' dance practices constituted what Hebdige calls a subculture (1979: 43–5), and their subculture

of dance reterritorialized the dominant "parent culture" (Hebdige 1979: 127) narratives of refugee Sudanese boys that are articulated through popular media.

All the boys who danced at school chose[8] to do so as a way of reconstructing and parodying their masculinity through choreographing fights. This was a noticeable connection across the age, race, and contextual differences that distinguished these groups. The link here between the imperative to perform publicly and explicit negotiations of masculine identity is striking. For example, it seemed to me that the schoolboys could have danced very differently if they had not felt obliged to construct and perform their masculinity through dance for the viewing publics of eisteddfods.[9] As technologies of assessment and texts that assembled relatively conservative viewing publics, eisteddfods functioned as disciplinary technologies for the schoolboys.

The three groups who were interested in hip hop drew choreographic material from the LA-based movement that developed the practice of "krumping" which I introduced in chapter three, and the affiliated practice of "clowning." They learnt these styles through a range of popular cultural texts and were particularly interested in the film *RIZE*. In spite of the age and race differences between the groups and the structural disparities in their educational contexts, the groups respectively developed an interest in, and an appreciation of, the film. They brought it into their dance classroom or workshop space as a chosen choreographic resource. *RIZE* tells the stories of individual dancers who were instrumental in establishing the evangelical subculture of clowning and krumping. The subculture retained a traditional breakdance focus on "battling" but reshaped battle dances as showdowns that are undertaken through clowning and krumping.

As I have suggested, some aspects of the VET boys' dancing, and also the dancing of one of the year nine boys, constituted critiques of the school culture and the roles accorded to hegemonic patterns of masculinity that developed in the school around the practice of b-boying. In order to understand the fora in which these critiques were staged, I extend the discussion of eisteddfods that I initiated in chapter one. One way eisteddfods operate as a disciplinary technology is that they can be – and generally are – used to school gendered identity through styles of performance that reproduce embodied aesthetics popularly associated with heteronormative performances of gender.

The dance styles presented at eisteddfods are generally read in uncritical ways by their viewing publics. The year nine boys discussed below read breakdance as a signifier of socially marginalized "protest" masculinity (Connell 1995: 109–14). Hip hop was seen as signifying blackness and symbolizing disadvantage. The choreographic scene of the fight became the "frenzied and showy" (Connell 1995: 110) spectacle of working-class-cum-welfare-class retaliation.

In addition to being technologies for performing race and constructing masculinity, eisteddfod dance practices are forms of popular and public pedagogy that extend young people's imaginings of themselves in ways that are designed by adults. Eisteddfods largely express adult visions of what young people doing "performing arts" should look like. As such, the spaces within their eisteddfods where the young men in my study were able to critique adult imaginings of socially marginalized masculinity warrant careful analytic attention.

Many of those involved in my research enjoyed eisteddfods and were obviously invested in the modes of subjectification they effect. If participants were not interested in being or becoming "a star" – or, at the very least, in being a certain kind of performer – eisteddfods would not be as popular as they are.[10] Just as dance becomes a means of physical or vocational education rather than performing arts education in so many Australian schools, the identity work that occurs onstage at eisteddfods is similarly responsive to context.

I have suggested that for the VET boys, breaking on stage gave them the chance to parody the hierarchies of cool that they were compelled to cite through learning breakdance. These hierarchies of cool are a requisite means of performing a popularly valorized, raced masculinity. Gates Jnr (1988) is of use when thinking through the ways in which the boys worked their dance practices as citations of race, or modes of what he refers to as motivated and unmotivated "signifying." His work allows us to see moments of critical purchase in the boys' dancing, as held distinct from their general states of uncritical repetition.

As an adjective used to describe the speech acts of a monkey trickster figure featured in African American folklore, "signifying" as a concept was developed to analyze the intertextual relationships between works of prominent African American writers.[11] A number of folktales feature the character of the signifying monkey. Each tells the story of an exchange between a monkey, a lion, and an elephant, in which the monkey uses his wit to trick the lion. In so doing, the monkey disrupts the law that suggests the jungle is the lion's domain.

The "trick" of which the story tells, is a series of events in which the monkey teases the lion, pretending that an elephant had been insulting him, the lion's wife, his "mamma" and his grandmother (Gates Jnr 1988: 56). The monkey defends his actions, suggesting he was harmlessly repeating what the elephant had been saying. Upon confronting the elephant about his supposed mockery, the lion is (perhaps unrealistically) beaten by the "self-confident but unassuming" (Gates Jnr 1988: 56) elephant, at which point he realizes the monkey has been deceiving, or "signifying on" him. As such, the politic of motivated signifying is subversive: it's a practice through which people living on the edges of social hierarchy (aka the monkey) assert power through wit as cultural critique and the use of subcultural knowledges. The monkey knew the elephant would beat the lion and this knowledge motivated his trickery. Thus, signifyin(g) is the practice of reversing power structures. This critique occurs through working with the context-specific meanings of actions that are only accessible to those who share the values of a community.

There are two types of signifyin(g): cooperative, "unmotivated signifying" and oppositional, "motivated signifying." Unmotivated signifyin(g) involves the repetition and alteration of a text in ways that demonstrate appreciation of and reverence for an existing work. It is characterized "not [by] the absence of a profound intention but [by] the absence of a negative critique" (Gates Jnr 1988: xxvi, author's parentheses). Unmotivated signifying is uncritical repetition that features "refiguration as an act of homage" (1988: xxvii) through an intertextual pastiche of calls and responses that mirror the style of exchange between the monkey and the lion.

Motivated (oppositional) signifyin(g), the mode of repetition with critical purchase, is Gates Jnr's focus. He is interested in how it "functions as a metaphor for formal revision, or intertextuality, within the Afro-American literary tradition" (1988: xxi). Motivated signifyin(g) occurs when authors reuse motifs from previous works but alter or "signify" on them to create their own meanings. It is "what we might think of as the discrete black difference" (1988: xxiii) in literature written by blacks. Signifying, then, is both a rhetorical strategy (a method through which Afro American writers find their voice) and an organizing principle of Afro American literary history.[12] Later writers can be seen to have "signified on" earlier writers: that is to say, they have critiqued them through a reversal of their strategy.

While developed for literary studies, the politic of motivated signifying as a form of critique has proven useful in cultural studies,

particularly in relation to music and dance practices (see Chatterjea 2004; Marini 2003; Maxwell 2003: 42, 45, 82). It offers a relief through which to distinguish between the boys' critical and uncritical reproductions of hegemonic b-boy masculinity, b-boy protest masculinity, and subordinated wrestling masculinity that characterized their engagements with popular cultural forms as choreographic sources. Most importantly, motivated signifying is a means through which to understand how, at times, boys employed dance to critique celebrated forms of masculine comportment.

Signifying on breakdance

In the school, the two groups of boys who produced their masculinity through hip hop were distinct. While they read b-boying differently, they were both clearly invested in economies of cool that they identified in breakdance. Schloss explains how b-boying began as a kinesthetic response to breaks in hip hop music, or

> the part of a song where all instruments except the rhythm section fall silent and the groove is distilled to its most fundamental elements. [As such] … the break was an opportunity … dancers responded by creating a new dance form that was nothing *but* devastating moves: b-boying. Some even began dropping to the ground and spinning around [down rocking]. Hip-hop music and b-boying were born as twins and their mother was the break.
> (Schloss 2009: 18–19, author's parentheses)

Schloss' tone and his description of boys with "devastating moves" coming from the "mother as the break" is illustrative of the economy of cool and sentiments of control and hegemony that are privileged in practices of, and discourses surrounding, b-boying. Clearly this "coolness" appealed to all the b-boys, as did the relationships between beats, breaks, and dance. They were largely all kinesthetically adept and by choice they listened to hip hop outside the classroom.

The older VET students were, respectively, first-generation Maori, Greek, and Southeast Asian. They crafted their performances of masculinity around a gangsta style that has been associated with some articulations of hip hop and is positioned prominently in commercial culture targeted at the youthful consumer. The notion of gangsta was read as black style and has a long history in popular culture of being

read this way. Richardson summarizes this history as:

> [A] very limited and questionable representational formula for black masculine subjects [which is] … in some ways quite regressive – far more regressive than it would appear to be on the surface. For it forecloses a broader and more diverse spectrum of black masculine representations.
>
> (2007: 237)

This act of foreclosure was assisted in the school by the fact that the VET boys' breakdance performances were celebrated on the promotional postcard for the school's dance program, which features four students of color wearing bright, baggy hooded tops, jumping in the air, bringing their bent arms in front of their bodies. They are clearly adept breakdancers. These boys embody the hyperhegemonic masculinity required to perform gangsta. However, unlike the often immobile, "hard" modes of corporeality that characterize gangsta men, the VET boys were also "soft" and kinesthetically skilled enough to dance. Being able to perform gangsta *and* breakdance is quite unique. To the extent that gangsta identity is manifest in a "hard," inflexible emotional and physical style of embodiment, gangsta masculinity is antithetical to any kind of dance – even the more overtly masculine practices of breaking. As an acknowledgment of this capacity to be gangsta and dance, teachers and students heralded the VET boys as heroes. These boys offered a very marketable version of "blackness" which the school valued in light of its profile of leading Koori (Aboriginal Australian) education.

In spite of the amount of subcultural capital which these boys held in the school culture and the public honor of being the "face" of the dance program, the achievements of their masculinity must be seen as limited. In embodying a form of masculinity that is hegemonic in youth popular culture and which was clearly the dominant pattern of masculinity in the school, these boys marginalized others, such as the majority Koori boys who were too shy to dance, and the subordinated boys, who based their dance around World Wrestling Entertainment. They also constrained their own possibilities for becoming a man to a very specific trope that was racialized in limiting ways. Richardson explicates the racist intonations of gangsta thus:

> The internalisation of the gangsta concept by black young men … has had subversive aspects to be sure. Yet the question remains about the extent to which it can be detached from the salient

epithets that have maligned black male subjectivity in the past and from the ones that are manifest in the present day.

(2007: 222)

Through the VET boys' style, which translated into their dance practices, gangsta was cited as a trope of masculinity that became separated from dance as a curriculum area and from the historical ethos of hip hop as a social movement.[13] As I discussed in the introduction to this book, the school has a public profile constructed around success in Koori education. As such, there is a tacit connection between hip hop cultures in the school and the politics of racial activism, although this politic was not acknowledged by the dance teachers through their pedagogy. B-boying as a practice was taught in ways that reinforced, rather than challenged, stereotypes of gangsta masculinities.

In spite of the stereotypical depictions of non-white masculinities that resulted from the VET boys' hip hop performances, the composition, rehearsal, and public display of their dance pieces marked significant milestones in their schooling year. The performance pieces were also assessment items of significance in the school curriculum. More than just providing the contexts in which the boys' dances were staged, eisteddfods offered an opportunity for the boys to satirize, or signify on, the style that gave them kudos in the school community.

The moments of motivated signifying in the boys' dancing were a way of critiquing the school culture's valorization of hegemonic, racist patterns of masculine gender performance. Not all the VET boys performed motivated signifying. Four boys from the class, those who were the most confident dancers (and were featured on the publicity postcard), had the cultural capital required to signify on the school's appreciation of their dancing. Neil, a boy of Greek descent and one of these four, signified on the school's valorization of hegemonic hip hop masculinity through parodying his own kinesthetic aptitude. Shaking his hand up and down at the audience, a movement which usually signifies a critique of other dancers, he cheekily looked at himself, then at his peers on each side of him, expressing that as far as he was concerned, he wasn't "the shit" which his positioning on stage as a "star" of the eisteddfod suggested he might be. The other VET boys also had moments of critical purchase, although they were less pronounced. A satirical wink of the eye or smile was often an expression of their awareness of the way the school capitalized on their capacity to work cultural economies of cool. Not surprisingly, the older VET boys made dance texts

that were both more confident and more critical than those of their younger classmates. This capacity for satire was partly derived from age – the boys' advanced maturity and post-pubescent, heterosexed identities were critical resources that informed their dancing. They were "cool" and socially successful. They were aware of the level of public visibility derived from serving as figureheads for patterns of hegemonic masculinity in the school. This offered them the confidence and power to be critically engaged with their performances. Such critical engagement was not communicated verbally, but was present kinesthetically – their movements and facial expressions were peppered with flickers of satire and moments of jesting reflexivity.

In some respects, the dance teacher foreclosed critical possibilities for other students to read the critique in the boys' performance. The teacher did this through reinforcing stereotypical ideas about non-white masculinity as being of value because it embodies "patriarchal notions of cool" (Hooks 2004: 156). The teacher chose the hyper-hegemonic images of the boys breaking that were the public face of the dance program. These images were featured in positions of prominence on the school website and promotional materials for the dance program. This aesthetic pedagogy closed off space for visibility of the identities of the Koori boys who were most genuinely marginalized in the school culture. These boys were not as physically and kinesthetically adept as the VET boys. They were not confident enough to dance in front of an audience. Nor were they interested in traditional practices of Aboriginal dance. They were stuck in between contemporary dance practices they could not physically access and traditional dance forms that held no interest. The gender identity presented by the marginalized boys would have been somewhat accepted if the dance teacher had been able to present forms of masculine embodiment on stage that extended beyond the aggressively heteronormative styles of male dancing that were valorized in the school.

In a public aestheticization of localized racism, the teachers lauded the VET boys' depictions of non-white masculinity crafted through hip hop and referred to their dance performances as evidence of the performing arts program's capacity to engage marginalized boys of color. Reading these boys within the racial and socioeconomic distribution of Australian society, the employment of European Australian and Asian Australian boys as signifiers of marginalized Australian youth could be said to possess aspects of truth. However, as I have made clear, in the context of the school, those boys were not the most marginalized boys of color – these were the Koori boys. The Koori boys were most often found on the back oval, smoking, wearing

Eminem[14] tracksuits. In what must be read as an unconscious performance of racism and sexism, the VET boys were encouraged to signify on the school's deployment of breakdance as a symbol of black empowerment in two ways.

First, the VET boys overshadowed the Koori boys, undermining their status as legitimate signifiers of black masculinity in the school culture. They claimed this public act of signification as their right, effecting a political "(anti) mediation … between two forces … [which they sought] to oppose … and then reconcile" (Gates Jnr 1988: 56, author's parentheses). The boys separated hip hop in the school from the Koori boys who were marginalized. They reconciled their own status as young men of color through developing public b-boy identities. The dance teacher facilitated this process by reading the VET boys' muscular physiques and kinesthetic competence as evidence of what she saw as "successful" (hegemonic, heterosexual) masculinity. Second, the VET boys signified on this positioning of their dance practice as the figurehead for patterns of hegemonic masculinity in the school through moments of satire. These moments implied they absolutely understood their b-boy masculinity as an act, an exaggerated "imitation" of an ideal (Butler 1995: 32). This understanding of dance as a means of magnifying the imitative nature of gender shows an awareness of the fact that all performances of masculinity are a normalized form of imitation.

As I have suggested, the VET boys' work featured prominently in the school eisteddfods and was interspersed with the other student dances and musical performances. They also performed cameo moments in front of other student groups' blocks of dance moves. Of these four boys, one, who I will call Alex, was a particularly successful Asian Australian dancer and rapper. He was signed to a commercial record label during the course of my fieldwork and was the most kinesthetically competent of these dancers. Alex was one of a group of three proficient hip hop dancers who signified on their teacher's valorization of the dance style through their attitude.

Alex satirized himself through facial expressions which self-reflexively acknowledged the prowess and control evident in his breakdance. He signified on style by caricaturing his successful achievement of hip hop masculinity. Alex also satirized the eisteddfod audience and the other dancers by hyping up the crowd, beckoning to them with his hands and dancing behind the backs of other performers. He knew his battle was already won; he danced and riled

the crowd in a manner that suggested the competition existed so the audience could appreciate him.

Alex's sense of ownership and power came at a price to other students, as he upstaged their performances wherever possible. For example, three young Koori women were presenting a short hip hop/funk dance piece that had been choreographed by their teacher. It was clear from their anxious comportment and awkward movements that they weren't comfortable on stage or with the movements they had been taught. As they progressed through the piece, Alex entered the stage behind them and won the audience's attention by breaking at the back of the stage. To my surprise, the teachers as well as the students appreciated Alex's performance.

I read Alex's spontaneous performance as a sexist and racist upstaging of the shy Koori girls, whose corporeal anxiety was clearly, in part, an articulation of the embodied difficulty of occupying a position of racial and gender minority in a white patriarchal society. Alex's performance is of interest because it can be read as a commentary on the school's mobilization of dance as a technology for the production of hegemonic masculinity. In the school context, breakdance became a form of violence through which "race" was sited in ways which continued to marginalize Aboriginal students and forms of masculinity that differed from popularly endorsed visions of masculine athleticism.

The younger b-boys, the second group I introduced above, were a largely white class of year nine students. They proudly identified as "b-boys" inside and outside the dance classroom and were clearly attracted to the "battle" as a core choreographic component of breaking. As I have suggested, more than being "cool" and enjoying the physicality of dance, these boys developed their breakdance as a form of what Connell (1995) characterizes as protest masculinity – that is, a working-class masculinity in crisis that is a "claim to power where there are no real resources for power" (Connell 1995: 111). Individually, the year nine b-boys wanted to challenge each other's attempts at achieving the idealized status of the hegemonic b-boy. Collectively, they wanted to pose a challenge to the contextually endorsed masculinity of the VET boys. There is a distinction that needs to be made here, though. As my analysis makes plain, while the year nine boys danced as a form of class protest, they did so in a way that possessed some forms of cultural capital and featured an aspect of motivated signifying. This distinguishes them from the wrestling boys, whose protest masculinity was clearly subordinated and possessed no cultural capital.

106 *Do you want to battle with me?*

The first time I met the year nine boys was in a dance class in which they were blocking out[15] ideas for a battle. This exercise ended in a genuine fight, which saw a number of the participants sent home. These boys have parallels with the young men who Poynting, Noble and Tabar[16] (1999: 74) suggest are part of a

> minority ... who "take the discipline system as a challenge, especially in peer networks that make a heavy investment in ideas of toughness and confrontation." For such boys, the cultural response of "they bring me down, I'll bring them down" leads typically to devalued education or even exclusion from school – "the consequences not of a passively suffered fate but of ... vigorous response to [their] situation."
>
> (1996: 220)

For these boys, fighting was a response to their social situation. The dance floor was an arena in which their masculinity was to be shaped and proven. They were committed to breaking and enthusiastically developed a performance for the school and local community eisteddfods. This seemed, in part, to be a way of reclaiming socio-economic disadvantage through mimicking "blackness" as a popularly endorsed motif of marginalization. Their dance was composed mainly of unmotivated signifying – stock hip hop moves they performed with as much machismo as they could generate. The classroom teacher brought in a professional b-boy to teach the boys how to top rock (a genre-specific noun for breakdance moves performed on your hands). The boys were delighted and incorporated athletic toprocks into their reproduction of a breakdance routine of down rocks, detailed footwork, spins, and freezes.

Through rehearsing with these boys as they crafted their protest battles, it became evident that the "blackness" of hip hop in their imaginations operated as a way of legitimating their experiences of being and becoming working-class young men. It was a grasp at a patriarchal dividend.

Signifying on b-boying occurred in this group through the work of a young, chubby Greek boy whom I call Mario. Mario's movements offered comic reflections on his classmates' investments in producing tough masculinity through dance. His body and the bodies of the others in his group constituted the grounds on which his critique occurred. Mario's critique was a cameo moment. In the midst of the year nine boys' dance piece that cited dominant tropes of

"hard" masculinity, Mario presented a gem of motivated signifying. He spontaneously developed a "Biggie Smalls" style dancing fat boy routine. For those unfamiliar with the figure, Biggie Smalls, or "The Notorious B.I.G.,"[17] was a black North American rapper who was large in stature. He was a central figure in East Coast[18] hip hop and has become a representational motif for larger boys and men in the movement.

Mario's signifying consisted of krumping repeatedly. Through his facial expressions and repeated eye rolls, he satirized the fact that his stomach and chest wobbled while he krumped. His cheeky awareness of the juxtaposition between his stature and physique and the aggressively athletic act of the krump was the source of much humor. In the midst of a group of boys earnestly fighting to prove the toughness of their masculinity through breaking, the least athletic of these boys critiqued the act of performing (and even subscribing to) such hegemonic ideals. Mario was the "motivated signifier," the monkey, in the group. The hilarity that he generated about the (im)possibility of embodying the stereotypes of masculinity associated with krumping operated as a friendly critique of the desires for hegemony displayed by those dancing beside him. He physically articulated the sentiment advanced in the monkey's jest to the lion, expressed in Gates Jnr's recounting of the ape's taunt: "… while I'm swinging around in my tree … I ought to swing over your chickenshit head and pee. … " (1988: 56). Mario metaphorically laughed at his classmates while they battled. For most of the school b-boys, then, dance performance provided a space in which they worked their bodies as "arenas" (Connell 2000: 12). Thanks to the small dancing fat boy, this conservative forum for crafting and presenting masculinity provided a home for a cameo critique of the ideals and hierarchies of masculine physicality on which it depends.

In the remaining sections of this chapter I discuss the work of two very different groups of dancing boys. The first of these is the third and final group of schoolboys, who developed dance practices that served to recuperate their subordinated masculinity and regulate their sexuality (Mac an Ghaill 1994). These boys presented alternative modes of masculine embodiment and modeled their battle dances on the television franchise World Wrestling Entertainment. The other group was composed of Sudanese refugee boys who danced in the community education context. These boys chose to develop dance practices that had little to do with their gender identity. I begin with the schoolboys who developed a dance based on World Wrestling Entertainment.

The geek's revenge: World Wrestling Entertainment and fantasies of hegemony

The third group of schoolboys who crafted a battle dance piece did so through a very different stylistic aesthetic from the breakdancers. These were the year ten students whom I introduced at the beginning of the chapter as displaying subordinated, protest masculinity (Connell 1995: 109–14). These boys are analogous to those who McDowell describes so evocatively as

> young men [who] misbehaved, messed about, caused havoc in the classroom and were constantly in conflict with their teachers … at school an alternative narrative also underlay their self-presentation, one in which there was some recognition of the function of a "devil may care" attitude as self-protection. It became clear that most of these young men had a clear sense of the ways in which they were regarded by their teachers and by their more conventionally successful peers. They had not failed to recognise their classification among the "low achievers" and its consequences.
>
> (McDowell 2002: 108)

These boys would pull out pornographic magazines and ask for my "opinion" on explicit sex scenes; they stole my rehearsal music CDs, and one of the boys would spontaneously place one hand over my mouth and pretend to kiss me while actually kissing his hand. They were proud of being subordinated and they were naughty. In their daily school experiences, these boys were shy of girls, but they recuperated their sexual anxiety and subordination within hegemonic patterns of gender through public displays of their pride in their capacity to cause disruption. Their gender identity, their behavior at school and their dance practices were articulations of subordinated protest masculinity: they were limited attempts at fighting back.

The project I undertook with these boys involved them choreographing and performing an original dance work that fulfilled curriculum assessment requirements. They did so quite successfully. This was quite an achievement, as each struggled to engage with the school context. Indeed, each of the boys left school the following year. These boys were not able to embody the b-boy masculinity required to achieve success in breakdance and presented very different kinds of masculinity from those performed by the other male dance students, who were distinguished from the wrestling boys by their bodily

confidence. Their dancing and their masculinity were consistently maligned.

Like all the dance students, the wrestling boys had chosen dance as an elective. Unlike some other students, they attended school regularly. I call these boys John, Scott, and Mike. John was a young Koori man who was substantially overweight.[19] Scott and Mike were of Anglo Australian heritage; they had slight frames and were short and very thin. Mike was in a band called "The Muffin Man??" [sic] and was heavily invested in his cultivation of an Emo[20] aesthetic. Scott was the biggest sports fan of the three. This taste expresses his alignment with dominant Australian tropes for performing masculinity, a difference that marked him out from the other boys with whom he danced. Scott loved cricket, soccer, and Australian Rules football, but also enjoyed wrestling. He had short spiky hair and usually dressed in soccer t-shirts. Halfway through the year, Scott bleached his hair. He was humiliated by the attention this caused. Despite the fact that his identity negotiations were marked with an awkwardness that is common for adolescent boys, Scott possessed the most popularly endorsed forms of social and cultural capital. The facts that he consciously negotiated his identity and that he undertook this process in relation to popularly endorsed gender ideals were indicators that he was able to perform a kind of gender identity that was more widely accepted in his school than the other boys in his group.

These boys were apathetic about most things; they were naughty at school and comprehensively invested in risk taking. Together we developed a dance based around the theme of "World Wrestling," which, as I have suggested, was modeled on the television franchise World Wrestling Entertainment Inc (WWE).[21] The boys loved spectacle, noise, and aggression – partly, it seemed, because it took them away from their daily experiences of self as unspectacular members of the school community. The choice of "World Wrestling" as a theme for their dance can be read as an attempt to recuperate their masculinity by making themselves more spectacular, aggressive, and "macho" on the dance floor than they were when off it.

Unlike the b-boys and rappers who are role models for gangsta masculinity, the stars of World Wrestling Entertainment do not appear, or even try to be, "naturally" cool. Quite the opposite, WWE wrestlers have to try hard to be what they see as successful men. They openly celebrate their achievement of masculinity. When one beats another in a wrestle, they are clearly overjoyed: the winner jumps up and down and yells with excitement. The kinds of cool comportment required from b-boys or rappers would never stretch to allow for the

portrayal of that much emotion. For example, if a b-boy or rapper were to win a dance or rap battle, their likely response would be that victory was expected, deserved, and clearly the appropriate result.

I took up a game that these boys played regularly as a catalyst for choreographic processes. It consisted of mock fighting and extended, homoerotic wrestling. The game was a means by which the boys regulated same-sex desire and offered a window on the fact that "[h]eterosexual identity formation is a highly fragile, socially constructed phenomenon" (Mac an Ghaill 1996: 195). The boys would begin by putting each other down verbally, with statements such as "John, you fucken' poofta, what are you doin' man?" They would then embrace in a wrestle, fall to the floor, roll around, and hit each other. One of the boys would finally grab another in a lock from which they could not escape, and this would signal the end of the bout. At this point, the captured partner or wrestler would yell at the others to "get off of" him. The erotic moment of the wrestle now behind them, these orders usually involved "accusations" of homosexuality.

Typically, John, the largest of the three, would be the dominant fighter and the winner. For him, perhaps most obviously, the fight was a negotiation of sexuality and gender identity. It brought a chance for homoerotic intimacy together with the machismo he associated with being a "straight man." In order to equate homosocial desire with play, John configured moments of homoerotic intimacy around childish behaviors: flatulating,[22] giggling, and teasing. On one level, then, these fights were an attempt at recuperating his heterosexually identified, postpubescent subordinated protest masculinity. However, they were also a means of exploring homoerotic desire that John made safe through performing the subjectivity of a child. All the boys who participated in the game clearly wanted to be physically close and this closeness was a complicated and erotic space for them. During the fights, they pretended to have sex either with each other and/or with the floor.

Apart from the fact that the boys clearly liked this game a lot, one of the reasons the game seemed important was because it was the only time I had seen adolescent boys in the school space express sexual desire for each other. Second, the game was important because the boys played it as often as they could. For these reasons I thought it was a good place from which to start dancing.

The boys' mutual appreciation of WWE also suggested to me that they read the televisual text as a staging of homoerotic desire that,

in a similar fashion to their classroom fights, allowed for an exploration of same-sex desire which could be written over (made safe) by popularly endorsed heteronormative ideas of masculinity. The boys seemed to imagine they were increasing their masculinity by aligning themselves with the muscled bodies of WWE wrestlers. This gave them license to explore facets of their subjectivity usually abjected from the school space and curriculum, if not from their social worlds more broadly.

The school dance teacher asked if, as part of my research, I could choreograph a performance piece for these boys to perform at a large community eisteddfod and an interschool dance competition. In order to meet the curriculum assessment requirements, the dance needed to display particular choreographic features, including diagonal lines, a lift, floor rolls, solos, and duets. After considerable effort, we were able to structure the ritual play-fight into a dance piece in which the boys not only achieved the requisite compositional aspects of the choreography, but during which they delighted in performing the persona of a wrestler taken from the WWE stable of celebrity wrestlers. I built a wrestling ring as a set and the boys made their own costumes. We edited a soundtrack of music taken from WWE and, like the performers in televised wrestling, each of the boys chose entrance and exit music.

On the day of the community eisteddfod, the boys' fathers came from work to watch them perform. They were timetabled last, after three hours of other performances, which were predominantly breakdance and funk routines. Each of these routines presented what read as an explicitly heterosexually styled approach to co-educational interaction. The occasional primary school choir piece or "sexy cabaret" piece for girls broke up the stream of hip hop and funk performances, although the unifying feature of each of these acts was a clear alignment between the performing body and the dominant, gendered, and racialized "genre" in which the body was being schooled.

For example, the costumes in which the teenage girls performed cabaret suggested a very specific schooling in being a female body on the stage, at the same time as they recreated a popularly recognized genre. Like the teenage girls performing cabaret, b-boys breaking offered an easily recognizable relationship between genre, student, and gender identity. The wrestling boys did not offer such a clear alignment. While they were attempting to recreate heteronormative performances of masculinity, the materiality of their bodies and the residues of the homoerotic processes through which they devised

112 *Do you want to battle with me?*

the material ensured that the WWE dance constituted an outside to dominant patterns of hegemonic male identity in the school.

By the time the WWE performers took the stage, the school day was almost over. The program had been held up by earlier acts running over time and some technical problems. School buses had arrived to collect audience members. The wrestling boys were only halfway through their dance when the sound and lights were turned off and the attending students from district schools began to leave. The boys cut to the end of their performance and undertook their "exits" with gusto, in silence, on what was by then an unlit stage.

The teachers and students filed out, having just applauded what could be read as an extended stream of unmotivated signifying which featured numerous young men performing b-boy moves. To the extent that they possessed the capacity to perform b-boy identities convincingly, many of the boys breaking seemed interchangeable. There was an uncritical appreciation held by both teachers and students for this achievement of hegemonic gender identity. This appreciation was detrimental to those who occupied less socially valorized gender identities. While the wrestling boys created their dance as a piece of assessment that was mandated by the curriculum, neither the schoolteacher responsible for the timetabling nor the audience at the eisteddfod took their performance seriously enough to watch. These boys were not deemed fit for the school publicity postcard. They showed the labor and struggle that can be part of embodying a gendered identity.

The school dance program valorized the affective politics of b-boying as a form of socially marginalized masculinity that had worth because it is a practice based on publicly endorsed tropes. The masculine style of b-boying was read as signifying social disadvantage through citing blackness as cool (Hooks 2004). Through the dance curriculum, the celebration of Koori culture and a multicultural, working-class student demographic became an uncritical appreciation of mainstream hip hop aesthetics. This valorization not only limited possibilities for how young black men were encouraged to succeed, but also created a chasm between the subject position of the hegemonic b-boy and other male identities in the school.[23] This left those like John (the large Koori boy involved in the WWE dance) scrabbling for some form of visible identity and literally left on stage in the dark.

In contrast to the choreographic focus on "battling" that came to characterize my work with schoolboys, the Sudanese boys in the

community education setting were afforded a more relaxed attitude to dance because they were not required to publicly perform. Their approach did not lead them to explore movement as a vehicle for identity work.

Dancing and filming with the lost boys

As I have suggested, the boys involved in the community dance program were Dinka young men who had migrated from Southern Sudan. They had left a nomadic lifestyle that supported a pastoral, agrarian economy and were learning to embody the fairly sedentary life and capitalist economy of the Australian suburbs. Along with the speeds, sounds, senses, and economies of daily life, the belief systems that underlie the society in which they live had radically changed.

To extend the discussion of Appadurai which began in chapter three, these boys can be considered part of an "ethnoscape," or shifting landscape of people, that is characterized in mediascapes as "the lost boys of Sudan" (Mylan and Shenk 2003; Eggers 2006). The phrase "the lost boys" was developed by international aid organizations to refer to refugee young men who left Sudan after the second Sudanese civil war.[24] As a noun, it is employed to name the 27,000 (plus) boys from the Dinka and Nuer who were displaced or orphaned during the war. The young men involved in the community education programs I ran were part of this moving scape of people.

The ethnoscape of the lost boys is distributed across North America, Canada, and Australia (Department of Immigration and Citizenship 2007). Their depiction in mediascapes constructs a sensibility of masculinity based around what are often fairly romantic ideas of struggle, survival, and strength.[25] Mediascapes of the lost boys are composed of texts such as the documentary films *The Lost Boys of Sudan* (Mylan and Shenk 2003) and *God Grew Tired of Us* (Quinn and Walker 2006), the books *Echoes of the Lost Boys of Sudan*[26] (Singleton 2004), *The Journey of the Lost Boys* (Hecht 2005), *What is the What: the autobiography of Valentino Achak Deng* (Eggers 2006), *The Lost Boys of Sudan* (Bixler 2005), and *They Poured Fire on Us From the Sky* (Deng, Deng, and Ajak 2005). Through images and words, these texts unpack the trauma and displacement experienced by young male Dinka refugees.

As I explained in the introduction, I began my work with the Sudanese boys by playing soccer with them once a week. After spending months building trust through my involvement with this game, we planned our dance workshops as a group. At the boys' request,

our workshops combined film, face painting, gymnastics, and dance to explore styles and sounds presented in *RIZE*. Of the boys, four were primary school age, ranging between eight and eleven years old. Others were older – between fifteen and nineteen. There were usually nine boys who attended the dance workshop. These boys painted their faces like clowns and krumpers. They loved using the video camera and their filming was incredibly fast paced. They had a frenetic but playful energy and their video footage was analogous to their movement styles. In contrast to the violent depictions of Sudanese masculinity that feature in the dominant media discourses of Australian black panic characterized in chapter two, these boys were playful, gentle, and did not want visibility in their local public sphere. They did not want to make a public or overtly respond to a public. As such, they chose not to work towards a performance.

These boys had never danced before and were surprised to learn that they enjoyed dancing for recreation. They chose to film their dance as a way of experimenting with the production of subjectivity. Rather than b-boying as a means of citing or signifying on a masculine or racialized identity, the Sudanese boys danced as a means of experimenting with feeling their bodies. B-boying offered a way of becoming a less constrained, less competitive, kind of young male subject and created space for new "kinds of embodied selves [which emerged] around, within and between stories" (Gard 2006: 113). There are two points I want to make about this, both of which suggest the dance practices of the lost boys had elements that offer an outside to the school b-boying I discuss above.

Firstly, while the Sudanese boys chose to dance hip hop as a way of playing within a popular cultural space with which they implicitly identified, they were not trying to dance in a "masculine" style. On some level, the school-based groups of b-boys and the wrestling boys danced as a way of increasing, redeeming, or proving their masculinity. This imperative was partly a response to the requirement that they perform in public and the positioning of eisteddfod performances as statements about identity. The role that dance plays in increasing or diminishing men's gendered identities is an enduring concern for male dancers (Crawford 2008; Ramsay 1995). For the schoolboys, b-boying was the only possible "dance style ... which was like an Afro style that men felt very safe in" (Gard 2006: 129). I encouraged them to incorporate aspects of traditional male Sudanese dance, but these were not of interest to them. Nor were other styles of dance I presented via YouTube clips, video, or images. I compiled color booklets about the traditional roles of men in Sudanese folk

dance as resources for the boys, although they were more interested in exploring dance media of their own choosing.

Rather than offering the boys a platform for working on their masculinity, or publicly proving their identity, dance gave these boys a way of being which they found enjoyable and curious. It is interesting that they chose breakdance for markedly different reasons to the schoolboys. As I have suggested, b-boying is popularly thought as "black boys' dance"; this public visibility is both a signifier of the cultural capital the dance holds and, I would suggest, the reason why breakdance was part of the boys' consciousnesses. Like the Sudanese girls, they had no interest in "traditional" Sudanese dance forms; unlike the girls, however, dance held appeal for them simply because it was presented as an option in a recreation program – the boys didn't dance outside their involvement with the dance workshop series. Reflecting the broader cultural feminization of dance, they saw b-boying as "fun," whereas their commitment to soccer was much more serious.

Due to its contemporaneity, these boys also had an interest in the documentary *RIZE*. In contrast to the schoolboys, the Dinka boys did not dance as a technology for gendered identity production or as a means of context-specific satire. In spite of this, their choice of style suggests that even though their dance practices did not reflect a substantial subjective investment in dancing, and while they certainly did not want to acknowledge it, they were fitting in with what they saw as a popularly accepted, cool form of black masculinity (see Savage and Hickey-Moody 2010). This, in itself, needs to be read as a kind of cultural pedagogy that calls Sudanese boys living in Australia to fit in on some level with the popular, racist overcodings of the ways young black youth might be of value to Australian culture. This cultural capacity to "assimilate" through aesthetic forms was identified by Hebdige (1979). There are clear parallels between the Sudanese boys' dance and Hebdige's explanation that

> patterns of rejection and assimilation between host and immigrant communities can be mapped along the spectacular lines laid down by white working-class youth cultures. The succession of white subcultural forms can be read as a series of deep-structural adaptations which symbolically accommodate or expunge the black presence from the host community. It is on the plane of aesthetics: in dress, dance, music; in the whole rhetoric of style, that we find the dialogue between black and white most subtly and

comprehensively recorded, albeit in code. By describing, interpreting and deciphering these forms, we can construct an oblique account of the exchanges which have taken place between the two communities.

(Hebdige 1979: 44–5)

It is exactly such a symbolic form of accommodation that has seen hip hop style and b-boying gain the kinds of popular currency that have lead to films such as *RIZE* and festivals such as *Scribble Jam* becoming successful parts of popular culture. As I have argued elsewhere (Savage and Hickey-Moody 2010), in a cultural pedagogy of racism, hip hop aesthetics are associated with global flows of masculinized gangsta culture, or performances of racialized masculinities which "fit in" with gangsta style. Such performances of masculinity have often become the sites of moral panic about youth. As I argued in chapter two, these moral panic discourses are forms of governance.

In the instance of Sudanese refugees living in Australia, such media narratives are often developed as a means of attempting to demonstrate failure to integrate into "mainstream" (white) culture and, as Windle (2008) argues, are often a means of linking Sudanese youth to depictions of traditions of violence. Such narratives also become a way of characterizing boys as part of a larger "problem" group of Sudanese men. While these discourses are significant in the respect that they illustrate a dominant means through which Sudanese people living in Australia are positioned in the national cultural imaginary, the ways the Sudanese boys danced hip hop had little, if anything, to do with the qualities identified within media moral panic discourses.

If we consider these popular media discourses of hip hop and school curriculum imperatives to perform in public as respectively institutionalized and individual forms of governance, the ways the Sudanese boys danced outside these imperatives for governance were notable. While the fact that hip hop was the only dance style the boys had any interest in can be understood as an articulation of broader structures of racism as they are taught through culture, the agency these young men displayed through not wanting to create a public and through b-boying in a non-aggressive, curious, playful way are styles of engagement that demonstrate desires not to build and maintain hegemonic patterns of masculine identification.

Offering a non-verbal response to the dominant discourses of black panic through which they are predominantly understood in the Australian popular cultural imaginary, the Sudanese boys were

the most experimental and creative hip hop dancers with whom I worked. They did not "battle" and they offered very different models of black marginalized masculinity to the aggressive forms featured in their inspirational American documentary *RIZE*, as well as the local media discourses surrounding them. Indeed, these boys shied away from achieving cultural visibility through being "gangsta" and, rather, could be seen as "black males [who] turn away from patriarchal notion of coolness" (Hooks 2004: 156). Their dancing was quotidian; it was an everyday, suburban Australian, non-aggressive, and unselfconscious experiment with newness. On one level, the boys could be read as unconsciously doing what Bell Hooks refers to as quietly choosing "life over death" (Hooks 2004: 159). Amidst a culture that applauded public celebrations of breakdance, they declined the invitation to receive such public approval.

The incitement to public visibility that can be undertaken through involvement with hip hop or the performance of gangsta masculinity was a part of these young men's cultural contexts which they chose to ignore. Going against a range of ways breakdance might be made more "masculine" – by battling, by performing in public, or even by making a structured work – these boys chose to play, not to be structured, and enlisted technologies such as the video camera, which they used experimentally, and face painting, which was clearly a way of enhancing their identity play. For the Sudanese boys, dance was a practice of feeling in their bodies, rather than a practice of making social faces.

The stories of the boys' dances which I have told in this chapter offer illustrations of two very different modes of engagement with the form. The schoolboys' dance practices show how dance can be a way of both producing and mediating very public, gendered, and racialized identities within school communities. These practices are learnt through forms of popular and public pedagogy. They have a regulative aspect – namely, the fact that they are about the public display of identity. This reflects the governmental function of schools in young people's lives. In marked contrast to the kinds of identity work undertaken by, and the cultural politics of, school dance, the Sudanese boys' choice to dance as a way of feeling their bodies presents dance as possibly an "everyday" activity, and the practice of dancing as one not necessarily entwined with spectacle or public identity. While for the schoolboys, the imperative to perform publicly became linked to the battle as a signifier of masculinity, the governmental function of public performance as mandatory curriculum assessment is made plain when held alongside the more radical

choices of the Sudanese boys – who, when liberated from having to "prove" masculinity, developed a style of breakdance which did not feature a battle.

In the discussions of boys' dancing undertaken in this chapter I hope, amongst other things, to have advanced three particular lines of argument. Firstly, I have shown that dance can be a technology for the production of gendered and racialized identities. When undertaken through curriculum imperatives to perform in public, the call to battle became an imperative to perform gender identity in all instances of the schoolboys' dance. Through the concept of signifying, I have shown that the schoolboys with the most cultural capital have been able to critique the school culture's investments in them and in the contextual success of their dance. Signifying on breakdance, some of the schoolboys were afforded moments of critical agency in which they satirized the hegemonic patterns of masculinity favored within the school. Not all schoolboys were afforded this power; the story of the WWE dancers is one of a couple of threads that are woven throughout the chapter to show how the politics of school dance worked to consistently privilege hegemonic patterns of gender identity. Finally, the story of the Sudanese boys offers a discursive outside to the conservative school dance practices. Through working very selectively within their chosen genre (choosing not to battle, only taking up aspects of clowning and krumping that appealed), the "lost" boys reframed popular uptakes of b-boying and, more importantly, offered an alternative to the ways they are commonly presented in the Australian media. Here, dance was about feeling, not showing. If dance can be a way of making and displaying racialized and gendered identity, then it can also be a means of undoing exactly such constructions.

5 Affective pedagogy
Reassembling subjectivity through art

Ramces, a young French-born Lebanese man, stands with his back against a graff wall, arms crossed. He explains that "[r]ap is like the artistic intifada … I am hip hop, hip hop is me" (Secker 2010). This statement bringing genre and identity together is partly reflective of Ramces' investment in rapping, producing, and writing. He also beat-boxes, breakdances, and is actively involved in emerging aspects of the Palestinian street art scene and hip hop culture. For many of the youth who comprise the ten percent of Palestinians living in Lebanon,[1] hip hop offers a site where they can express resistance to dominant political regimes in non-violent ways. More than this, though, the Lebanese hip hop movement is a localized example of the global nature of art-based, affective communities. Through bringing styles that were developed in New York boroughs in the 1970s together with contemporary Middle Eastern, French, European, and British rap and MC practices, Lebanese youth involved in the hip hop scene make political comment through sound and style. For example, lyrics written in Arabic and tracks featuring traditional instruments from the region bring sounds that articulate Palestinian culture into listeners' daily lives. References to significant Palestinian poets, artists, and leaders are made through lyrics and samples that suggest political intervention carried out in non-violent ways. These are just a couple of instances in which young hip hop artists make, or attempt to make, political interventions in their listeners' subjectivities by presenting sounds, languages, and stories of Palestinian youth that are usually omitted from daily life in Lebanon. Here, in ways that have parallels with the other examples of young people's arts practices discussed across this book, we find young subjectivities being changed through local articulations and adaptations of global texts. While Ramces clearly sees himself as an activist, the landscape in which

his activism occurs and the processes of creation it effects are formed through a coming together of two cultures: global hip hop culture and local Palestinian activist art. Respectively, both cultures – a broadly defined, often very commercially oriented and corporately run global hip hop culture, and generally more localized activist forms of art – can constitute spaces through which young people attempt to effect change in others or broadcast political statements through art. When successful, this modification occurs through the politics of aesthetics rather than institutionalized or legislative structures. Larger changes that ensue from this – such as modulations in institutionalized or legislative structures – happen later, after the affect of art has created pathways and connections between subjectivities and communities.

For example, Palestinian graffiti street art affectively articulates the stories of young detainees through images and slogans. This artwork often features "intifada" stencils, which serve to symbolically reclaim spaces that have been "cleansed" of Palestinian occupation. Alongside street art, languages, sounds, and samples used in Palestinian hip hop music bring histories and cultures into local contemporary cultural imaginaries. Both examples illustrate the fact that art can be a vernacular, accessible way of making invisible peoples, histories, and acts able to be seen. Through expressing aspects of a people's aesthetic subjectivity via hip hop and street art, Palestinian culture and the people for whom it speaks live on with new levels of visibility and possibilities for political purchase.

This capacity of art to effect a movement from invisibility to visibility, to make stories and publics, is a critical cultural function. It is how youth arts work as forms of popular and public pedagogy. Through the examination of three little publics created by youth art, in this chapter I consider some ways art can be thought to reassemble subjectivity through affect. I offer three examples that illustrate how art can articulate new images of youth who are commonly represented in popular culture in ways that reinscribe marginalization. More than this though, I begin to think through how young people's atypical readings of popular culture and different forms of youth taste and style illustrate the fact that culture works as pedagogy. As suggested by Grossberg (1997), taste and culture are forms of affective pedagogy that young people mobilize to make social and political possibilities. He argues:

> [a]n affective pedagogy [is a] pedagogy of possibilities … It is a pedagogy that aims to not to predefine its outcome (even in terms

of some imagined value of emancipation or democracy) but to empower its students to begin to reconstruct their world in new ways, and to rearticulate their future.

(Grossberg 1997: 387)

In this chapter I consider some examples of what such an affective pedagogy might look like. I focus on interdisciplinary places of learning that bring communities which are often socially separated together through informal educational sites, engagement with creative professionals and industry. Such a cross-disciplinary focus extends understandings of the educational, social, and economic benefits associated with youth arts. I advance this project via theoretical means that open up discursive spaces for discussing the politics of pedagogy, forms of aesthetic citizenship, and processes of fostering creativity in youth that occur through youth arts. Specifically, I take up Deleuze's idea of differentiation as the creative becoming of the world to theorize case studies of the work of two UK arts companies and one Australian youth arts company, each of which state their intention to support or encourage creativity in young people. Through the concept of differentiation, I show that the various forms which the act of fostering creativity might take are often processes of magnifying uniqueness. These processes are effected by affect. To put it another way: affect is the modulation through which art works.

This examination of the pedagogy that occurs through art advances my suggestion that discussions of popular and public pedagogy need to be utilized as a way of opening doors for more theoretically diverse considerations of pedagogy in education and cultural studies. When it comes to understanding the politics of young people's reading practices and the ways that cultural forms teach us about youth, we need to think seriously about how the resources of cultural studies might continue to inform the work of theoreticians in education. Broadly, two sets of questions arise from Grossberg's (1997) writing on affective pedagogy. The first of these relates to reading culture as pedagogical and asks us to consider the ways culture imbues but also critiques ideology through material forms and style. The second relates to classrooms and pedagogy as something that happens in classrooms. Both sets of questions can be reframed in terms of contemporary discussions of affect and research questions at the heart of contemporary cultural studies after what Papoulias and Callard (2010: 29) refer to as "the turn to affect." My concern here is with reading culture as a kind of pedagogy and considering the ways culture imbues but also critiques ideology through material forms and

style. Public art with young people can be an important part of this critique. I have considered the turn to affect in terms of classrooms elsewhere (Hickey-Moody, Windle, and Savage 2010; Hickey-Moody and Crowley 2011). I have advanced this line of inquiry through theorizing the embodied complexities of learning through culture in school. This is clearly a line of investigation that warrants further thought, as studies such as Watkins' (2012) nuanced and insightful investigation of the embodied nature of literacy practices makes plain.

Deleuze (1970), Tomkins (1962/1992), and Sedgwick (2003), along with others such as Seigworth (2003), Gregg (2006), and Watkins (2012), take up affect to offer a validation of the practical. I maintain that this consideration of affect in bodies and scholarship has the potential to inform a reading of culture as pedagogy. The roles of art made by youth and public art made for youth in this reading can be seen as a further articulation of what Grossberg (1997) terms "affective pedagogy." Grossberg later claims that the turn to affect needs to be continued with caution; that scholars should to pay attention to "specifying modalities and apparatuses of affect" (2010: 315). The concept of affective pedagogy provides one way this can occur. It can articulate exactly how, as a modality of affect, art made by and for youth affects culture. The various forms that compose youth art as a modality of affect define their affective nature: eisteddfods teach popular ideas of "youth performance" to school community viewing publics; street art modulates landscapes for urban publics; community youth arts centers make art that presents young people to local community in ways that extend the modes of representation attached to their existing social roles. Art offers one instance of culture as affective pedagogy that is critically mediated by youth taste but which also has – and makes – little publics.

The processes of making and consuming art constitute forms of aesthetic citizenship, of belonging to community through style. These processes of belonging rely on affect. Deleuze's idea of "differenciation" is a tool with which we can better understand the material intensifications of uniqueness, the different modes and apparatuses, through which art makes affect. Such affects variously involve youth; they change the ways youth are engaged by different publics and alter how young people feel about themselves. Along with Deleuze's notions of affect, thinking through differentiation can illustrate how youth arts work as forms of popular, public, and cultural pedagogy. These are the processes that make little publics: civic spaces in which youth voices are heard through art and/or performance. Through

Deleuze's concepts of differentiation and affect, we can see that the material products of youth cultural practices, such as dance texts, stencil art, or music, can refigure individual subjectivities as well as augment the dominant storylines about youth told through popular and more localized media.

Differenciation (Deleuze 1968: 207–21, 245–7, 249–51) is the material power of art to magnify difference, uniqueness, or what we might think about as individuality. It is a concept that explains how material changes are effected through aesthetics. Differenciation works with, or is built on, Deleuze's ontological model of inherent difference. This position can be employed to suggest that each young voice, articulated through music, visual art, or performance, matters precisely because it is different. The value of each voice is increased as it is magnified through creative process and product. In *Difference and Repetition* (1968), Deleuze makes an argument for creativity as the way that the world continually becomes *different from itself*. This process of becoming different is called "differenciation" (1968: 207, 245, 249) when it occurs in relation to material conditions. Differenciation is the physical process through which things become different from themselves in a magnification of uniqueness. On the other hand, "differen*t*iation" (1968: 207), the twin concept advanced by Deleuze, is a process of virtual change that is effected when things are conceived differently.

For example, the qualitative alteration of the idea of how a young black subject as "citizen" might be known and valued is a kind of differentiation or virtual distinction. The materiality effecting this change – the actual image or dance piece that presents the young black subject differently – is an example of differenciation. This materiality of becoming different, of change – differenciation – takes on a particular role in art. Art is a way of making material differences with meanings that are particular to the communities who make them and the places in which they are made. In explaining how art works as a way of magnifying voice, Deleuze suggests that the

> object of art is to bring into play simultaneously all these repetitions, with their differences in kind and rhythm, their respective displacements and disguises, their divergences and decentrings; to embed them in one another and to envelop one or the other in illusions the "effect" of which varies in each case. Art does not imitate, above all because it repeats; it repeats all the repetitions, by virtue of an internal power (an imitation is a copy, but art is

simulation, it reverses copies into simulacra).[2]

(1968: 293)

This passage explains differenciation, or material change, as a theory through which we might better understand the political aspects of how art intensifies uniqueness. Deleuze describes this process of intensification as "individuating difference" (1968: 38). In the instance of young people's arts practices, processes of individuating, of magnifying, difference happen through the material products of arts practices and the politics of style; through the ways young people read and reproduce popular culture and how their artworks inform contemporary cultural imaginings. Because of the radical differences in context that characterize locations in which youth arts are made, their material products can often articulate very different kinds of youth voice.

Together, Deleuze and Guattari (1991: 165–6, 196, 168, 176–7, 211) characterize the act of art making the invisible visible as "fabulation." As a process of effecting movement from virtual to the actual – a process of differentiation and differenciation – fabulation is how art allows young people to "begin to reconstruct their world in new ways, and to rearticulate their future in unimagined and perhaps unimaginable ways" (Grossberg 1997: 387). Fabulation is a series of occurrences that makes a "monument," a material form that presents an aspect of the world in a new light. Deleuze and Guattari explain:

> It is true that every work of art is a *monument*, but here the monument is not something commemorating a past, it is a bloc of present sensations that owe their preservation only to themselves and that provide the event with the compound that celebrates it. The monument's action is not memory but fabulation. ... [A] complex material that is found in words and sounds [...]
>
> (1991: 167–8)

Fabulation is the process by which "monuments" are made and is how art presents visions of possible difference. It articulates young voices through the materiality of art. It makes space for the possible futures art creates. Deleuze and Guattari explain:

> Creative fabulation has nothing to do with a memory, however exaggerated, or with a fantasy. In fact, the artist, including the

novelist, goes beyond the perceptual states and affective transitions of the lived. The artist is a seer, a becomer.

(1991: 171)

Differentiation and differenciation, creation in the actual and the virtual, are brought together through fabulation. It creates possibilities, both in terms of offering new qualitative senses through which people, things, or issues might be known, and through calling into being possible future trajectories associated with the specific qualitative states produced through art.

The concept of the monument, as an idea that articulates the specificities of the artifact that produces senses and futures, provides grounds on which to read "art" as a pedagogy of youth and a material expression of citizenship based on style. The implications that the idea of fabulation has for thinking about art are that projects can only be seen to have made "art" if they create a set of sensations, or ways of relating to young people through art, that do not reinforce stereotypes or re-tell dominant popular narratives. Such a definition brings together popular notions of "high" and "low" art in instances where a sense or idea of a young person is created, or via which a young person understands themselves differently through the consumption of art. A product does not stand as art because it is created by an artist as "art": it is only art when and *if* it makes a new aesthetic sensibility connected to youth.

This means that youth art, regardless of whether or not it is made in or out of school, makes subjectivities through fabricating speaking positions, new "I's": "[T]his *I* is not only the 'I conceive' of the brain as philosophy, it is also the 'I feel' of the brain as art. Sensation is no less brain than the concept" (Deleuze and Guattari 1991: 211). The fact that art makes speaking positions through monuments illustrates the fact that cultural processes are pedagogical. They involve dialogues between individuals and institutions and mobilize affect as a form of cultural pedagogy in ways that highlight how art teaches cultural difference. Advancing this line of thought elsewhere (Hickey-Moody and Crowley 2011; Hickey-Moody, Windle, and Savage 2010; Hickey-Moody 2009b), I have argued that Deleuze's concept of affect, of embodied becoming in relation to an experience or encounter, renders the materiality of culture a kind of pedagogy. I read Deleuze's concept of affect as he advances it with Guattari (1980, 1991) and in his books on Spinoza (1968a, 1970) to describe embodied change, and also as a methodology for understanding how art works.

Affective pedagogy

The lived experience of learning is always affective; whether learning how to conjugate a verb in a classroom (Watkins 2012) or how to dance in a nightclub (Henriques 2010), our bodies and their affective registers are the flesh of pedagogy. Sandlin, Schultz, and Burdick (2010: 32) acknowledge this in their analysis of existing literature on public pedagogy. They situate the role of affect and the body in learning in relation to the work of Elizabeth Ellsworth, contending:

> Like Ellsworth (2005), many ... scholars ... focus on forms of learning existing beyond the dominant focus on language within most formal educational sites. These learnings elevate body, position, and affect to serve as direct modes of address, rather than tangential *learning styles* to be deployed as an accompaniment to the *real* education inherent in illocution.
> (Sandlin, Schultz, and Burdick 2010: 32)

As I have intimated, exactly what "affect" is taken to mean varies depending on the theoretical lineage a theorist cites through using the term (Gregg and Siegworth 2010). Deleuze's notion of affectus as "an increase or decrease of the power of acting, for the body and the mind alike" (1970: 49) provides a way of thinking through the material changes that occur before a feeling is generated or a response to a situation or subject is assembled. Deleuze expands this fairly broad framework of affectus as an increase in the power to act (*puissance*) for the body and mind, through explaining affectus as the noun he gives to the superstructure or foundation on which emotion is built. Affectus is the virtuality and materiality of the increase or decrease effected in a body's power of acting, on which – or as a result of which – feeling grows, or is built. The architecture of emotions is based on affectus; it effects shifts that choreograph a superstructure of feeling and relationality:

> The *affection* refers to a state of the affected body and implies the presence of the affecting body, whereas the *affectus* refers to the passage [or movement] from one state to another, taking into account the correlative variation of the affecting bodies.
> (Deleuze 1970: 49)

Deleuze, then, reads feelings as expressions of the fact that a body has been affected. If a body has been affected, it has been changed in some way. As the materiality of change, affectus maps "the passage from one state to another" which occurs in relation to "affecting

bodies." As such, any discussion of affect is, in some way, about the relationality of the body. The theorists cited above have already advanced discussions of affect as part of an agenda to consider the ways culture as pedagogy implicates, and is informed by, embodied experiences. Arguing for the utility of the theoretical trajectory of affect that is based on psychology, most notably on the work of Silvan Tomkins and Eve K. Sedgwick, Papoulias, and Callard describe this turn to affect as being:

> [M]otivated by a desire to address intimate aspects of life through attending to an enfleshed understanding of action and thought. In so doing, affect theory works to compensate for an assumed neglect of the body's materiality in earlier paradigms dominating the humanities and the social sciences. Through such paradigms, it is argued, the body was considered only insofar as it was subjectivised and had become discursively meaningful. "Affect theory" may thus be seen to emerge out of the perceived inadequacies of constructionist models of the subject in dealing with how embodied experience might contribute to a certain kind of agency that is not reducible to the social structures within which bodies are positioned...
>
> (2010: 34)

This development of affect as a science of feeling, then, is a methodology for mapping the emotions that offers a contemporary, psychologically framed version of Spinozist thought for the humanities and social sciences. It can be seen as one way of shaping understandings of what happens *after* affectus, of understanding how emotions change as a result of, or in response to, shifts in material conditions. As a science of the emotions, affect theory unpacks the ways material changes create possibilities for feeling differently. In terms of thinking through the cultural politics of changes created by art, understanding how young people might feel differently about themselves and their peers and how they might be perceived differently, both Deleuzian and contemporary pseudo-psychological models of affect contribute usefully to our understanding of how art can shift young people's understandings of themselves and public understandings of youth. As a cultural x-ray mapping the empirical things on which such changes in perception and relationality are based, Deleuze's (1970) concept of affectus shows us that emotions are expressive of material shifts.

128 *Affective pedagogy*

The act of making a work of art, of assembling people, textures, colors, places, sounds, is a physical modulation that prompts feeling. Similarly, changes in policy documents and broader discursive frameworks through which demographics of youth are known augment possibilities for feeling and can create opportunities for feeling differently about young people. In the case studies presented below, physical changes to the spaces young people occupy and acts of reshaping public images of marginalized youth in socially disadvantaged spaces invited the local community to feel differently about marginalized youth. For example, the UK public art project *The Margate Exodus* and the photographic exhibition *Towards a Promised Land* that accompanied it constituted a form of affective pedagogy that shifted local stigmas attached to migrant youth.

One particular kind of learning is the basis of change resulting from affective pedagogy. Seigworth (2003) gave an early, useful, and enduringly valuable explication of affective learning in his piece "Fashioning a Stave, or Singing Life." Here, he reminds his readers that "what affect calls forth is precisely this more immediate intermingling of bodies. ... Forget any particular words that might be exchanged; affect involves an exchange between bodies" (2003: 87). Through bringing marginalized and mainstream bodies together in new ways and effecting material changes in viewing and participating bodies, the Creative Partnerships project *The Margate Exodus* and the exhibition it featured, *Towards a Promised Land*, built connections between young people, place, and community that would not otherwise have been possible. Art choreographed spaces for new thoughts and community attachments to the refugee body.

In chapter one I argued that theories of popular pedagogy advance discussions of how curriculum might be conveyed via means intended to interest or engage marginalized young people. Commercial media, such as film and music, are often suggested forms of "popular pedagogy." I also argued that theories of public pedagogy tend to read the metanarratives articulated through cultural forms such as popular media, rather than engaging with young people's uptakes of these media. Offering an alternative to these popularist theories of education, the idea of culture as pedagogy expresses the notion that plural cultural forms, practices, events, convey content through the politics of affect.

Affective pedagogy, as I use the term, refers to the way art teaches. This is a specific kind of cultural pedagogy. It differs from the core premises on which ideas of public pedagogy are built in the respect that theories of public pedagogy tend to be grounded in narrative

readings of cultural forms. Cultural pedagogy – the idea that affect is a form of pedagogy writ large, and the premise that learning happens first through affect – are ideas based on the belief that cultural systems are altered through affect. Policies, institutionalized practices, and modes of spatial organization effected by institutionalized practices, are shifted as the result of affective allegiances.[3] Such theoretical projects are a contemporary reframing of Grossberg's "affective pedagogy" (1997: 387); they offer new investigations of "a pedagogy of articulation and risk" (1997: 386).

In *Bringing it All Back Home: essays on cultural studies*, Grossberg not only offers a mapping of relationships between education and cultural studies and a framework for how we might think about pedagogy, but also calls upon his readers to

> use our authority, mobilized through a pedagogy of risk and experimentation, to discover what the questions [that we ask in our research, questions about investments in politics and popular culture] can be in the everyday lives of our students and what political possibilities such questions open up.
>
> (1997: 389)

Such critical dialogue occurs all the time, albeit unconsciously, through the politics of affect; through style and changes in relationality that are effected by art.

Relationality and style are often unconscious forms of labor employed by young people as a means of shaping publics. In this respect they constitute the grounds on which citizenship is formed and can constitute youth voice. As a concept, affect explicates changes effected by pre-cognitive drives. Deleuze's ideas about creativity as the differential becoming of the world (differenciation) and affect as the kind of labor that effects such becomings are a model for how we can think about creativity and creative labor in ways that allow us to understand art's cultural and political potential to create change.

Differenciation and affect explicate the value of creative labor via terms of measurement that do not correspond neatly to popular capitalist markets. Indeed, the economies shaped through young people's creative practices often constitute an outside to capitalist economies. Through affect we can extend ideas of style as citizenship advanced in contemporary theories of subculture (Hebdige 1979; Gelder and Thornton 1997) and neo-tribes (Bennett 1999; Maffesoli 1996). Like affect theory, each of these theoretical ideas are built on aesthetics and style as material grounds for attachment.

130 *Affective pedagogy*

Differenciation offers a way of understanding the cultural changes effected by creativity. Through this concept Deleuze argues that art, like philosophy, is highly responsive to environment. He all too rightly reminds us that the slippery nature of life can leave us blind to understanding the central features of environments in which creativity is produced. We know that environments impact on creativity, but our set, or striated, conscious means of understanding creativity and the world obscure our chance to see environments as creative triggers.

Our daily lives require our subjectivity to be striated. Deleuze and Guattari explain striation as a process "which inter-twines fixed *and* variable elements, [and] produces an order and succession of distinct forms" (1980: 478). Striation makes lines: it is a process of organization. For the most part, our consciousness occupies a striated space–time relation. Striation is the process through which the chaosmosis of pure difference in which we live becomes ordered into seemingly linear experiences. Differenciation, on the other hand, is not linear. It is the production and intensification of singularities. In order to counter a capitalist model in which fixed modes of financial value are bound to the becoming of creativity, Deleuze argues that social formations must attempt to grasp significant aspects of our environments by expressing them in new ways. These acts of expression inevitably change the generative aspects of our environments: they differenciate.

Becoming is the modality of operation employed by processes of differenciation, or material change, which are misapprehended in our perception of apparently static things. Through Deleuze's ontology of becoming, in which "reality" is in a permanent state of flux, or continual differenciation, we can see that creative endeavor combines an unconscious engagement with the reality of flux and change with a conscious recognition of this process. Because reality is a flux, a creative affirmation of becoming is a resistance to our acceptance of a determined, striated world around us.[4]

Deleuze would contend that we are overly occupied with proving our imaginings of the way things are, and that because of this, we lose the capacity to pay attention to *what things are becoming*. People and places (or contexts) are folded into one another at different points of their constitution. Outside these connections they are also part of other assemblages, in relation to which they are not connected, and through which they become quite differently.[5] Differenciation is, then, in part the means through which we effect connections with others and with contexts. This is threefold. It is the process of change that

it. And people have lost that sense that anything is possible here. In Austin, they have been offered things and they haven't happened, so that is the history of Margate in particular, that offers have been made and they haven't turned out ... so there is a lot of frustration here and people feel that they don't deserve anything because it gets reiterated through people's practice. As for the architecture of the place, it signals terrible poverty, there is rubbish in the streets; sometimes we don't get our rubbish picked up for ... week[s][7]

Looking beyond the "terrible poverty" that Anna describes, art provided a way of re-thinking the social and personal situations of members of the Margate community. It became a communal method of material thought: a form of affective pedagogy. Deleuze explains that

> the modern work of art develops its permutating series and its circular structures, it indicates to philosophy a path leading to the abandonment of representation. It is not enough to multiply perspectives in order to establish perspectivism. To every perspective or point of view there must correspond an autonomous work with its own self-sufficient sense: what matters is the divergence of series, the decentring of circles, "monstrosity."
>
> (1968: 69)

Each work of art makes a new point of view (a "monster"; a hybrid) through creating a feeling: a "self-sufficient sense."

By bringing new and old community together and folding migrant and refugee youth across the architecture and landscape of the town, *Exodus* and *Towards a Promised Land* made feelings of community. These feelings were based in a togetherness of old and new residents. Both works were an affective pedagogy of new community. They made aesthetic systems – signs and feelings for relating to refugee and migrant youth that did not articulate existing dominant narratives of race, class, and gender. In making systems of relation, art became a practice of resistance to racism, articulated through aesthetics rather than ideology.

Anna Cutler's reading of place as a diagram for creative process ensured that Margate, as a community, was pushed to grasp the defining features of its environment – the juxtaposition between the mess and the arcades, the flashing lights and the boarded-up buildings, the Georgian architecture and the beaches. The paradox between

136 *Affective pedagogy*

possibility and historicity became the creatively significant aspect of this community's context. Expressing these relationships between historicity and futurity in new ways, folding virtual futures into the space of the present, the landscape of Margate was modulated. It had a particular kind of becoming in which members of community became part of the architecture and landscape of the town. The features of Margate's environment that are necessary to creativity were an inseparable part of these processes. The implementation of this process was a considerable feat. Anna offered some insight into how this worked, explaining:

> [W]e've been working ... in schools with 20 local artists ... on the concept of 'what a plague is'. The kids have been doing plagues of apathy, plagues of exclusion, plagues of cabbage locusts (because we grow cabbages around here), but it has been extraordinary because ... we've got ... professional gallery spaces to exhibit the children's work ... We are looking at bands who are going to join in, ... we are going to have plague songs that famous writers have written ... we've got a layer of international artists ... working with the community to produce a broadcast film that will be shown [in cinemas and on BBC TV]. So it's ... high profile, I think that ... one of the important things is [having] high stakes, because everybody moves up to them.[8]

After broken promises and the disillusionment that comes once opportunities have been lost, this act – saying "stand up now, because the nation is looking" – has certainly proved reason to rise to an occasion. The project remade the community of Margate into little public spheres in a range of ways. These included presenting community members on film to cinema audiences across the globe in the *Exodus* movie, calling pedestrians to attention as a critical viewing public of the faces of migrant and refugee youth exhibited in *Towards a Promised Land*, and presenting artwork made by schoolchildren to adults and those outside the school community.[9]

Architecture as affective pedagogy

Now I move to discuss an institutionalized example of macro and micro scales of affective pedagogy, in which community is reimagined through a place-based aesthetic. I turn to a sixth-form college in

Affective pedagogy 137

London, at Stratford Circus. The Circus is a center for the performing arts and moving image, managed by the college in collaboration with five professional arts organizations.

The Circus is a thoughtfully designed, well-equipped building in East London. It has a large, circular structure with three floors that circle around an open, central community space. One enters the well-lit community space in the foyer, to see that the ceiling is three levels up. Everyone who enters the space is automatically part of an open cafe space in the middle of three stories of offices, galleries, workshop spaces, and performance venues. The stairs to different levels run along the outside of this open space. The architecture places importance on community and the use of the space is based on flexibility – many of the regular studio rooms can also be rehearsal and audition rooms, meeting places, small exhibition spaces. There are also large performance areas and theater stages: the Circus has a capacity to cater for large-scale events. Proximity and spectacle are both possible.

The Circus is run by the sixth-form college as a site of arts education, yet it also houses professional dance, music, theater, and new media studios and facilitates a range of adult education programs. The companies who lease parts of the building include East London Dance, a design and urban music firm called Urban Development, Theater Venture, NewCEYS (the performing arts bloc of Newham's community education and youth service), and the "Circus Media" Centre. The latter is also affiliated with the sixth-form college and supports emerging freelance artists and production companies in delivering broadcast media. In the Circus as a space, local community members, artists, and educators are brought together. A community that ranges from the very young to the very old and is composed of members from a diverse range of backgrounds is thus built around an aesthetic of place and experience. They extend themselves and know themselves differently through place and learning in place. The Circus as an architectural space is an activator for a community based on relationality. It is an affective pedagogy of intergenerational community. Architecture brings generations and skill groups together in non-traditional ways and opens up formal systems of schooling to industry.

As part of my coming to understand the ways these processes of pedagogy operate, in a cafe on Canary Wharf in London's East End, I interviewed Graham Jeffrey[10] about the role he played in establishing the sixth-form college's involvement with the Circus. Following a similar trajectory to the conversation with Anna Cutler, our interview

examined some ways social context informed, and was also affected by, the Circus Arts Centre. The project was built on a brief to respond to social context in a comprehensive way. It was part of a broader push to creatively redesign London's East End and Docklands. The local student community do not have a history of performing well academically and the practical training offered by the performing arts and new media programs at The Circus, alongside the links to industry that are part of these programs and a part of the building, provide students with a model of arts education which has been developed in response to their needs.

When I asked Graham to comment on this responsiveness to context, he suggested that such reflexivity is:

> [a]bsolutely critical. The idea was always ... that every aspect of our work ought to have a really clearly articulated relationship to the communities that we were working in, ... [and] that's partly out of necessity, because we work in a borough like Newham, [so in terms of] the social context, you can't take [any student engagement] as a given because
>
> (a) the levels of deprivation are really high, [and]
> (b) the level of diversity is ... amazing,
>
> so you can't make any assumptions about the young people that you have to work with ... some of them may have arrived in the UK in the last six weeks, others might come from families who have lived in the East End of London for generations, others might be second generation immigrants, [who are] profoundly religious, some of them might be greatly ... disadvantaged in all sorts of ways ... that sort of ... diversity leads you to be much more conscious of ... social context than you would be if you just worked in a suburb, where ... there is ... a relatively "monoculture".... [C]ommunity education has always been the sector in education that's ... done more than schools or universities to engage with learners that don't fit the traditional mould.[11]

Graham clearly envisages the politics of community as inseparable from his arts education practice. He understands and engages critically with the fact that there are certain ideas of creativity associated with working in such a diverse student demographic. His critical reading of the act of trying to teach, or facilitate, creativity rearticulates the point introduced above – that for Deleuze creativity works to destratify; to break out of the everyday, the "familiar." The question

Affective pedagogy 139

of facilitating creativity is the question "how is difference possible?" How can we go beyond the current coordinates of our constitution? Teaching is a mode of addressing a little critical public and asking its members to extend or augment their subjectivity. The Stratford Circus assembled a unique critical public in its learning spaces.

There is a political utility in asking students to extend or refigure their subjectivity through differenciation. Graham clearly understands this, although he expresses his understanding using different language. He explains:

> The other thing I'm interested in is that creativity ... inevitably, implies deviance, implies breaking the rules, implies criticism and challenge. It's not about working within the framework of what if [this actually] exists, except to say "what if"? So, creativity to me is essentially bound up with the notion of social change, with the notion of trying to alter things, and of course that brings it inevitably into conflict with institutions, because that's not what institutions are in the business of doing. On the whole, institutions ... are in the business of regimenting, of disciplining, of ordering, of cataloguing and creating taxonomies and systems which bind people to certain ways of being. ... you've got to understand how it works in order to subvert, you can't hack an organization if you don't really get [into] the politics of it.[12]

Graham sees art as a means of deterritorializing striated social systems and rigid modes of consciousness designed to support such systems, yet he is also engaged with a process that must support young people through schooling and facilitate learning about art as part of this process. This itself is an act of creativity that engenders new pedagogies which mobilize affect as the means through which subjectivity is extended. It echoes the politics of critical literacies introduced in chapter one. Articulating a similar sentiment decades before this statement was made, Deleuze quotes Nietzsche in *Difference and Repetition* (1968: 136) as an impetus for his theory of creativity. Nietzsche details "creativity" as an act or process that effects new values, recognizes established values, and affirms both in their differences. In a Deleuzian model of creativity, relationships between the new and the old are redesigned through such a process of affirmation.

Such a fractured temporality and tensions between creativity (differenciation) and striation were folded into the architectural design

140 *Affective pedagogy*

of the Circus. Graham explained this through saying:

> We wanted to have an awareness of ... [multiplicity] in the work that we were doing, and not hold up school or college as the centre of the universe, but to understand that in fact people have multiple places they identify with, and multiple kinds of selves in relation to those places, so they've put on one face to do this thing and perform in a different way [and then another face for another thing] ... with somewhere like Stratford Circus, the idea was to create a ... flexible sort of place, but it could be lots of different things, so that for example, Friday evenings are grind night, and it's like the East London masses ... everybody comes down and it's pretty ... noisy and most people are between 16 and 22, ... it's really hardcore grind music, and at an earlier time that day, there might have been a tea dance in the same space, so it's a hybrid space. ... [I]t becomes a place where it's possible to bring groups of people together who otherwise would have sod all to do with each other.[13]

Intergenerational and intercultural contact is difficult to facilitate and formal educational institutions rarely effect such cross-cultural development successfully. Engendering such contact is one of the ways the Arts Centre at Stratford Circus practices affective pedagogy. To the extent that the Centre fosters teaching and learning in ways that enable diverse groups of people, including young people, to build relationships with community based on arts production and consumption, it also supports them in changing community. It is a material pedagogy of culture and affect. The institution works to support community members to develop sustainable connections to each other and to learn skills that allow them to practice art in ways that relate to, but also exist outside, very harsh economic climates.

After Deleuze, we can see that one value of art and the creative design of the Circus as the space in which the young people learn art is that it allows subjects (and in this instance, youthful subjects) to escape cliché. Art and architecture are core components of the process of affective pedagogy that can destratify the existing dominant subject positions through which young people are known and can know themselves. This process of becoming is facilitated when making art requires being part of communities and producing the self in atypical ways.

Across the globe, in a starkly different physical and political environment, I spent time researching a youth arts hub with

parallels to Stratford Circus and the work of Creative Partnerships. The Courthouse Youth Arts Centre is a regional Australian youth arts center that was designed to respond to social and environmental issues specific to young people in rural and regional Victoria. I now contextualize my discussion of the two UK projects described above in relation to this regional Australian case study in order to draw out some themes that seem to characterize affective pedagogy.

The Courthouse Youth Arts Centre in Geelong, Victoria, operates on the premise that the arts, music, and movement can bring people together in ways that are not possible in other social situations. Community is formed at the Centre by making new senses: of self, of belonging, of being known, and ways of being recognized. Music and movement are two media through which individual recognition and collective enjoyment are primarily facilitated in the Courthouse program. Increasingly, over the past three decades, hip hop, rap, R&B, and movement styles which have evolved with these sounds have brought together communities from a range of ethnic backgrounds and social classes. For example, Wathaurong Koori[14] (Aboriginal Australian) people, Sudanese refugees, Lebanese, Greek, Italian, and Anglo Australian young people in Geelong come to the Courthouse to rap, make beats, and dance in hip hop styles under the umbrella of community youth arts. They form a community that isn't about nationality, sexuality, or money as much as it is about movement and style.

The Centre occupies a spacious 1950s building that was once a courthouse. The Centre's pastel-colored art deco facade is one of the more eye-catching buildings in the heart of Geelong. The refurbishment of the building celebrates the old with a contemporary flavor. A sense of place and an understanding of social context are critical when looking at the work the Courthouse is doing. Remote regional sites are kept in focus through the Centre's outreach programs and through the multidisciplinary focal lens of the Centre, which has been designed to embrace a diverse cross-section of young people living in and around the rural center of Geelong. The Courthouse runs programs that focus on music, dance, visual arts, film, arts management, and theater making. Reflecting the global purchase that hip hop culture holds as a medium for articulating the political struggles of marginalized young people, the Courthouse theater-making program includes street dance, break dance, and MCing – tools of performance making with which young people are particularly keen to engage.

142 *Affective pedagogy*

The Courthouse sustains an active arts community in Geelong, the second most populated city in Victoria. The city began as a wool distribution port. A successful textiles trade was built upon the wool industry that forged the financial heart of Geelong and this is still reflected in the ways some local young visual artists approach their work. The old Geelong wool stores now serve as campus buildings for Deakin University and while Geelong is still an industrial town, the focus of labor has shifted distinctly. Alongside Deakin's growing contribution to the community, the Ford engine manufacturing plant and local Shell oil refinery are Geelong's core financial sources, and have been for decades.

There is a range of thriving youth subcultures in Geelong. Many of the young people's parents work for Ford and they live on the cutting edge of a very different kind of cultural production – jamming acrobatics, street dancing, and rhymes, sourcing stories of their own and giving them platforms through arts practices. Through the affective pedagogy of their art practices, these young people illustrate the fact that while some parts of Geelong tell tales of engines, petrol, and colonial Australian heritage, other kinds of cultural production are still acknowledged as important. Through young people's arts practices, relationships between the new and the old are redesigned while being affirmed. Deleuze states:

> Nietzsche's distinction between the creation of new values and the recognition of established values should not be understood in a historically relative manner, as though the established values were new in their time and the new values simply needed time to become established. In fact it concerns a difference which is both formal and in kind. The new, with its power of beginning and beginning again, remains forever new, just as the established was always established from the outset, even if a certain amount of empirical time was necessary for this to be recognized. What becomes established with the new is precisely not the new. For the new–in other words, difference–calls forth forces in thought which are not the forces of recognition, today or tomorrow, but the powers of a completely other model, from an unrecognised and unrecognisable *terra incognita*.
>
> (1968: 136)

The young people's arts practices at the Courthouse embrace and produce *terra incognita*. Through making aesthetic sensibilities, which are attached to young bodies that might be popularly thought

of as marginalized, they materially critique dominant discourses of the arts "helping" youth at risk. The Centre publicizes itself as being concerned with engaging marginalized and disenfranchised young people and as making opportunities for creative types to build their skills and excel. As a community-based organization, the concerns of Geelong's young people are reflected in the programs run by the Courthouse. In turn, the programs attempt to produce works that appeal to Geelong's youth.

Endeavoring to better understand the culture and the workings of the place, I joined in with some classes at the Courthouse. I participated in the weekly *HeadSpin* master classes held for eight young emerging visual artists, writers, and theater makers. The *HeadSpin* program had a focus on theater making and applied this focus broadly to encompass all aspects of theater production. The project invited eight emerging artists to work in teams to devise and stage three short performance works of roughly twenty minutes each. These works were then presented as a triple bill. *HeadSpin* consisted of weekly classes with the Courthouse's coordinator of the theater-making program, Naomi Steinborner. Specialist mentors in different disciplinary areas came on board the project to support individual young people developing their areas of specialist interest. These additions to the artistic team individually supported the eight young *HeadSpin* artists through the finalization of their performance concepts, auditions, rehearsals, design, production, and presentation.

The *HeadSpin* participants were interesting and diverse, including a sculptor, a design student, a visual dramaturge, two writers, a sound designer, a puppeteer, and two directors. *HeadSpin* produced striking works: a puppetry fantasy about a young boy's journey through a gypsy forest, a contemporary satirical perspective on parlor games, and an affective atmosphere/soundscape of adolescence. The audiences for these works were a broad cross-section of Geelong's community.

My observation of, and participation in, the program reminded me that one of the most important things about youth arts work is the ways it can include, speak to, and be modeled around, marginalized community groups, yet can also create aesthetics that do not reinscribe this marginalization. Furthermore, theater work by its very nature is not marginalizing. Making theater is about getting along with people. It's about working together and *getting out there*. It's also about aspects of irreducible humanness. Whatever the specific difficulties of people's lives, they often laugh and cry at similar "human" things. Through affective pedagogies of place, architecture,

and communities made through the production and consumption of aesthetics, collectives like the Courthouse can augment the subjectivities of young people who come to make art and those whose attentions are assembled to witness the art.

There seem, then, to be three organizing principles via which affective pedagogy operates through arts practice, and these run across the three case studies I have discussed in this chapter. The first of these is a spatial sensibility that mobilizes landscape, architecture, and material environment writ large as a pedagogic resource. The *Margate Exodus* and *Towards a Promised Land* inscribed local beaches, architectural features, theme parks – the scapes of the township – with new representations of marginalized young people. The projects spatially and aesthetically repositioned the faces of marginalized youth in the imaginary of the community. The Stratford Circus sixth-form college in London similarly organized community through architectural aesthetics. The Circus as a building brought together younger and older community members and facilitated student involvement with industry. The location of the cafe in the heart of the space called everyday community to witness the production and consumption of art in ways that are atypical for most secondary educational institutions. The Courthouse Youth Arts Centre similarly employs architecture as a pedagogy, although it does so in different ways. The 1950s architecture of the building speaks to the history of settlement and colonial sheep farming and the contemporary articulations of industry in automobile manufacturing. The interior of the building features aesthetic forms that fold histories of local Koori people and the arts (often hip hop) into the practices of migrant and refugee youth. The artworks presented bring often marginalized youth to the attention of local publics in ways that characterize young people through new aesthetic forms.

The work of temporality is similarly central to the various ways in which pedagogies of affect operate in these case studies. An affirmation of past and present through bringing them together in art occurs in *Exodus* and *Towards a Promised Land* in the use of architecture and spatiality as a landscape for photographic images and as a stage for the filming of *Exodus*. The Stratford Circus is a contemporary reworking of historically renowned principles for theater architecture developed in Stratford-upon-Avon's theater in the round in 1955. Yet, in a contemporary articulation of this old theatrical innovation, rather than bringing audiences to attend one performance in the pit or yard surrounding the stage, at Stratford Circus community members are called to the central space as a cafe to witness

art as industry. Art education, production, and performance occur in different ways on the three levels of the building. The temporiality of affective pedagogy is a negotiation of old and new ways of bringing community and learners together. As I suggested above, the Courthouse Youth Arts Centre negotiates old and new economies and histories through its architecture. More than this, though, the ways art forms are practiced by participants (such as visual artists incorporating locally spun wools in their work as an acknowledgment of the sheep-farming histories of the town) effect a validation of old and new through aesthetics.

Finally, in different ways, all three projects produce aesthetic forms that represent young people to little viewing publics in new ways. *The Margate Exodus* and *Towards a Promised Land* do so through film, photograph, and school art exhibitions; the Stratford Circus does so through performances, community events, and a blending of industry and secondary education. The Courthouse Youth Arts Centre similarly calls community together to see young people – often young people considered to be on society's margins – in terms of the art they produce. The emotional attachments and sensibilities of engagement that are configured around or across these scapes of relationality are particular to this art education context.

Aesthetic citizenship

I want to conclude my discussion in this chapter by suggesting that, through working with space, time, and aesthetic forms that represent young people to publics in new ways, affective pedagogy is a kind of sociability which makes aesthetic citizenship. Little publics operate as communities grounded in aesthetic sensibilities rather than institutionalized forms of social organization. Such citizenship has a material dimension constituted in the products of youth cultural practices, or affects of youth. These affects are the materiality of art texts and the physical experiences of person-in-relation to community; namely, the ground on which aesthetic citizenship is built. Such practices of citizenship have to be as diverse as those who undertake them. Across the experiences and practices of young people and youth arts practitioners in the United Kingdom and Australia, places and practices of youth arts clearly operate as a form of community building and social and political activism. These communities come together through affective pedagogy and form little publics. They offer young people ways to understand themselves differently, to reassemble or augment their subjectivity, and to connect

to unique communities. In creating little publics, community youth arts projects work through affective pedagogy: a materialist exchange that operates by building aesthetic connections.

My consideration of these three projects gestures towards the respective utility and need for a critical reconsideration of the educational work undertaken by youth arts programs. While the connections drawn together here span a broad range of discourses, I want to outline some of the force, complexity, and cultural significance that lies at the intersection of youth arts work and to emphasize the fact that this work happens through affect. I have drawn on Deleuzian theories of creativity and place, alongside theories of affect more broadly, to show that the intersection of youth arts work can be taken up in order to see how publics come together and how young people can remake themselves through the arts. As sites of affective pedagogy, such projects involve young people in publics that offer them opportunities to represent themselves and assemble their subjectivity in new ways through creative practice.

* * *

This book offers a theory of aesthetic citizenship that is specific to the lives and tastes of young people. More than this, it begins to account for the politics of arts work with marginalized youth. The advancement of this argument occurs across, and in relation to, quite different groups of young people and arts media, although my ethnographic fieldwork maintains a focus on dance. The ways arts practices mediate young people's experiences of citizenship and senses of selves as citizens, and the fact that these practices can augment community perceptions of youth, are enduring aspects of the stories contained within.

Reading art as both a popular and elite form facilitates thinking about how popular cultural forms of art, which are featured at the beginning of each chapter, and "high" art, as it is taught in institutional forms, teach people to feel and respond. Through this conceptual trajectory, five lines of argument are advanced across the book. I contend that the capacity of art to effect a movement from political invisibility to visibility, to create stories and publics, is a critical cultural function that existing scholarship on youth arts and discussions of popular and public pedagogy fails to acknowledge. Publics are always/already multiple. A theory of little publics captures the political agency of minority that is inherent in this multiplicity. It also speaks to the materiality of youth. Youth arts make little publics

in which youth voice articulates through performance or through the display of visual art.

The concept of little publics offers an active and aesthetically focused theoretical apparatus with which to consider youth arts. It augments existing discussions that tend to see arts work with socially marginalized youth as part of larger assemblages of governance. This is the second line of argument advanced in the book: specifically, that "youth arts" practices tend to be employed uncritically as methods of saving, improving, or occupying particular demographics of young people. This form of mobilization of the arts is positioned within particular assemblages of governance, which are composed of media discourses of moral panic and educational and psychological discourses of risk, and feature arts practices as technologies of salvation with the capacity to support young people in developing accounts of themselves as marginalized, yet manageable, subjects. Here, arts practices are technologies for social control rather than means of building communities or developing aesthetic economies and subjectivities.

Exploring some of the ways arts practices can build intergenerational and aesthetically focused communities and how they facilitate young people's capacities to act as aesthetic citizens, the final three chapters of this book explore the production of aesthetic citizenship and the workings of affective pedagogy. Chapter three catalogs the interplay of tradition and innovation, the local and the global, and the popular and the traditional in Sudanese girls' dance practices. Mapping local articulations of global scapes of non-white girl dance, the chapter illustrates some of the ways popular music and media operate as powerful pedagogies of dance and femininity. Drawing on Appadurai, the concept of scapes of non-white girl dance illustrates that learning dance can facilitate belonging to global, as well as local, communities and can be a practice of performing gender and race as much as a movement style. Dance created a framework for an ideoscape of refugee and migrant femininity; it articulated across mediascapes of non-white femininity and reshaped a localized ethnoscape in relation to globalized and globalizing connections.

This investigation of dance as a racialized technology for gendered identity production is extended in chapter four. Here, through the stories of boys' dance practices, ways the process of making dance can also be a process of making masculinity – and the fact that this process is classed and gendered – become plain. Through the work of Gates Jnr we see that popular dance practices can be a method of social critique as much as they are ways of developing and displaying publicly endorsed gendered identities.

Lastly, chapter five suggests the concept of affective pedagogy as a tool through which we might understand how art works as a materialist technology for the creation of community and a means through which individual and group subjectivities are reassembled. People know themselves in place differently through art – whether they are young refugees in coastal towns in Kent, urban youth looking for a career in the creative industries in London, or second-generation Lebanese youth living in Victoria, Australia, the case studies in chapter five show the different ways learning, making, and displaying art also provide new ways of knowing the self and community. These processes are spatial, temporal, and aesthetic forms of affective pedagogy; the communities they make are little publics and participating in these processes of learning is a form of citizenship.

These ideas are offered as analytic tools to inspire further investigation – to prompt lines of inquiry that pay attention to the politics of youth arts in ways that generate critical thought. In its popular and its high forms, art is a constitutive feature of the lives of all young people. The arts remain a preferred technology through which to "engage," occupy, or retrain marginalized youth. As such, this book offers a provocation to those interested in scholarship that examines the kinds of pedagogies which young people draw upon to learn arts and which are employed to teach young people arts. It is intended to invoke inquiry that is not defined by disciplinary boundaries in scholarship or trends in educational practice, but by attention to youth taste and to what "works" in youth arts. Critical examinations of the politics of this work and of the utility of taste will refine and regenerate our understandings of young people and the processes through which they learn art.

Notes

Acknowledgments
1 The name of the school is being withheld for ethical purposes.

1 Little publics: performance as the articulation of youth voice
1 I use this term satirically to refer to the practice of running youth arts programs to "help" socially marginalized young people. These programs are generally intended to increase young people's self-esteem and increase their visibility in the local community. The outcomes are socio-cultural rather than aesthetic.
2 Kate Crawford's book *Adult Themes* (2006) usefully illustrates the roles that contemporary media play in problematizing "adult" as a stable category. Crawford suggests that in debates about the age-appropriate nature of different popular cultural forms:

> What's really at stake ... is the question of who gets to decide what counts as a valuable, timeless cultural product, and what will be disregarded as a passing childish fad. In other words, the fights over adult culture are really fights over authority: who has the authority to dictate what is good culture and what isn't.
>
> (2006: 184)

3 SES is an abbreviation of socioeconomic status.
4 Specifically extending Dewey's work, Anand Marri (2003) has begun to rethink little publics in relation to distinctions between public and private school systems and multicultural education.
5 I spell liberal with a lower-case 'l' deliberately and use the adjective to refer to a broad use of the word in which it is taken to mean an encompassing, accepting perspective.
6 As my discussion of the affective community drawn together through art in chapter five makes plain, I want to develop a more positive, generative, and responsive model of youth subjectivity in which art is part of the practice through which young subjects create themselves.

7 Specifically, Rheingold explains:

> The public you choose to address could be a public in the sense of a political public sphere that undergirds democracy—the communications you engage in with your fellow citizens, with whom you share responsibility for self-governance. The public doesn't have to be political, however. It could be an engaged community of interest—others who share your profession, a vocation, or obsession. When fans begin writing fan fiction or remixing and sharing cultural content, they are acting as a public—a culture-producing public.
>
> (2008: 108)

8 Here I refer to work on media audiences, such as Butsch's influential collection *Media and Public Spheres* (2007) and *The Citizen Audience* (2008), which offer investigations of how different publics are created through diverse media forms. Butsch began mapping this field in 2000 with *The Making of American Audiences: from stage to television, 1750–1990*, and his influence can clearly be seen in contemporary works such as Coleman and Ross' (2010) *The Media and The Public: "them" and "us" in media discourse*.

9 Fraser (1990: 62–3) advances this critique through arguing that the notion of the public sphere is built on problematic assumptions:

1 The assumption that it is possible for interlocutors in a public sphere to bracket status differentials and to deliberate "as if" they were social equals; the assumption, therefore, that societal equality is not a necessary condition for political democracy.
2 The assumption that the proliferation of a multiplicity of competing publics is necessarily a step away from, rather than toward, greater democracy, and that a single, comprehensive public sphere is always preferable to a nexus of multiple publics.
3 The assumption that discourse in public spheres should be restricted to deliberation about the common good, and that the appearance of "private interests" and "private issues" is always undesirable.
4 The assumption that a functioning democratic public sphere requires a sharp separation between civil society and the state.

10 Although this acronym is somewhat self-important, "A/r/tography" is used to describe an arts and education practice-based research methodology dedicated to acts of inquiry through the arts and writing. The acronym is supposed to acknowledge the act of positioning art and writing, and the identities of artist, researcher, and teacher (a/r/t) side by side. See the work of Lacy (1995).

11 In the second edition of *Communications*, Williams reflects that the book was written as a response to "problems of social and cultural policy" undertaken through "analysis of the structure and content of our existing institutions and systems" (1966: 9). Work based around consciousness raising, involving "critical work ... on the content of popular culture" and the "New Left," has led to "an extension to the problems of institutions" (1966: 10) which reinscribe ideas of "a minority culture

and a democratic culture" (1966: 10). Savage (2010) later extends this vein of analysis.
12 Youth arts practices that mix genres are also invested in ideas of public good, although typically they want to critique existing forms of social relation and increase what they see as social capacity for democracy through their practices, rather than "improve" young people and thus advance society through art.
13 In this respect, in line with the style of argumentation advanced by Giroux, the REC can be read as a corporate public pedagogy of what Giroux would call "neoliberal ideology."
14 I am referring to high school musicals as a genre, not specifically to the films of this name.
15 Examples can be found in films such as Disney's *High School Musical* series (2006, 2007, 2008), *West Side Story* (1961), *Bye Bye Birdie* (1963), *Grease* (1978), *Rock and Roll High School* (1979), *Fame* (1980), and *Cry-Baby* (1990). This trope is also cited in dance movies, or "dancicles," such as *Footloose* (1984), *Center Stage* (2000), *Step Up* (2006), and *StreetDance 3D* (2010).
16 While Williams and Willis have different ideas of common culture, youth, and school arts projects can be seen as embedded in both these ideas.
17 Hoggart co-founded the Birmingham Centre for Contemporary Cultural Studies. His book *The Uses of Literacy* was one of the first British calls to take working-class taste and knowledge seriously.
18 Writing about the value that Hoggart places on "ordinary" life, Gregg states:

> *The Uses of Literacy* therefore produced the missing perspective that would go on to define the epistemological novelty of cultural studies: a grounded, local analysis offered the surest critique of the broad claims that had been made for "the" working class as a whole. In a construction worth remembering, Hoggart aimed to write against that genre of "middle-class Marxist" who had the effect of "part-pitying" and "part-patronising" the working class "beyond any semblance of reality" (Hoggart 1958: 16).
>
> (Gregg 2008: 2)

19 In *Culture and Society* (1963) Williams develops a particular position on culture through arguing that the industrial revolution effected changes to the meaning of the word "culture." He points out that once "to culture" meant to grow or to train, but the phrase now refers to social forms, arts practices, and aesthetic texts. He further suggests that this development of meaning can be read as a "map by means of which the nature of the [post-industrial revolution] changes [to industry, democracy, class, and art] can be explored" (Williams 1963: xvi).
20 He defines "communication" as "the institutions and forms in which ideas, information, and attitudes are transmitted and received. I mean by communication the process of transmission and reception" (Williams 1966: 17).

21 Later, in *Disturbing Pleasures: learning popular culture* (1994b), Giroux further considers the intersection of popular culture and pleasure as a site in which – and though which – questions about the politics of taste might be asked. The ways in which the politics of race articulate in relation to pleasures and pedagogy form Giroux's focus in *Fugitive Cultures: race, violence, and youth* (1996).

2 Assemblages of governance: moral panics, risk, and self-salvation

1 Missy Elliot is a commercially famous North American rapper.
2 Foucault develops neoliberal governance as an art subjectivation, a process of self-monitoring. It is in this sense that I use the word, although others such as Giroux use the term to refer to private corporatization encroaching on the public domain.
3 See Aries (1962), Foucault (1977), and Hendrick (1990) for discussions of the production of childhood that demonstrate the different ways in which ideas of childhood are socially developed and regulated strategies.
4 Cohen examines mods and rockers as one example of a socially resistant subculture that is fanned through the media. The natures of the mod and rocker subcultures aren't relevant here; what are relevant are the defining features of "moral panics" and the ways in which they characterize young people as deviant.
5 From 1969 onwards in Britain there was a marked increase in racist "moral panics" about black youth.
6 The Australian Human Rights Commission describes the NT intervention as follows:

> On 21 June 2007, the Australian Government announced a "national emergency response to protect Aboriginal children in the Northern Territory" from sexual abuse and family violence ... This has become known as the "NT intervention" or the "Emergency Response." The catalyst for the measures was the release of Report of the Northern Territory Board of Inquiry into the Protection of Aboriginal Children from Sexual Abuse, titled Ampe Akelyernemane Meke Mekarle: "Little Children are Sacred."
> (Australian Human Rights Commission 2007: online)

7 The Redfern riot is the name given to a fight between police and civilians on the evening of Saturday 14 February 2004. The riot was an event in the inner Sydney suburb of Redfern that was sparked by the death of Thomas "TJ" Hickey, a seventeen-year-old Indigenous Australian.
8 He pointedly remarks that "the only 'offenders' who were linguistically marked and separated by 'race' were Aboriginal offenders" (Cunneen 2008: online).
9 Dog whistles are used to train dogs and cats as they produce a frequency only audible by animals. The phrase "dog whistle politics" is used in Australia to describe a type of political campaigning that uses coded language that appears to mean one thing to the general population but has a more specific meaning for a particular group.

10 Garmezy has traced the emergence of the risk concept through epidemiological research that is concerned with identifying the factors that "accentuate or inhibit disease and deficiency states, and the processes that underlie them" (1994: 9). This medical perspective is, thus, founded on the belief that if "determinants" of risk can be found, effective preventative efforts can be implemented.
11 Other terms used in educational literature to describe at-risk students include "disadvantaged," "culturally deprived," "low-ability," "dropout-prone," "alienated," "disenfranchised," "low-performing," and "remedial" (Lehr and Harris 1988; Natriello, McDill, and Pallas 1990).
12 International Monetary Fund.

3 Tradition, innovation, fusion: local articulations of global scapes of girl dance

1 A krump is a contemporary form of hip hop dance, which I discuss in greater detail in chapter four. In vernacular terms, a krump is a whole-body movement bringing together aspects of hip hop dance such as the body roll and chest pops.
2 Beyoncé Knowles is an American pop artist who rose to fame in the late 1990s as the lead singer of the group Destiny's Child.
3 Shakira Ripoll is a Colombian singer, songwriter, and dancer who came out of the music scene of Colombia and Latin America in the early 1990s.
4 In this instance, the landscape is image and sound-based, rather than narrative-based.
5 The young women in the dance workshop group ranged in age from nine to nineteen.
6 For example, in 1992 the government controllers of the prominent South Sudanese radio station Radio Juba wiped all original tapes of the celebrated South Sudanese singer Yousif Fataki. While South Sudan, as exemplified by the work of Yousif Fataki and members of the Sudan People's Liberation Army (such as the group The Black Stars), creates plenty of music, because of political censorship there are fewer opportunities to hear it now than in recent decades.
7 Kyra Clarke reminds me that this pleasure is complex: the song is critical of men's appreciation of women's bodies; the women take pleasure in refusing men and emphasize that there are more important things in life, and yet they also work to cultivate "attractive" bodies and appear to enjoy the attention. Nevertheless, I feel the kind of work required to maintain the appearances of these performers would prevent them from any other significant investment of time and energy in major life goals.
8 In employing the term "third-wave feminism" I refer to feminist responses to second-wave feminism since the 1980s, especially those that have called for attention to be paid to women of colour and which create space for the acknowledgment of the cultural specificities of the lives of women who are not part of a mainstream white culture.

154 *Notes*

9 Ednie Kaeh Garrison (2004: 24), amongst others, problematizes the term third-wave feminism, stating:

> The very claim to know what third wave feminism means is riddled with contradictions and problems. Few can agree about what and whom it encapsulates – advocates and detractors alike. The only general consensus to have emerged is that it has become a name for young women who identify as feminists (but not the feminists of the sixties and seventies) and, especially among its detractors, it is a name assigned to those who have no real clear sense of what feminist ideology/praxis, feminist movement, or feminist identity have meant across time and place. In both cases, the construction of third wave feminist meaning has hinged upon a series of simplifications and mis-conceptions about the object "feminism" that circulate in the national popular imaginary.
>
> (2004: 24–5)

10 For example, searching YouTube with the phrase "dancing at home to The Pussycat Dolls" brings up a page of video clips which mainly features school groups practicing dance routines to TPD but also includes some clips of girls at home filming themselves dancing.
11 Here I refer to the fact that second-wave feminists such as Barbara Kruger, The Guerrilla Girls, Margaret Atwood, and Valerie Solanas (to name a few) have viewed popular culture as sexist and created explicitly feminist popular cultural texts of their own in response.
12 Here I think of others who have also explored and critiqued MTV as a forum for feminist politics, including Freccero (1992), Roberts (1991, 1994), and Kaplan (1993).
13 Global – local.

4 Do you want to battle with me?: schooling masculinity

1 Top rock generally refers to a string of steps performed from a standing position. It is usually an opening display of style, though dancers often transition from other aspects of breaking to top rocking and back. A great deal of freedom is allowed in the definition of top rock: as long as the dancer maintains cleanness, form, and attitude, theoretically anything can be top rock. Top rocking can draw on other dance styles such as popping, locking, or house dance.
2 Down rocking, or floor work, is a term used to describe any movement on the floor with the hands supporting the dancer as much as the feet are. Down rocking includes moves such as the six step, in which the dancer uses their arm to support their body above the floor while their legs walk around in a circle.
3 Moves such as this, often called "power moves," are common in hip hop dance. The name reflects the fact that such acrobatic moves require great physical power. The upper body supports the dancer, while the rest of the body creates momentum. Famous examples are the windmill (described in the vignette that begins this chapter), the "swipe" (circular

half handstands, the legs swipe over the torso), the head spin, and "the flare," an acrobatic move in which the performer alternates balancing the torso between either arm while swinging the legs in circles beneath the torso. Moves such as the flare are borrowed from gymnastics; others are adapted from martial arts.
4 There is a contextual parallel between the political history of hip hop and the educational institutions in which my ethnography was based which is interesting to note, as both institutions (the school and the community learning centre) are involved in forms of race-based advocacy and activism.
5 Released in 2005, *RIZE* is a commercially distributed documentary directed by David LaChapelle. It chronicles a dance movement that arose out of South Central Los Angeles from street youth culture. The boys were interested in the aesthetics of the film broadly; for example, they had graffitied *RIZE* across their dance space.
6 Such a localized appropriation of dance as sport can be read as an expression of the practical emphasis of the Vocational Education and Training (VET) curriculum in the Australian state of Victoria. This curriculum is structured around attaining subject-specific sets of practical competencies, rather than engaging with dance as a scholarly field.
7 These students are in years ten and eleven in the Victorian state curriculum.
8 Dance was an elective subject, so my characterization of their "choice" is intentional. As I suggested, the boys in the community education context did not employ dance as a technology of gendered identity production.
9 Eisteddfods are showcases of singing and dancing.
10 I refer to the popularity of eisteddfods in the Australian school system.
11 Gates Jnr is interested in the works of Richard Wright, Ralph Ellison, Zora Neale Hurston, and Ishmael Reed.
12 The concept of signifying allows Gates Jnr to create what he calls an "indigenous" system of principles for the interpretation of Afro American literature which are located within the tradition of Afro American literature. Secondly, it enables him to fix a specific line of descent within this literary tradition.
13 Famously, hip hop has historical links to black activism and was originally developed as a vehicle for African American black rights (Kitwana 2002; Watkins 2005). While, as Kitwana (2002) notes, signifiers of hip hop culture can no longer be read as synonymous with any form of activist sentiment, the movement needs to be understood as having political origins.
14 Eminem is a white North American rapper.
15 To "block out" a work is to mark its staging.
16 Poynting, Noble, and Tabar argue that this sort of protest masculinity is compounded by ethnicity in a response to racism in the friendship groups of Lebanese male youths.
17 21 May 1972–9 March 1997.
18 East Coast hip hop in North America originated in New York and its surrounding areas. Biggie Smalls is often thought of as a figurehead for this movement.

156 *Notes*

19 I observed John's awkwardness with his own body. He looked like he weighed well over 190 kgs and was about 160 cms tall. John always had noticeable body odor, wore oversized, baggy clothes, and sweated profusely.
20 Emo is an adjective derived from the musical genre known as "Emotional-Punk" and used as a noun that refers largely to young people who listen to "Emotional-Punk" music. The investment in a cultural group or identity experienced by young people who identify as Emo generally extends beyond music taste to encompass style and politics.
21 WWE is a publicly traded, privately controlled sports entertainment company that stages, promotes, and televises professional wrestling.
22 In most cases John would flatulate at least once on his wrestling partner once they were not able to escape his weight. This routine would begin most rehearsals.
23 Indeed, white boys who were able to perform gangsta successfully were lauded over young Koori men like John.
24 The Dinka's religions, beliefs, and lifestyles led to conflict with the Islamic government in Khartoum. The Sudan People's Liberation Army took arms against the government in 1983. The ensuing war lasted 21 years. During this time government forces massacred thousands of Dinka and non-Dinka southerners.
25 For example, see the film *The Lost Boys of Sudan* (Mylan and Shenk 2003).
26 This is a visual novel/comic book.

5 Affective pedagogy: reassembling subjectivity through art

1 Specifically, Chaaban *et al.* (2010) state that "between 260,000 and 280,000 [Palestinian refugees] are residents in the country" (author's parentheses, 24).
2 Deleuze develops an idea of the simulacra that is specific to his work. A simulacra is a kind of "pure" difference, Deleuze explains: "Simulacra are those systems in which different relates to different *by means of* difference itself. What is essential is that we find in these systems no *prior identity*, no *internal resemblance*" (Deleuze 1968: 299).
3 Thus, the materiality of affect offers a way of reconceptualizing pedagogy. As I have argued elsewhere (Hickey-Moody 2009a: 273), Deleuze's "affectus" (change) is what cultural theorists such as Lusted (1986) and McWilliam and Taylor (1996) call "pedagogy" – namely, a relational practice through which some kind of knowledge is produced. As Gregg and Seigworth (2010), amongst others, argue, the feelings that affect creates are a form of knowledge that has an effect on cultural change. Elsewhere (Hickey-Moody, Windle, and Savage 2010), I have contended that the project of thinking about affect as a kind of pedagogy opens ways for thinking about the roles that the body and pleasures play in teaching and learning.
4 This positive resistance is activated when, for example, an architect expresses the becomings at play in an actual site through the design

of a building (Williams 2000: 203), or when an artist actualizes possibilities for aesthetic vocabularies by painting an image that evades the clichés embedded in a blank canvas (Deleuze 1981: 71, 73, 76). These kinds of engagement with (or activations of) potentiality and resistance to unconscious, clichéd perceptions are also referred to by Deleuze as forms of "resistance to the present" (Deleuze and Guattari 1991: 108) *or resistance to assumed ideas of "the way things are."* The ontology of becoming is anti-teleological; it turns against progress as development towards an ideal. Instead of progress, becoming constitutes an expression of movement, defined as *variations* or *differentiations*. Reality is a flow of variations that needs no relation to different identities or fixed reference points. It is the constructed human subject that needs references to identities or fixed points.
5 For example, Australia is a sovereign nation. Yet if one were to fall in line with dominant ideas of Uluru as an Australian tourist attraction, generations of Aboriginal knowledge and connection to country, and the force of these connections, would be discounted. Uluru is a multiplicity. In some social assemblages it is a tourist attraction, where it is connected to ideas of 'authentic Australia' and is positioned as an attractive gem in the crown of our ruling monarch. In other social assemblages, Uluru articulates knowledges that cannot be understood by whitefellas, let alone the sovereign head of state to whom they claim allegiance.
6 Anna Cutler (2008) Research interview (26 June 2008).
7 Anna Cutler (2008) Research interview (26 June 2008).
8 Anna Cutler (2008) Research interview (26 June 2008).
9 I must note that it has been, and remains, a source of concern to me that the sustainability of the cultures generated by Creative Partnerships is limited. The projects they initiate involve communities and certainly effect change in communities, yet they are not primarily community-driven and they do not have the capacity to run without expertise brought in from outside the community (Hall and Thomson 2007). Certainly, this difficulty with sustainability is an enduring shortcoming of such specialist-run programs.
10 At the time Graham was working as a lecturer in Creative Industries at the University of East London.
11 Graham Jeffrey (2008) Research interview (15 June 2008).
12 Graham Jeffrey (2008) Research interview (15 June 2008).
13 Graham Jeffrey (2008) Research interview (15 June 2008).
14 Wathaurong people lived around the regions of Victoria now known as Ballarat and Geelong.

Bibliography

"Aboriginal Youth – WA is Sick and Tired of Your Violent Crimes – ENOUGH!!!" (2011) Facebook. Online. Available from http://www.facebook.com/pages/Aboriginal-youth-WA-is-sick-and-tired-of-your-violent-crimes-ENOUGH/106572746033410 (accessed 29 June 2011).

Alasuutari, P. (1995) *Researching Culture: qualitative method and cultural studies*, London: Sage.

Appadurai, A. (1996) *Modernity at Large: cultural dimensions of globalization*, Minneapolis, MN: University of Minnesota Press.

— (2000) "Disjuncture and difference in the global cultural economy" in F. J. Lechner and J. Boli (eds.) *The Globalization Reader*, Oxford: Blackwell.

Apple, M. (1979) *Ideology and Curriculum*, London: Routledge.

Aries, P. (1962) *L'Enfant et la vie Familiale sous l'Ancien Régime*; trans. R. Baldick, *Centuries of Childhood: a social history of family life*, New York: Knopf.

Artangel (2005) "Towards a promised land." Online. Available from http://www.artangel.org.uk/projects/2005/towards_a_promised_land (accessed 9 May 2012).

— (2007) "Exodus." Online. Available from http://www.artangel.org.uk/projects/2007/exodus (accessed 9 May 2012).

Australian Human Rights Commission (2007) *Social Justice Report 2007*. Online. Available from http://www.hreoc.gov.au/social_justice/sj_report/sjreport07/chap3.html (accessed 23 May 2011).

BBC News (2006) "Force to pay damages for racism" *BBC News Online*, 6 April. Online. Available from http://news.bbc.co.uk/1/hi/england/kent/4885562.stm (accessed 9 May 2012).

Beck, U. (1992) *Risk Society: towards a new modernity*, London: Sage.

Beep (2005) Music Video. Directed by B. Boom. USA: A&M Records. Online. Available from http://www.youtube.com/watch?v=1r9ghI7YcL0 (accessed 7 September 2011).

Bennett, A. (1999) "Subcultures or neo-tribes? Rethinking the relationship between youth, style and musical taste" *Sociology*, 33/3: 599–617.

Berlant, L. (1997) *The Queen of America goes to Washington City: essays on sex and citizenship*, Durham, NC: Duke University Press.

Bixler, M. (2005) *The Lost Boys of Sudan: an American story of the refugee experience*, Athens, GA: The University of Georgia Press.

Blagg, H. (2008) *Crime, Aboriginality and the Decolonisation of Justice*, Sydney: Hawkins Press.

Bloustien, G. (2003) *Girl Making: a cross-cultural ethnography on the processes of growing up female*, New York: Berghahn.

Bruns, A. (2006) "Towards produsage: futures for user-led content production" in F. Sudweeks, H. Hravhovec, and C. Ess (eds.) *Proceedings: cultural attitudes towards communications and technology*, Perth: Murdoch University.

Bruns, A., Burgess, J. E., Highfield, T. J., Kirchhoff, L., and Nicolai, T. (2010) "Mapping the Australian networked public sphere" *Social Science Computer Review*. Online. Available from http://eprints.qut.edu.au/39508/1/c39508.pdf (accessed 24 September 2011).

Butler, J. (1995) *Gender Trouble: feminism and the subversion of identity*, London: Routledge.

Butsch, R. (2000) *The Making of American Audiences: from stage to television, 1950–1990*, Cambridge: Cambridge University Press.

— (2007) *Media and Public Spheres*, Basingstoke: Palgrave Macmillan.

— (2008) *The Citizen Audience: crowds, publics and individuals*, New York: Routledge.

Bye Bye Birdie (1963) Film. Directed by G. Sidney. USA: Columbia Pictures.

Cahill, H. (2008) "Resisting risk and rescue as the *raison d'etre* for arts interventions" in A. O'Brien and K. Donelan (eds.) *The Arts and Youth at Risk: global and local challenges*, Newcastle upon Tyne: Cambridge Scholars Press.

Center Stage (2000) Film. Directed by N. Hytner. USA: Columbia Pictures.

Chaaban, J., Ghattas, H., Habib, R., Hanafi, S., Sahyoun, N., Salti, N. Seyfert, K., and Naamani, N. (2010) *Socioeconomic Survey of Palestinian Refugees Living in Lebanon*, Beirut: American University of Beirut.

Chatterjea, A. (2004) "Contestations: constructing a historical narrative for Odissi" in A. Carter (ed.) *Rethinking Dance History*, London: Routledge.

Cohen, S. (1972) *Folk Devils and Moral Panics: the creation of mods and rockers*, London: Routledge.

Coleman, S. and Ross, K. (2010) *The Media and the Public: "them" and "us" in media discourse*, Chichester: Wiley-Blackwell.

Collins, M. (2010) "Strangers in their own land" *Prospect*. Online. Available from http://www.prospectmagazine.co.uk/2010/01/strangers-in-their-own-land/ (accessed 12 May 2011).

Connell, R. (1995) *Masculinities*, 2nd edn, Crows Nest, NSW: Allen and Unwin.

— (2000) *The Men and the Boys*, St Leonards, NSW: Allen and Unwin.

Crawford, K. (2006) *Adult Themes: rewriting the rules of adulthood*, Sydney: Pan MacMillan.
Crawford, M. N. (2008) *Dilution Anxiety and the Black Phallas*, Columbus, OH: Ohio State University Press.
Creative Partnerships (2007) Online. Available http://www.creative-partnerships.com/ (accessed 19 December 2007).
Cry-Baby (1990) Film. Directed by J. Waters. USA: Universal Pictures.
Cuban, L. (1989) "The 'at-risk' label and the problem of urban school reform" *Phi Delta Kappan*, 70/10: 780–801.
Cunneen, C. (2008) "Riot, resistance and moral panic: demonising the colonial other" *University of New South Wales Faculty of Law Research Series*, 29. Online. Available from http://www.austlii.edu.au/au/journals/UNSWLRS/2008/29.html (accessed 4 July 2011).
Cutler, A. (2008) Research interview (26 June 2008).
Davis, M. (1997) *Gangland: cultural elites and the new generationalism*, St Leonards, NSW: Allen and Unwin.
Deleuze, G. (1968a) *Différence et Répétition*; trans P. Patton (1994) *Difference and Repetition*, New York: Columbia University Press.
— (1968b) *Sphinoza et la problème de l'expression*; trans M. Joughin (1990) *Expressionism in Philosophy: Spinoza*, New York: Zone Books.
— (1970) *Spinoza: philosophie practique*; trans R. Hurley (1988) *Spinoza: practical philosophy*, San Francisco: City Light Books.
— (1981) *Francis Bacon: logique de la sensation*; trans D. W. Smith (2003) *Francis Bacon: the logic of sensation*, Minneapolis, MN: University of Minnesota Press.
Deleuze, G. and Guattari, F. (1980) *Mille Plateaux*; trans B. Massumi (1987) *A Thousand Plateaus: capitalism and schizophrenia*, Minneapolis, MN: University of Minnesota Press.
— (1991) *Qu'est-ce que la philosophie?*; trans G. Burchell and H. Tomlinson (1994) *What is Philosophy?*, London: Verso.
Deng, A., Deng, B., and Ajak, A. (2005) *They Poured Fire on Us From the Sky: the story of three Lost Boys from Sudan*, New York: Public Affairs Books.
Department of Immigration and Citizenship (2007) *Sudanese Community Profile*. Commonwealth of Australia. Online. Available from http://www.immi.gov.au/living-in-australia/delivering-assistance/government-programs/settlement-planning/_pdf/community-profile-sudan.pdf (accessed 27 May 2012).
Dewey, J. (1927) *The Public and its Problems*, New York: Henry Holt and Company.
Dryfoos, J. (1995) "Full service schools: revolution or fad?" *Journal of Research on Adolescence*, 5: 147–72.
DuBois, W. B. E. (1973) *The Education of Black People: 10 critiques, 1906–1960*, H. Aptheker (ed.), New York: Monthly Review Press.

Dwyer, P. and Wyn, J. (2001) *Youth, Education and Risk: facing the future*, London: Routledge/Falmer.

Eggers, D. (2006) *What is the What? The Autobiography of Valentino Achak Deng*, San Francisco: McSweeny's.

Ellsworth, E. (2005) *Places of Learning: media, architecture, pedagogy*, New York: Routledge.

Fame (1980) Film. Directed by A. Parker. USA: Metro-Goldwyn-Mayer.

Fine, M., Weiss, L., Wesdeen, S., and Wong, L. (2003) "For whom? qualitative research, representations, and social responsibilities" in N. K. Denzin and Y. S. Lincoln (eds.) *The Landscape of Qualitative Research: theories and issues*, 2nd edn, Thousand Oaks, CA: Sage.

Flii Stylz and Tenashus (2005) Song. "Break it On Down: Battlezone" *RIZE Soundtrack*, USA: Forster Brothers Entertainment.

Footloose (1984) Film. Directed by H. Ross. USA: Paramount Pictures.

Foucault, M. (1975) *Surveiller et Punir: naissance de la prison*; trans A. Sheridan (1977) *Discipline and Punish: the birth of the prison*; (1991) London: Penguin.

— (1976) *La Volonté de Saviour*; trans R. Hurley (1978) *The History of Sexuality, Volume 1*; (2008) Camberwell, Victoria: Penguin Books.

— (1983) "The subject and power" in H. L. Dreyfus and P. Rabinow *Michel Foucault: beyond structuralism and hermeneutics*, Chicago: University of Chicago Press. Brighton: Harvester.

— (1991) "Governmentality" in G. Burchell, C. Gordon, and P. Miller (eds.) *Foucault Effect: studies in governmentality*, Chicago, IL: University of Chicago Press.

— (2003) *Abnormal: lectures at the College de France 1974–1975*; trans G. Burchell, New York: Picador.

— (2005) *The Hermeneutics of the Subject: lectures at the College de France 1981–1982*; trans G. Burchell, New York: Picador.

— (2010) *The Government of Self and Others: lectures at the College de France 1982–1983*; trans G. Burchell, New York: Picador.

Fraser, N. (1990) "Rethinking the public sphere: a contribution to the critique of actually existing democracy" *Social Text*, 25/26: 56–80; reprinted in C. Calhoun (ed.) (1992) *Habermas and the Public Sphere*, Cambridge, MA: MIT Press.

Freccero, C. (1992) "Our lady of MTV: Madonna's 'Like a Prayer'" *Feminism and Postmodernism*, 19/2: 163–83.

Freire, P. and Macedo, D. (1987) *Literacy: reading the word and the world*, South Hadley, MA: Bergin and Garvey.

Galati-Brown, R. (2006) *Advice Statement on Indigenous Careers*. Online. Available from http://www.curriculum.edu.au/indigenouscareers/1141.doc (accessed 5 November 2006).

Gard, M. (2006) *Men Who Dance: aesthetics, athletics and the art of masculinity*, New York: Peter Lang Publishing.

Garmezy, N. (1994) "Reflections and commentary on risk, resilience and development" in R. J. Haggerty, L. R. Sherrod, N. G. Garmezy, and M. Rutter (eds.) *Stress, Risk and Resilience in Children and Adolescents: processes, mechanisms, and interventions*, New York: Cambridge University Press.

Garrison, E. K. (2004) "Contests for the meaning of third wave feminism: Feminism and popular consciousness" in S. Gillis, G. Howie, and R. Munford (eds.) *Third Wave Feminism: a critical exploration*, Houndmills, UK: Palgrave MacMillan.

Gates, L., Jnr (1988) *The Signifying Monkey: a theory of African American literary criticism*, New York: Oxford University Press.

Geelong City Council (2012) *Geelong, Community, Multicultural*. Online. Available from http://www.geelongaustralia.com.au/community/multicultural/ (accessed 12 January 2012).

Gelder, K. and Thornton, S. (1997) *The Subcultures Reader*, London: Routledge.

Giroux, H. A. (1988) *Teachers as Intellectuals: toward a critical pedagogy of learning*, Granby, MA: Bergin and Garvey.

— (1994a) "Doing cultural studies: youth and the challenge of pedagogy" *Harvard Educational Review*, 64/3: 278–308. Online. Available from http://www.henryagiroux.com/online_articles/doing_cultural.htm (accessed 14 July 2011).

— (1994b) *Disturbing Pleasures: learning popular culture*, New York: Routledge.

— (1996) *Fugitive Cultures: race, violence, and youth*, New York: Routledge.

— (1999) "Cultural studies as public pedagogy: making the pedagogical more political" *Encyclopaedia of Philosophy of Education*. Online. Available from http://www.ffst.hr/ENCYCLOPAEDIA/doku.php?id=cultural_studies_and_public_pedagogy (accessed 7 September 2011).

— (2001a) *The Mouse that Roared: Disney and the end of innocence*, Lanham, MD: Rowman & Littlefield.

— (2001b) *Stealing Innocence: corporate culture's war on children*, New York: St Martin's Press.

Giroux, H. A. (2004a) *The Terror of Neoliberalism: authoritarianism and the eclipse of democracy*, Boulder, CO: Paradigm.

— (2004b) "Cultural studies and the politics of public pedagogy: making the political more pedagogical" *Parallax*, 10/2: 73–89.

— (2005) *Against the New Authoritarianism: politics after Abu Ghraib*, Winnipeg, MB: Arbeiter Ring.

Giroux, H. A. and Freire, P. (1989) "Pedagogy, popular culture, and public life" in H. A. Giroux and R. Simon (eds.) *Popular Culture, Schooling and Everyday Life*, Granby, MA: Bergin and Garvey.

Givhan, R. (2007) "'Girl power' group's look gave voice to individuality" *Washington Post*, 6 July. Online. Available from http://www.

washingtonpost.com/wpdyn/content/article/2007/07/05/AR2007070502-069.html (accessed 27 November 2008).
Glee (2009–) TV Series. USA: 20th Century Fox Television.
God Grew Tired of Us (2006) Film. Directed by C. D. Quinn and T. Walker. USA: National Geographic Films.
Gore, S. and Eckenrode, J. (1994) "Context and process in research on risk and resilience" in R. J. Haggerty, L. R. Sherrod, N. G. Garmezy, and M. Rutter (eds.) *Stress, Risk and Resilience in Children and Adolescents: processes, mechanisms, and interventions*, New York: Cambridge University Press.
Grease (1978) Film. Directed by R. Kleiser. USA: Paramount Pictures.
Gregg, M. (2006) *Cultural Studies' Affective Voices*, Basingstoke, UK: Palgrave Macmillan.
— (2008) "The importance of being ordinary" in S. Owen (ed.) *Richard Hoggart and Cultural Studies*, Basingstoke: Palgrave Macmillan.
Gregg, M. and Seigworth, G. (eds.) (2010) *The Affect Theory Reader*, Durham, NC: Duke University Press.
Grossberg, L. (1997) *Bringing it All Back Home: essays on cultural studies*, Durham, NC: Duke University Press.
— (2010) "Affect's future: rediscovering the virtual in the actual" in M. Gregg and G. Seigworth (eds.) *The Affect Theory Reader*, Durham, NC: Duke University Press.
Habermas, J. (1962) *Strukturwandel der Öffentlichkeit*; trans. T. Burger and F. Lawrence (1989) *The Structural Transformation of the Public Sphere: an inquiry into a category of bourgeois society*, Cambridge: Polity Press.
Hall, C. and Thomson, P. (2007) "Creative partnerships? Cultural policy and inclusive arts practice in one primary school" *British Educational Research Journal*, 33/3: 315–29.
Hall, S. and Jefferson, T. (1976) *Resistance through Rituals: youth subcultures in post-war Britain*, London: Hutchinson.
Hartley, J. (2007) "The 'Uses of Literacy' revisited in the multimedia age" *QUT Digital Repository*. Online. Available from http://eprints.qut.edu.au/12648 (accessed 31 March 2011).
— (2009) *The Uses of Digital Literacy: creative economy and innovation culture*, St Lucia, QLD: University of Queensland Press.
Hebdige, D. (1979) *Subculture: the meaning of style*, London: Methuen & Co.
Hecht, J. (2005) *The Journey of the Lost Boys*, Jacksonville, FL: Allswell Press.
Hendrick, H. (1990) *Images of Youth: age, class and the male youth problem, 1880–1920*, Oxford: Clarendon Press.
Henriques, J. (2010) "The vibrations of affect and their propagation on a night out on Kingston's dancehall scene" *Body and Society*, 16/1: 57–89.
Henriques, J., Hollway, W., Urwin, C., Venn, C., and Walkerdine, V. (eds.) (1984) *Changing the Subject: psychology, social regulation and*

subjectivity, London: Methuen.

Hickey-Moody, A. (2009a) "Little war machines: posthuman pedagogy and its media" *Journal of Literary and Cultural Disability Studies*, 3/3: 273–80.

— (2009b) *Unimaginable Bodies: intellectual disability, performance and becomings*, Rotterdam: Sense Publishers.

— (2011) "Tradition, innovation and fusion: Local articulations of global scapes of girl dance" *UNESCO Observatory E-Journal*, 2/2. Online. Available from http://www.abp.unimelb.edu.au/unesco/ejournal/pdf/007_HICKEYMOODY.pdf (accessed 12 March 2012).

Hickey-Moody, A. and Crowley, V. (2011) "Disability matters: pedagogy, media and affect" *Discourse*, 31/4: 399–409.

Hickey-Moody, A., Savage, G. C., and Windle, J. A., (2010) "Pedagogy writ large: public, popular and cultural pedagogies in motion" *Critical Studies in Education*, 51/3: 227–36.

High School Musical (2006) TV Film. Directed by K. Ortega. USA: Disney Channel.

High School Musical 2 (2007) TV Film. Directed by K. Ortega. USA: Disney Channel.

High School Musical 3: senior year (2008) TV Film. Directed by K. Ortega. USA: Disney Channel.

Hoggart, R. (1958) *The Uses of Literacy: aspects of working-class life with special reference to publications and entertainments*, Harmondsworth, UK: Penguin; first published (1957) London: Chatto and Windus.

Honey (2003) Film. Directed by B. Woodruf. USA: Universal Pictures.

Hooks, B. (1996) *Reel to Real: race, class and sex at the movies*, London: Routledge.

— (2004) *We Real Cool: black men and masculinity*, New York: Routledge.

James, K. (2010) "Domestic violence within refugee families: intersecting patriarchal culture and the refugee experience" *The Australian and New Zealand Journal of Family Therapy*, 31/3: 275–84.

Jeffrey, G. (2008) Research interview (15 June 2008).

Jermyn, H. (2001) "The arts and social exclusion: a review prepared for the Arts Council of England" Arts Council England. Online. Available from http://www.artscouncil.org.uk/publication_archive/arts-and-social-exclusion-a-review-prepared-for-the-arts-council-of-england/ (accessed 29 June 2011).

Johnston, E. (1991) *Royal Commission into Aboriginal Deaths in Custody*, National Report, 5 volumes, Canberra: AGPS.

Judy, R. (1994) "On the question of nigga authenticity" *Boundary 2*, 21/3: 211–30.

Kacha, S. (2009) "The NT Intervention: does the end justify the means" *Aboriginal and Social Justice Issues*. Online. Available

from http://stoptheintervention.org/uploads/files_to_download/The-NT-Intervention-25-8-2009.pdf (accessed 17 June 2011).

Kaplan, E. A. (1993) "Feminism(s)/Postmodernism(s): MTV and Alternate Women's Videos" *Women and Performance*, 6/2: 55–76.

Kelly, P. (2001) "Youth at risk: processes of individualisation and responsibilisation in the risk society" *Discourse*, 22: 23–34.

— (2007) "Governing individualized risk biographies: new class intellectuals and the problem of youth at risk" *British Journal of Sociology of Education*, 28/1: 39–53.

Kenway, J. and Bullen, L. (2001) *Consuming Children: education–entertainment–advertising*, Buckingham: Open University Press.

Kenway, J. and Hickey-Moody, A. (2008) "Moving abjection" in W. Ayers, T. Quinn, and D. Stovall (eds.) *Handbook of Social Justice and Education*, New York: Laurence Ehrlebaum.

Khun, R. (2007) "The rise of anti-Muslim racism in America: who benefits?" paper presented at the Humanities Research Centre Work in Progress Seminar, Australian National University.

Kitwana, B. (2002) *The Hip-Hop Generation: young blacks and the crisis in African American culture*, New York: Basic Books.

Knowles, B., Harrell, T., Stewart, C., and Nash, T. (2008) Song. "Single ladies (put a ring on it)" *I am ... Sasha Fierce*, USA: Columbia.

Lacy, S. (ed.) (1995) *Mapping the Terrain: new genre public art*, Seattle, WA: Bay Press.

Lash, S. and Urry, J. (1994) *Economies of Signs and Space*, London: Sage.

Leahy, D. (2012) *Assembling a Health[y] Subject*. Unpublished PhD Thesis.

Leahy, D. and Harrison, L. (2004) "Health and physical education and the production of the 'at risk self' " in J. Evans, B. Davies, and J. Wright (eds.) *Body Knowledge and Control: studies in the sociology of physical education and health*, London: Routledge.

Lehr, J. B. and Harris, H. W. (1988) *At-Risk, Low-Achieving Students in the Classroom*, Washington, DC: National Education Association.

Lena, J. C. (2006) "Social context and musical content: rap music, 1979–1995" *Social Forces*, 85/1: 479–95.

Lingard, B., Martino, W., and Mills, M. (2009) *Boys and Schooling: beyond structural reform*, London: Palgrave Macmillan.

Lower, G. (2008) "Fatal brawl that doused so much hope and potential" *The Australian*, 24 November. Online. Available from http://www.theaustralian.com.au/news/nation/fatal-brawl-that-doused-so-much-hope-and-potential/story-e6frg6nf-11111181-19921 (accessed 4 July 2011).

Lupton, D. (1999) *Risk*, London: Routledge.

Lusted, D. (1986) "Why Pedagogy? An introduction to this issue by David Lusted" *Screen Education*, 27/5: 2–16.

Mac an Ghaill, M. (1994) *The Making of Men: masculinities, sexuality and schooling*, Buckingham, UK: Open University Press.

— (1996) "Deconstructing heterosexualitites within school arenas" *Curriculum Studies*, 4/2: 191–235.
McDowell, L. (2002) "Masculine discourses and dissonances: strutting 'lads', protest masculinity, and domestic respectability" *Environment and Planning D Society and Space*, 20/1: 97–119.
McGee, K. (2010) "From Mata Hari to the Pussycat Dolls: modernism, orientalism and multiculturalism in popular culture." Online. Available from http://www.kristinmcgee.net/uploads/From-Mata-Hari-to-the-Pussycat-Dolls1.pdf (accessed 24 August 2011).
McLaren, P. (1989) *Life in Schools: an introduction to critical pedagogy in the foundations of education*, New York: Longman.
McManus, G. and Packham, B. (2007) "Refugees face tough new Test" *The Herald Sun*, 1 August. Online. Available from http://www.heraldsun.com.au/news/refugees-face-tough-new-test/story-e6frf7jo-111-1114082098 (accessed 4 July 2011).
McRobbie, A. (2000) *Feminism and Youth Culture*, 2nd edn, Basingstoke: Macmillan.
McRobbie, A. and Thornton, S. L. (1995) "Rethinking 'moral panic' for multi-mediated social worlds" *British Journal of Sociology*, 46: 559–74.
McWhirter, J. J., McWhirter, B. T., McWhirter, A. M., and McWhirter, E. H. (1998) *At-Risk Youth: a comprehensive response*, Pacific Grove, CA: Brooks/Cole.
McWilliam, E. (1996) "Pedagogies, technologies, bodies" in E. McWilliam and P. G. Taylor (eds.) *Pedagogy, Technology and the Body*, New York: Peter Lang.
McWilliam, E. and Taylor, P. G. (eds.) (1996) *Pedagogy, Technology and the Body*, New York: Peter Lang.
Maffesoli, M. (1996) *The Time of the Tribes: the decline of individualism in mass society*, London: Sage.
Margate Exodus (2006) Online. Available from http://www.themargateexodus.org.uk/home.html (accessed 19 December 2007).
Marini, S. (2003) *Sacred Song in America: religion, music, and public culture*, Champaign, IL: University of Illinois Press.
Marri, A. (2003) "Social studies, race, and the World Wide Web" in G. Ladson-Billings (ed.) *Critical Race Theory Perspectives on the Social Studies: the profession, policies, and curriculum*, Charlotte, NC: Information Age Publishing.
Maxwell, I. (2003) *Phat Beats, Dope Rhymes: hip hop down under comin' upper*, Middletown, CT: Wesleyan University Press.
Mickelburough, P. and Mawby, N. (2010) "Violence a Way of Life for some Sudanese" *The Herald Sun*, 28 April. Online. Available from http://www.heraldsun.com.au/news/more-news/violence-a-way-of-life-for-some/story-fn7x8me2-1226045873069 (accessed 1 July 2011).

Natriello, G., McDill, E., and Pallas, A. (1990) *Schooling Disadvantaged Children – racing against catastrophe*, New York: Teachers College Press.

NewVic Sixth Form Arts College (2012) Online. Available from http://www.newvic.ac.uk/ (accessed 9 May 2012).

Noble, G. and Watkins, M. (2009) "On the arts of stillness: for a pedagogy of composure" *M/C Journal*, 12(1). Online. Available from http://journal.media-culture.org.au/index.php/mcjournal/article/viewArticle/130 (accessed 10 June 2012).

Noble, G. and Watkins, M. (2011) "The productivity of stillness: composure and the scholarly habitus" in D. Bissell and G. Fuller (eds.) *Stillness in a Mobile World*, London: Routledge.

O'Brien, A. and Donelan, K. (2008a) "'Doing Good': the ethics of arts interventions with 'at risk' youth" in A. O'Brien and K. Donelan (eds.) *The Arts and Youth at Risk: global and local challenges*, Newcastle upon Tyne: Cambridge Scholars Press.

O'Brien, A. and Donelan, K. (eds.) (2008b) *The Arts and Youth at Risk: global and local challenges*, Newcastle upon Tyne: Cambridge Scholars Press.

O'Toole, J. R., Sinclair, C., and Jeannret, N. (2008) *Education in the Arts – teaching and learning in the contemporary curriculum*, Melbourne: Oxford University Press.

Office for National Statistics (2012*) England and Wales Neighborhood Statistics*. Online. Available from http://www.statistics.gov.uk/hub/index.html (accessed 24 January 2011).

Ogg, A. with Upshall, D. (1999) *The Hip Hop Years: a history of rap*, London: Channel 4 Books.

Owen, M. and Nason, D. (2009) "Indigenous kids better off in jail: South Australian A-G Michael Atkinson" *The Australian* 13 October. Online. Available from http://www.theaustralian.com.au/news/indigenous-kids-better-off-in-jail-south-australian-a-g-michael-atkinson/story-e6frg6p6-1225786083208 (accessed 4 July 2011).

Papoulias, C. and Callard, F. (2010) "Biology's gift: interrogating the turn to affect" *Body and Society*, 16/1: 29–56.

Polan, D. (1996) "Globalisms' localisms" in R. Wilson and W. Dissanayake (eds.) *Global/Local: cultural production and the transnational imaginary*, Durham, NC: Duke University Press.

Poynting, S., Noble, G., and Tabar, P. (1999) "Intersections of masculinity and ethnicity: a study of male Lebanese immigrant youth in Western Sydney" *Race, Ethnicity and Education*, 2/1: 59–77.

Rae-Grant, N., Thomas, H., Offord, D. R., and Boyle, M. H. (1989) "Risk, protective factors, and the prevalence of behavioral and emotional disorders in children and adolescents" *Journal of the American Academy of Child and Adolescent Psychiatry*, 28: 262–8.

Ralph, J. (1989) "Improving education for the disadvantaged: do we know whom to help?" *Phi Delta Kappan*, 70: 395–401.

Ramsay, B. (1995) *The Male Dancer: bodies, spectacle, sexuality*, London: Routledge.

Rasmussen, M. L. and Harwood, V. (2004) "Using ethnography to enhance contemporary understandings of Australian youth underachievement," AARE Conference, Melbourne: December.

Reality TV World (2011) "The Pussycat Dolls." *Reality TV World*. Online. Available from http://www.realitytvworld.com/realitytvdb/wiki/The_Pussycat_Dolls (accessed 24 August 2011).

Rheingold, H. (2008) "Using participatory media and public voice to encourage civic engagement" in W. L. Bennett (ed.) *Civic Life Online: learning how digital media can engage youth*, Cambridge, MA: The MIT Press.

Richardson, R. (2007) *From Uncle Tom to Gangsta: black masculinity and the U.S. South*, Athens, GA: University of Georgia Press.

Riley, S., More, Y., and Griffin, C. (2010) "The 'pleasure citizen': analysing partying as a form of social and political participation" *Young*, 18/1: 33–54.

Ringrose, J. (2011) "Beyond discourse? Using Deleuze and Guattari's schizo-analysis to explore affective assemblages, heterosexually striated space, and lines of flight online and at school" *Educational Philosophy & Theory* 43(6): 598–618.

Ringrose, J. (2012) *Post-Feminist Education? Girls and the Sexual Politics of Schooling*, London: Routledge.

RIZE (2005) Film. Directed by D. LaChapelle. USA: David LaChapelle Studios.

Roberts, R. (1991) "Music videos, performance and resistance: feminist rappers" *The Journal of Popular Culture*, 25: 141–52.

— (1994) "'Ladies First': Queen Latifah's Afrocentric feminist music video" *African American Review*, 28/2: 245–57.

Rock and Roll High School (1979) Film. Directed by A. Arkush. USA: New World Pictures.

Rock Eisteddfod Challenge (2010) Online. Available from http://www.rockchallenge.com.au/ (accessed 11 April 2011).

Roman, L. G. (1996) "Spectacle in the dark: youth as transgression, display and repression" *Educational Theory*, 46/1: 1–22.

Rose, N. (1996) "Governing 'advanced' liberal democracies" in A. Barry, T. Osborne, and N. Rose (eds.) *Foucault and Political Reason: liberalism, neo-liberalism and rationalities of government*, London: UCL Press.

Ross, A. and Rose, T. (eds.) (1994) *Microphone Fiends: youth music and youth culture*, New York: Routledge.

Sandlin, J. A., Schultz, B. D., and Burdick, J. (eds.) (2010) *Handbook of Public Pedagogy: education and learning beyond schooling*. New York: Routledge.

Savage, G. (2010) "Problematizing 'public pedagogy' in educational research" in J. A. Sandlin, B. D. Schultz, and J. Burdick (eds.) *Handbook*

of Public Pedagogy: education and learning beyond schooling, New York: Routledge.
Savage, G. and Hickey-Moody, A. (2010) "Global flows as gendered cultural pedagogies: learning gangsta in the 'Durty South' " *Critical Studies in Education*, 51/3: 277–93.
Scheikowski, M. (2010) "Boy, 15, jailed 16 years for murder of innocent bystander" *The Australian*, 21 May. Online. Available http://www.theaustralian.com.au/news/breaking-news/boy-15-jailed-16-years-for-murder-of-innocent-bystander/story-fn3dxity-1225869609159 (accessed 4 July 2011).
Schloss, J. (2009) *Foundation: b-boys, b-girls and hip hop culture in New York*, Oxford: Oxford University Press.
Scribble Jam (2011) *Scribble Magazine Online*. Online. Available from http://www.scribblemagazine.com/ (accessed 21 May 2011).
Secker, B. (2010) "Palestinian hip-hop in Beirut's refugee camps" *Demotix*. Online. Available from http://www.demotix.com/photo/461842/palestinian-hip-hop-beiruts-refugee-camps (accessed 9 May 2012).
Sedgwick, E. K. (2003) *Touching Feeling: affect, pedagogy, performativity*, Durham, NC: Duke University Press.
Seigworth G. (2003) "Fashioning a stave, or, singing life" in J. D. Slack (ed.) *Animations of Deleuze and Guattari*, New York: Peter Lang.
Shor, I. (1980) *Critical Teaching and Everyday Life*, Chicago: University of Chicago Press.
Singleton, N. (2004) *Echoes of the Lost Boys of Sudan*, Dallas, TX: Echoes Joint.
Skeggs, B. (1989) "Review symposium: louts and legends" *British Journal of the Sociology of Education*, 10/4: 484–90.
— (2001) "Feminist Ethnography" in S. Delamont, P. Atkinson, and A. Coffey (eds.) *Handbook of Ethnography*, London: Sage.
Slanted Magazine (2011) Online. Available from http://www.slanted-magazine.com/ (accessed 29 June 2011).
Step Up (2006) Film. Directed by A. Fletcher. USA: Buena Vista Pictures.
StreetDance 3D (2010) Film. Directed by M. Giwa and D. Pasquini. United Kingdom: Vertigo Films.
Swadener, B. B. and Lubeck, S. (1995) "The social construction of children and families 'at risk': an introduction" in B. B. Swadener and S. Lubeck (eds.) *Children and Families "At Promise": deconstructing the discourse of risk*, New York: State University of New York Press.
Tait, G. (1995) "Shaping the 'at-risk youth': risk, governmentality and the Finn Report" *Discourse*, 16/1: 123–34.
— (2004) "What is the relationship between social governance and schooling?" in B. Burnett, D. Meadmore, and G. Tait (eds.) *New Questions for Contemporary Teachers: taking a socio-cultural approach to education*, Frenchs Forrest, NSW: Pearson Education Australia.

Te Riele, K. (2006) "Youth 'at risk': further marginalizing the marginalized?" *Journal of Education Policy*, 21/2: 129–45.
The Lost Boys of Sudan (2003) Film. Directed by M. Mylan and J. Shenk. USA: Actual Films.
Thomson, P. (ed.) (2008) *Doing Visual Research with Children and Young People*, New York: Routledge.
Tomkins, S. (1962/1992) *Affect Imagery Consciousness*, 4 volumes, New York: Springer.
Turner, G. (2008) "Critical literacy, cultural literacy, and the English school curriculum in Australia" in S. Owen (ed.) *Richard Hoggart and Cultural Studies*, London: Palgrave Macmillan.
Universal Music Group (2011) *The Pussycat Dolls*. Online. Available from http://www.pcdmusic.com/bio/default.aspx?aid=455 (accessed 24 August 2011).
Vygotsky, L. (1978) *Mind in Society: the development of higher psychological processes*, Cambridge, MA: Harvard University Press.
Warner, M. (1992) "The mass public and the mass subject" in C. J. Calhoun (ed.) *Habermas and the Public Sphere*, Cambridge, MA: M.I.T. Press.
— (2002) "Publics and counterpublics" *Public Culture*, 14/1: 49–90.
Watkins, C. (2005) *Hip Hop Matters: politics, pop culture, and the struggle for the soul of a movement*, Boston, MA: Beacon Press.
Watkins, M. (2012) *Discipline and Learn: bodies, pedagogy and writing*, Rotterdam: Sense Publications.
West Side Story (1961) Film. Directed by J. Robbins and R. Wise. USA: United Artists.
Williams, J. (2000) "Deleuze's ontology and creativity: becoming in architecture" *The Warwick Journal of Philosophy*, 9: 200–19.
Williams, R. (1958) "Culture is ordinary" in N. Mackenzie (ed.) *Conviction*, London: McGibbon and Kee; reprinted in J. O. Higgins (ed.) (2001) *The Raymond Williams Reader*, Oxford: Blackwell.
— (1963) *Culture and Society*, New York: Columbia University Press; first published (1958) London: Chatto and Windus.
— (1965) *The Long Revolution*, Harmondsworth: Penguin; first published (1961) London: Chatto and Windus.
— (1966) *Communications*, 2nd edn, New York: Barnes and Noble.
Willis, P. (1977) *Learning to Labour*, Aldershot: Gower.
— (1981) "Cultural production is different from cultural reproduction is different from social reproduction is different from reproduction" *Interchange*, 12: 48–67.
Windle, J. A. (2008) "The racialisation of African youth in Australia" *Social Identities*, 14/5: 553–66.
Winnaman and Associates (2011) *Bally Fitness Website*. Online. Available from http://winnaman.com/pcd.html (accessed 24 August 2011).
Wright, H. K. (1998) "Dare we de-centre Birmingham? Troubling the origin and trajectories of cultural studies" *European Journal of Cultural Studies*,

1/1: 33–56.
Youdell, D. (2006) *Impossible Bodies, Impossible Selves: exclusions and student subjectivities*, Dordrecht, The Netherlands: Springer.
— (2010) *School Trouble: identity, power and politics in education*, London: Routledge.

Index

a/r/tography 26, 150
Aboriginal youth: moral panics 47–52; risk discourses 52, 54, 56, 59
activism 3–4, 70–1, 92, 93, 95, 119–20
aesthetic citizenship 13, 16, 121, 122, 145–6
affect 120–3, 125–31; as pedagogy 131–6
affective pedagogy 119–22, 128–9; institutionalized example of 136–45
"affectus" (change), Deleuze 126–7, 156
Appadurai, A. 14–15, 69–73, 74, 76
"at-risk" youth 14, 16, 21, 52–9; role of arts in helping 59–65
Artangel 131, 132, 133
Australian black panics 47–52
authentic masculinity 93–4

b-boys and b-boying 97, 100, 102, 104–5, 112
Bally Fitness, gym group 68
battle dance 96, 108–13
"battling" 97, 112–13, 117
Beep (music video) 67, 68–9, 77, 78, 84, 85, 88
Bennett, A. 90–1
Berlant, L. 26
Blagg, H. 49, 50
breakdance 94, 96, 97, 98, 115, 117–18; signifying 100–7
Bringing it All Back Home (Grossberg) 129

Bruns, A. 25
Bullen, L. 20, 32
Burdick, J. 20, 26, 27, 28, 29, 126

Cahill, H. 63–5
Callard, F. 121–2, 127
citizenship: aesthetic 13, 16, 121, 122, 145–6; Appadurai's notions of scapes 72, 73, 91; little publics promoting 19–20, 26, 34–5; and the public sphere 23; style as 129
"clowning" 97
Cohen, S. 44–6, 48, 51–2
"common culture" 35
Communications (Williams) 37, 150–1
competitions 32–5
Connell, R. 96, 105
control culture 48, 52
corporatization 25, 28
Courthouse Youth Arts Centre, The 141–4, 145
creative fabulation 124–5
Creative Partnerships 6, 128, 132–5
Cuban, L. 53–4
Culture and Society (Williams) 151
Cunneen, C. 48, 50
Cutler, A. 132–5, 137

Davis, M. 52
Deleuze, G. 13, 43, 87, 121, 122–7, 129–31, 135, 139, 140, 142, 156, 157
deviance 45–7, 49, 51
Dewey, J. 19, 26

Difference and Repetition (Deleuze) 123, 139
differenciation and differentiation, Deleuze 121, 122–5, 129–31
Dinka youth 77, 113, 115, 156
doll power 82
Donelan, K. 61–3

Eckenrode, J. 53–4
eisteddfods 32–5, 97–8, 111
Ellsworth, E. 126
empowerment 62, 82, 104, 121; post-feminist 67–8
ethics: of arts interventions 62–3; consent issues 74–5; research 11–12
"ethnoscapes," Appadurai's concept of 14–15, 69–73, 113
Ewald, W. 131–2

fabulation 124–5
femininity: non-white 76, 77–8, 91; and visuality 78–88
feminism 70–1, 80, 81, 82, 88, 153–4; post-feminist empowerment 67–8
fighting dance 97, 98, 106, 108–13
Fine, M. 64
Fraser, N. 24–5
Freire, P. 39

gangsta masculinity 100–2, 116–17
Gates, L., Jnr 15, 98, 99, 104, 107, 147
Geelong, Victoria, Australia 8, 141–3
gender(ed) identity 117, 118, 147; Koori boys 103–4; Sudanese boys 114–15; through breaking and hip hop 94, 95, 96; wrestling boys 108, 109, 111–12
genre(s) 13, 14, 15, 33, 34, 96, 111
"girl culture" 68
girl power 79–80, 81–2, 88; minoritarian 74, 87
Giroux, H. A. 27–8, 30–1, 38–9, 73, 152
Givhan, R. 80, 88

Glee (television comedy) 17–19
Global Rock Challenge 32–5
Gore, S. 53–4
governance 3, 14, 16, 21, 43–4; reflexive 63–4; and risk discourse 52–9
Gregg, M. 151, 156
Grossberg, L. 120–1, 122, 124, 129
Guattari, F. 43, 87, 124–5, 130

Habermas, J. 23–5, 33, 34
Hall, S. 45
Hartley, J. 36
HeadSpin (master classes) 143
Hebdige, D. 96–7, 115–16
high school musical genre 32–3, 38, 67
hip hop dance 93–8, 100, 102–7, 111–12, 114, 116–20
Hoggart, R. 36
Honey (film) 41–2
Hooks, B. 117

identity issues 46, 89, 90, 94–8, 117–19, 132
ideoscapes 72–4
"individuating difference," Deleuze 124

Jefferson, T. 45
Jermyn, H. 59–61

Kelly, P. 55, 57–8, 59, 63
Kenway, J. 20, 32
Knowles, B. 17
Koori youth 4–5, 11–12, 101, 103–4, 105, 112
"krumping" 97, 107

Lacy, S. 26, 27
Lebanese youth 119, 148
Lingard, B. 96
literacies, popular 35–40
"little publics" 12–13, 17–21, 146–7; making through youth arts 21–8; popular literacies 35–40; public pedagogy 28–32; Rock Eisteddfod Challenge 32–5
"lost boys" 113–18

Index

McDowell, L. 108
McGee, K. 81–2
McRobbie, A. 45
McWhirter, J. J. 56
McWilliam, E. 156
majoritarian versus minoritarian 87
Mapping the Terrain (Lacy) 26
Margate Exodus, The (film) 6–7, 128, 132–6, 144
Martino, W. 96
masculinity 94–8, 100–18
mediascapes, Appadurai's concept 14–15, 69–74, 88, 91
mediatized moral panics 43–52, 116
Mills, M. 96
"minoritarian," cultural position 87
monument concept 124–5
moral panics 43–52; educational and psychological perspectives 52–9

neoliberalism 27, 28, 30–1, 61
Nietzsche, F. 139, 142
Noble, G. 106

O'Brien, A. 61–3

Palestinian youth art 119–20
Papoulias, C. 121–2, 127
photographic exhibitions 128, 131–2, 144, 145
Polan, D. 90
popular literacies 35–40
Poynting, S. 106
primary deviance 46, 51
"protest masculinity" 96, 98, 100, 105, 108, 110
public pedagogy 28–32
public sphere 19, 23–5, 26, 29–30, 31, 150
Pussycat Dolls, The (pop band) 67–88

racialized identity 17, 55–6, 118
racialized social panics 47, 50
Redfern riot 50, 152
reflexive governance 63–4
research ethics 11–12
Rheingold, H. 22–3

Richardson, R. 101
riots 48, 50
risk discourses 52–9
"Risky Business" project 61–2, 63
RIZE (documentary film) 94, 97, 114, 115, 117, 155
Rock Eisteddfod Challenge (REC) 32–5

Sandlin, J. A. 20, 26, 27, 28, 29, 126
satire 102–3, 104–5, 107, 118
Savage, G. 25–6, 30–1
scapes 69–74
Schloss, J. 100
Schultz, B. D. 20, 26, 27, 28, 29, 126
Scribble Jam (hip hop festival) 93
secondary deviance 46, 51
Seigworth, G. 128, 156
self-salvation, youth arts as 59–66
sexuality 42, 107, 110–11
signifying 98–9; on breakdance 100–7
Single Ladies (pop song) 17, 18
Skeggs, B. 95
social benefits of the arts 59–62
social exclusion 59–60
social inclusion, critique of 21
Stratford Circus sixth-form college, London 137–41, 144, 145
street art 119, 120, 122
striation 130, 139–40
Structural Transformation of the Public Sphere, The (Habermas) 23–4
subcultures 26, 96–7, 129, 142
subjectivation 55, 89–91
"subordinated masculinity" 96, 100, 101, 105, 107, 108
Sudanese youth: boys' dance styles 96–7, 114–18; dance and music traditions 74–7; moral panics 50–2, 54, 56; single-sex dance workshops 10–11

Tabar, P. 106
Tait, G. 55, 56
Taylor, P. G. 156

theater making programs 141–2
top rock/top rocking 154
Towards a Promised Land (photography exhibition) 6, 128, 131–2, 135, 136, 144, 145
"truth of youth-at-risk" 57–8
"the turn to affect" 121–2

Uses of Literacy, The (Hoggart) 36, 151

violence, accusations of 47–52
visuality and femininity 78–88
Vocational Education and Training (VET) students 95–6, 98, 100–5

Warner, M. 13–14, 25
Watkins, M. 122
Williams, R. 27, 35, 37–8, 150, 151
Willis, P. 35, 89
Windle, J. A. 51, 116
Woolcock, P. 132, 133
working-class culture 36, 39, 106, 115, 151
World Wrestling Entertainment (WWE) 108–13
wrestling boys 96, 108–13

youth arts as cultural production 89–91
youth arts programs 59–66

Printed in Great Britain
by Amazon.co.uk, Ltd.,
Marston Gate.